松玉新賦

淳雅齋藏綠松石飾　翁啟榮結藝

Treasured Turquoise from Wang Hsien-Chao's Collections

Contents

序　文
PREFACES

淳雅齋

● 前言

我常常覺得浸沁古歔，進入多元寬廣、安和雍容的賞鑑世界，是一件最美，心靈最感快慰的事。生為中國人是十足幸運驕傲的！擁有數千載盛茂與頹宕更迭的豐厚歷史，諸朝各代遺留下來的故物何止億萬，也因此成為以骨董收藏為樂趣的民族。因為每件藏品的背後都蓄涵深厚的文明精神，可供深思、索解，所以才值得我們珍視、投入，從舊昔老件的蒐求與析究中找尋未知的天地。第一次與王醫師晤見，我心裡揣度的是：一位知名的耳鼻喉科醫師怎麼會是古玩迷呢？再端視他所攜來準備展出的部分作品及圖錄照片，更詫異於他對文史和藝事的稽揆下了不少苦功夫，愈加引起我對此展的觸興。在台灣，偏嗜寶石的契友為數甚夥，然單只集聚綠松石飾器的藏家卻極少，淳雅齋主人王顯昭醫師真是個特例！他行醫之餘，愛素好古，多年來以暇閑從事高古綠松石藝的韞蓄及鑽研。近年來，為使物用得以活化，開始耙梳整理：商請國內結藝名家翁啟榮老師設計編製，使原處零散之綠松石構件轉為可佩戴之實用飾玩，讓觀者銘記文物重熙同藝術創造兩者交迸昌華的可貴。

綠松石因其色澤巧妍、硬度適中、開採頗易的性質，早受青睞進而大規模開發利用，故自古以來名稱繁多，中外混雜。英文名為 "Turquoise" ，乃源自十三世紀法語 "Pierre Turquoise" ，十字軍東征時，經由土耳其傳入歐洲，因而命名為「土耳其石」沿襲至今。寶石學家欒秉璈認為：應譯為「突厥玉」，因綠松石古語為 "Turkeys" 或為 "Turkey stone" ，而波斯曾古屬突厥疆域，盛產綠松石之故，並非係波斯綠松石經土耳其輸往歐洲之故。綠松石的波斯語是 "ferozah" ，為「勝利」的意思；而西藏文是 "gyu" ，與 "yu" 相似， "yu" 在漢語中即是玉，喻指珍貴的寶玉。然綠松石一詞的稱名文獻，始見於《欽定大清會典圖》輯錄：「皇帝朝珠雜飾，惟天壇用青金石，地壇用密珀，日壇用珊瑚，月壇用綠松石。」近人章鴻釗在《石雅》中曾云：「此或形似松球，色近松球，故以為名」。

埃及、中國、波斯（今伊朗）與美國同是綠松石的主要產區，此外，墨西哥、巴西、智利、印度、阿富汗、俄羅斯及澳大利亞等國均有產出。它的摩氏硬度為五至六度，比重約在2.6至2.8之間，經由含銅、鋁、磷的地下水在早期花崗岩石中淋濾，於近地表的礦床中沉澱形成，礦體常呈細脈狀、皮殼狀、鐘乳狀、腎狀、結核狀及其他不規則狀，化學式為$CuAl6(PO4)4(OH)8 \cdot 4H2O$，具柔和的蠟狀光澤，屬三斜晶系，呈緻密的隱晶質集合體。色源係銅和鐵兩種元素，含銅成份多，顏色即偏藍；含鐵成份多，顏色即顯綠。其中以天藍色、淡藍色、藍綠色、綠藍色，顏色均一，表面微玻璃感似上了釉的瓷器，鮮有褐鐵礦網紋者，質地上佳。在距今五千多年前，埃及第一王朝的札爾皇后木乃伊手臂上戴有四隻綠松石鑲嵌的黃金手鐲，西元一千九百年挖掘出土時，依然光彩奪目，堪稱舉世奇珍。唐代文成公主遠嫁吐蕃，曾攜入來自薩珊王朝進貢的綠松石飾物，松贊干布下詔用之裝飾於釋迦牟尼佛像上，此後綠松石被藏胞視作辟邪魔、斥鬼蜮的聖物。居於美國西南部的印第安人則認為綠松石是大海和藍天的精靈，能賦予遠征者祥瑞和運勢，成功幸運之石的美譽不脛而走，又得聞十二月誕生石及清晨五時生時石的西方俗說，千百年來持續深受人們的寶用，甚或達至沉迷的程度，於此可窺一斑。

中國的綠松石礦產蘊藏豐富，集中於湖北的竹山、鄖縣、鄖西，陝西的白河，雲南的安寧，新疆的哈密，青海的烏蘭等地。據考古發掘實物而論，新石器時期出土的綠松石器主要分布在黃河流域，由距今七千年至一萬年的裴李崗文化首開先河，仰韶文化、大汶口文化、馬家窯文化、齊家文化和龍山文化皆屬延展範圍。遼河流域紅山文化，長江流域大溪文化、良渚文化及東南沿海石峽文化也有少量發現。若東北地區考古文化的玉器以岫玉作大宗：長江流域考古文化的玉器以閃玉為代表：那麼，綠松石足可躋登黃河流域考古文化玉器的核心品目之一。夏代出土的綠松石器以裝飾品居多，河南偃師出土的嵌綠松石獸面紋銅飾牌，其紋飾乃是青銅器上最早的獸面紋之一，應是由繩索穿綴為一體的飾物。安陽殷墟婦好墓出土嵌綠松石象牙雕杯、銅鉞等實用器，亦令人不禁驚歎。春秋、戰國時期，承續先代的工藝技巧，綠松石器有逐步經中原地區向邊陲少數部族擴散的趨勢，風格參差，因地域相異而多樣化，生就前所未有的盛況。綠松石泰半出自王室成員的隨葬品中，昭示了優越於木、陶、骨、石等材質器用功能之上的審美價值，並迅速演變成王權（軍事首領）與神權（巫覡）的身份表彰。又「側而視之色碧，正而視之色白」（唐末・杜光庭《錄異記》），「色混青綠而玄，光彩射人」（明・陶宗儀《輟耕錄》）的特徵，時有「天下所共傳寶也」的「和氏璧」，即是綠松石所製的臆斷。其魅力所在，不言可喻。

庋藏文翫需要時間的投注，知識的充實，財力的積累，及機緣的逢時。其中甘苦，非身體力行，無從領會。王顯昭、張海燕伉儷好藝之途的悉心和專執，結合繩編設計的發想，成就了此次綠松石與現代結藝的對話，著實令人感佩。現下官方單位正大力獎掖文化創意產業，王顯昭伉儷無吝提供一己私藏，悉心營造「古貌新妝」的弘朗氛圍，在在彰顯時尚與古典交匯的美學價值。生命因為屢逢驚喜、充滿刺激的收藏歷程而豐富、滿足。本次假中正紀念堂管理處三樓志清廳（四展廳）的展出，預計近百件作品，其中不乏先秦遺物，累世積澱，足供渴望領略一個悠邈民族淵淵灝灝承傳的繼之者細細品裁，盍興乎來。只要在這小不盈寸的綠松石盛飾前面靜默一番，盈藏在胸，似乎即可憑添、遙想剎那的另世風華。除了籌辦展示外，巧妍各異的作品圖像亦輯印成書，為展出畫下擊節稱快的驚嘆號，同時也帶給文翫收藏圈與傳統藝術界諸方大家心頭上無限的漪想。值此杏花春雨、蘇活韶節的佳日，謹撰斯文為賀。

華梵大學美術與文創系教授
兼書法研究中心主任
香港佳士得拍賣台灣分公司
文物展覽藝術顧問

2012.02.18 頓首

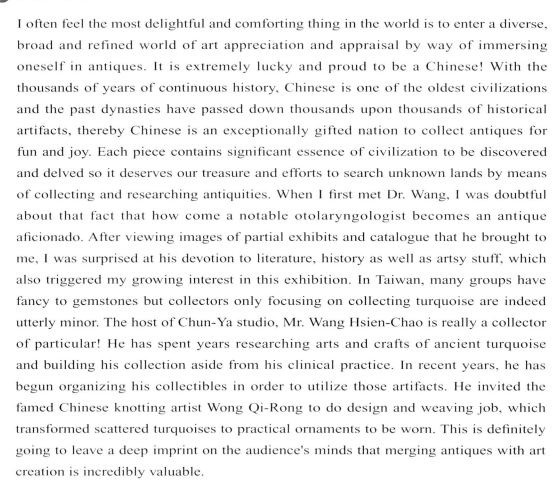

Foreword

I often feel the most delightful and comforting thing in the world is to enter a diverse, broad and refined world of art appreciation and appraisal by way of immersing oneself in antiques. It is extremely lucky and proud to be a Chinese! With the thousands of years of continuous history, Chinese is one of the oldest civilizations and the past dynasties have passed down thousands upon thousands of historical artifacts, thereby Chinese is an exceptionally gifted nation to collect antiques for fun and joy. Each piece contains significant essence of civilization to be discovered and delved so it deserves our treasure and efforts to search unknown lands by means of collecting and researching antiquities. When I first met Dr. Wang, I was doubtful about that fact that how come a notable otolaryngologist becomes an antique aficionado. After viewing images of partial exhibits and catalogue that he brought to me, I was surprised at his devotion to literature, history as well as artsy stuff, which also triggered my growing interest in this exhibition. In Taiwan, many groups have fancy to gemstones but collectors only focusing on collecting turquoise are indeed utterly minor. The host of Chun-Ya studio, Mr. Wang Hsien-Chao is really a collector of particular! He has spent years researching arts and crafts of ancient turquoise and building his collection aside from his clinical practice. In recent years, he has begun organizing his collectibles in order to utilize those artifacts. He invited the famed Chinese knotting artist Wong Qi-Rong to do design and weaving job, which transformed scattered turquoises to practical ornaments to be worn. This is definitely going to leave a deep imprint on the audience's minds that merging antiques with art creation is incredibly valuable.

Turquoise has enjoyed wide popularity and had a broad usage for its unique hue, mild hardness, and easy-to-dig feature. The substance has been known by many names, but the word turquoise, which dates to the 13th century, is derived from an old French word for "Pierre Turquoise," because the mineral was first brought to Europe from Turkey through Cruciata. According to the study of gem expert Luan Bing-Ao, the correct translation in Chinese should be jade of "tu-jue(突厥)." That's the reason why ancient name of turquoise is "Turkeys" or "Turkey stone." Turquoise is from the mines in historical Khorasan Province of Persia. Turquoise in Persian is "ferozah" which means victory and in Tibetan is "gyu," similar to the pronunciation "yu" in Chinese which means valuable gems. The formal Chinese writing found concerning

the name of turquoise is on an official catalogue（《欽定大清會典圖》）. Recent records from Chang Hong-Zhao's essay addressed the origin of Chinese name of turquoise, said "People name it after the similar shape and hue with pinecones."

The major production areas of turquoise include Egypt, China, Persia (Iran) and the United States. Besides from that are Mexico, Brazil, Chile, India, Afghanistan, Russia, Australia, etc. The hardness of turquoise ranges from 5 to 6. With lower hardness comes lower specific gravity (2.60–2.80) and greater porosity: These properties are dependent on grain size. Turquoise deposit is formed by leaching action of the groundwater consist of a copper containing basic aluminum phosphate in early granite and sedimentation (precipitation). Minerals are often seen in thread shape, kefnel shape, cystolith shape, kidney shape, and irregular shape. Its crystal system is proven to be triclinic, with chemical formula $CuAl6(PO4)4(OH)8\cdot4H2O$. The lustre of turquoise is typically waxy to subvitreous, and transparencyis usually opaque, but may be semitranslucent in thin sections. Colour is as variable as the mineral's other properties, ranging from white to a powder blue to a sky blue, and from a blue-green to a yellowish green. The blue is attributed to idiochromatic copper while the green may be the result of either iron impurities or dehydration. Its streak is a pale bluish white and its fracture is conchoidal, leaving a waxy lustre. Turquoise may also be peppered with flecks of pyrite or interspersed with dark, spidery limonite veining. Over 5000 years ago in First Dynasty, Egyptian Queen Zer had worn four gold bracelets with turquoise inlay on her wrist when she died. When her tomb was excavated in 1900, archaeologists discovered the jewelry bracelets still shining as if it had never been buried. Princess Wen Cheng of the Tang Dynasty who married Tibetan king had brought to Tibet turquoise jewelry and ornaments considered tributes from Sassanid Empire. Later Srong-btsans gam-po, the Tibetan King had turquoise used to decorate Sakyamuni Buddha Statue and thereby Tibetan people have taken turquoise as a symbol of the incarnation of God that can protect people from evil spirits and demon. The Indian in Southwestern United States believe turquoise is a piece of the sky which has fallen to earth. It was believed that turquoise could bring expeditions good luck and blessings and naturally has been known by reputation as "gemstone of success and good fortune." In western folklore, turquoise is the December birthstone and also the birthday stone for people born at 5 am in the morning. It has been widely

used in history for hundreds of thousands of years. It does have the right to be called "a gemstone of the peoples."

China has been a major source of turquoise, mostly in regions of Hubei, Sanxi, Yunnan, Xinjian, Qinghai, etc. According to archeological excavations, turquoise found in Neolithic Period is mainly located around Yellow River basin. First was found at Peiligang culture dating back to 7000 BCE – 10000 BCE. Yangshao culture, Dawenkou culture, Majiayao culture, Qijia Culture, and Longshan culture are also excavation turquoise zones. Minor source was discovered at Hongshan culture in Liao River basin area, Daxi culture and Liangzhu culture in Yangtze River basin area as well as Shixia culture around southeastern coast region. If Xiuyan jade is the major material of jade excavated in northeastern region, nephrite could present jade unearthed in Yangtze River basin area. Thus, turquoise is sufficient to be counted one of the core items among ancient jade found in Yellow River basin. Many turquoises were used as ornamental objects in Xia Dynasty. The bronze turquoise inlay pendants with beast face pattern unearthed in Henan Province are one of the earliest beast face patterns on bronze ware, which ought to be single adornment stringed by cord. Some practical tools excavated in Anyang Ruins of Yin, such as ivory carved turquoise inlay cups and copper tomahawks, are remarkable. During Spring and Autumn Period and Warring States Period, turquoise had gradually spread out from the central plain to minor tribes in the border area. Styles therefore varied from region to region that formed a golden time in turquoise history. Turquoise is mostly discovered within burial objects of members of the imperial family, which disclosed its greater aesthetic value over wood, ceramic, bone, stone and suchlike functional materials. Soon it became a symbol of dignity of imperial power (military leaders) and divine power (witches and wizards). There once was a saying assumed that He Shi Bi which thought the most precious disc of jade at that time actually to be made of turquoise. It can be said that the allure of turquoise is inexpressible.

Collecting antiques requires time, solid knowledge, financial supports and a right time for everything. People would never be able to stand in the shoes unless they go through the sweetness and bitterness of collecting experience themselves. It is admirable that Mr. Wang Hsien-Chao and Mrs. Chang Hai-Yen's endeavour to

embody their concept to integrate weave design with turquoise that made the dialogue between turquoise and modern knotting art happened. Since nowadays–official organizations are strongly committed to promote cultural and creative industries, Mr. and Mrs. Wang have unselfishly provided their private collections to help materialize the great exhibition, in the meantime, giving antiquities new lease of life. What they did features aesthetic value of fusion of modernity and tradition. Life has become abundant and completed in virtue of the exciting and surprising journey of collecting. The exhibition is going to present almost a hundred works in the National Chiang Kai-Shek Memorial Hall at 3F Zhi-Qing Exhibition Office. Some relics dating back to Pre-Qin Dynasty, which carry so much historical memories worth digesting over and over again by the posterity whom hope to realize the history of inheritance nationality. Only a moment of contemplation in front of a tiny piece of turquoise pendant could bring people back to some glorious era long gone. In addition to the preparation of exhibition display, Mr. and Mrs. Wang will edit and publish catalogue consist of fine and various work images as the exhibition highlight; meanwhile, the catalogue will create a ripple effect on the circle of antique collectors and every individual in the traditional art world. I hereby take the privilege of composing this note of my personal admiration and congratulation.

Professor, Huafan University–Department of Fine Arts and Culture Creative Design
Director, Huafan University–Calligraphy Research Center
Art Consultant at Cultural Relics and Exhibition, Christie's auction house, Hong Kong - Taiwan branch
Hsiung Yi-Chung
2012.03.03

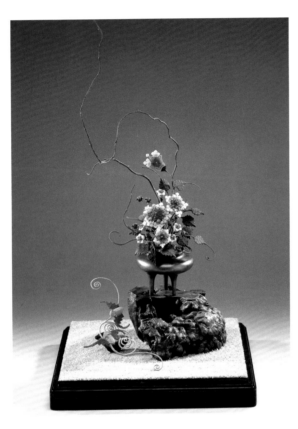

● 創作者序

中華文化中「綰結藝術」，在經緯之間起承轉合，成就獨步於其他悠久文明，精采而絢麗！遠從上古先民的結繩記事；漢唐盛世之器皿、石刻；乃至明清以降生活、服飾上的髮髻、衣帶；及宗教造像、人物畫作中，均可見其蹤影，在歷朝更為宮闈、閨中仕女們必學之女紅，亦是愛戀情愫傳遞的見證。

近半世紀來經官方單位、民間社團、有心人士不遺餘力的培植推廣，雖未能百家爭嶸，但卻也可各領風騷！而「善・思維」、「思維・善」是每每我個人接受新的挑戰時，心中的序曲與終章。

《松玉新賦》百餘件作品的完成展現，由衷地感謝王顯昭、張海燕賢伉儷的全力支持與包容信任，使其收藏的高古綠松石在編結、素材、理念多方因緣結合，讓老文物與新工藝再創新韻，和再一次的感動！

結藝創作者

2012.03.02 謹識

Preface

The art of tying knots dates back to prehistoric times, evolving over the course of thousands of years with the development of more sophisticated techniques and increasingly intricate woven patterns. The achievement is leading across cultures. It could be traced back from the antediluvian days used as a record-keep device and has appeared on many utensils as well as stone carvings in Han and Tang Dynasty. All along to Ming and Qing Dynasty, knotting has continued to exist in daily ornament and garb such as hairpins and belts. It has lived in many religious statues and figure drawings as well. Moreover, knotting is a must-learn woman craft for sole female and lady of the royal court in all the dynasties and may also serve to witness affection between lovers.

Knotting has steadily flourished up in recent half century due to the constant support from official organizations, folk communities, and people sharing the same goals. Nevertheless it has not yet been in the situation of a hundred schools of thought contending; Chinese knotting still enjoys wide popularity and successfully develops diversity! The "thought of benevolence" and "think benevolently" always serve as the prelude and finale on my mind whenever I take on new challenges.

With the exhibition accomplished and fine display of nearly a hundred knotworks, I am so grateful to Mr. and Mrs. Wang, Wang Hsien-Chao and Chang Hai-Yen for their trust and support. Their effort gives these ancient turquoises a chance to influx with new weaving techniques, materials and creativities. The reborn of Wang's treasured turquoise collection over the fusion of archaic artifacts and modern craft is definitely going to move us all over again!

Chinese Knots Artist
Wong Qi-Rong
2012.03.02

緒 記

收藏古文物的經驗，對於身為臨床耳鼻喉科醫師的我，一路走來，充滿了期待、驚喜、失望、迷惑與抉擇時的無奈，可謂五味雜陳，百感交集。當然，收藏的過程與收穫，也成為生活上的一大樂趣。

有人說，古文物是富人的玩具，而收藏古文物是富人的遊戲，我對此不大認同。我認為，收藏固然需以穩定的經濟基礎做後盾，但唯有量力而為，才能真正樂在其中。古文物不該被少數人私藏壟斷，應將之賦予新生命，使其以完美的姿態呈現於世人眼前，才是收藏最大的意義。

我涉入收藏古文物的年資不足廿年，仍是收藏界的小學生，而綠松石僅為諸多收藏品中的一項。雖然非常喜愛古玉簡潔的雕工及神秘的歲月痕跡，但受財力所限，我選擇了具備同樣特性但較冷門的綠松石為收藏目標。

數年前，古董市場上還能找到一些古代的綠松石。但每當面對業者展示新到貨品並開出價錢，取捨之間，內心總是承受莫大的折磨與衝擊。小小一塊古綠松石，價格往往超過一支新款手機，資金投入的壓力相當鉅大。遇見令人砰然心動的綠松石，卻礙於價格被迫放棄時，確實萬般無奈。自己心裡有數，收藏古物是長久的路，必須量力而為。

欣賞及鑑定古文物是一門相當深奧的專業。儘管期望市場上有佳品出現，但是面對判定真偽的考驗，常讓收藏者陷於徬徨無助。一旦經查證發現文物有瑕疵、改製或後仿情況時，收藏者不啻遭到當頭一棒，內心的失落及傷痛更是旁人無法體會的。

所幸，內人對於我的收藏雖不是十分贊同，卻經常給予精神上的支援與鼓勵。她會陪同我一起參與收藏的活動，在我失意時安慰我，迷惑時給我建議，並主動幫我收集相關資料，不愧是一位賢內助。因此，我決定暗地託人設計漂亮的綠松石中國結項鍊相贈，以為回報。

經過多位朋友介紹與作品比較，我大約在五年前，結識了結藝家翁啟榮老師。翁老師的作品風格清新脫俗，以優美動人的造型設計，結合流暢有力的編結藝術，能將數千年前的古物，化身為兼具古典優雅氣質與現代華麗丰釆的作品，巧妙細緻，令人激賞讚嘆。所以，我力邀翁老師為合作夥伴，共同展開綠松石項鍊的設計與編結工作。

見到翁老師所完成的第一批作品時，只能用「驚豔」一詞來形容內心的悸動。當下決定，往後以綠松石為收藏重心，其他項目暫且擱置，請翁老師持續幫忙設計與編結，待累積至相當數量後，以舉辦展覽會的方式，與古董藝術界的同好們分享成果。

此後，工作之外的餘暇更加勤訪古董店家，不斷以期待的心，收藏符合展出需求的綠松石；以無奈的心，放棄雖然喜愛但與展出無關的綠松石；以戰戰兢兢的心，收集價格節節上漲的黃金配件。投入無數精力、心血、時間，以及財務上的精細規劃運作，終於，很幸運的，作品一件件誕生了。零散的松石與配件，以巧妙的繩結聯繫、搭配，變化成優雅靈動、各具特色的作品。我知道，實現夢想的日子不遠了。

籌備本次展覽，令我相當戒慎恐懼。雖然力求達到真、善、美的境界，但由於本身畢竟不是古文物專家，對於文物的斷代，或許無法得到方家一致的認同，但是懇請學者、前輩們包容我這個行外人的勤奮努力，將欣賞的眼光，放在結藝作品的美感與藝術性之上。

在展覽會揭幕的此際，謹以萬分誠摯之心，由衷感謝熊宜中教授寫序題字，黃俊菘老師統籌策展、聯繫、宣傳事務，翁啓榮老師編結及編輯圖錄，陳彤亮老師創作油畫的鼎力相助，以及各方好友在幕後的全力投入，促使展覽會如期推出，圖錄亦順利刊行。當然，也要十分感謝中正紀念堂管理處賜予寶貴的機會，提供展出場地及人員、設備的配合協助。最重要的，感謝無條件支持我的家人－賢妻海燕，愛女婷、瑋，才能讓我五年來在繁忙的醫療本業之外，還有十足的動力一償夙願，完成這幾乎不可能的任務。

人生的經歷，來自諸多奇妙緣份的組合，收藏古物亦復如此。許多應屬於同一來源的古物，卻在不同的時空購得，像「蛙鼓談經」與「祈雨小蛙」的兩件蛙形器及「南有嘉魚」的幾件魚形器就是其中的例子。因緣際會的人與物聚合在一起，齊心協力完成此次展覽，是緣份。諸位貴賓前來參觀我們的展出，也是緣份。但願種種善緣綿延不斷，促使美好的傳統結藝得以傳承發揚，更多收藏家分享珍藏的古文物，尤其盼望藉由本展覽讓 大眾體認，刻畫著先祖藝師生命力、樸素、真切的古文物應受到人們的珍愛，並可借著藝術的再創造，賦予嶄新風貌，世世代代流傳在人間，而不是被淹沒於歷史中。

淳雅齋主人 王顯昭

2012.02.18 敬啓

Acknowledgments

I, as an otolaryngologist as well as an antique collector, have been through many different phases in my long way of collecting. I have reacted with mixed feelings of expectation, surprise, disappointment, confusion, and sometimes dilemma of compromise. Nevertheless, the process of collecting and result has already become the major joy of my life.

Some say, antiques are toys for the rich and collecting is a game exclusive to wealthy groups. I barely agree with that. I think collectors can find true happiness within collecting only by cutting coat according to cloth, nevertheless collecting does require a stable financial base as a backing. Antiques should not be cornered by minority's private collections. Collectors must give their collectibles a new lease of life and present them perfectly in front of the world, which I consider is the greatest meaning of collecting.

Accumulation of time for my involvement in collecting antiques is less than 20 years; I am still a junior in this field and turquoise is simply single item among my diverse collectibles. I am very much enamored with simplicity of jade carvings and the mystical footprints of tracks of passing years. However, due to budget restrictions, I choose turquoise to be my target objects with similar features but less popularity for collecting.

Ancient turquoises still could be found in antique markets few years ago. Whenever I ran into a situation where dealers displayed the new arrivals and named their price, it's torture to decide between those turquoises. A small piece of ancient turquoise sometimes costs more than a latest mobile phone; as a matter of course, I am under stress from placing a huge amount of money. It is indeed truly depressing to let go a ravishing turquoise because of the price concerns but I know in my heart that collecting antiques is a long journey in need of rational moderation.

Antique appreciation and appraisals is an expertise coupled with profound knowledge. Collectors are often deluded by helplessness when it comes to a challenge

of antique detection, despite the fact that they crave to see good pieces coming out to the market. It blows right on collector's head once historical artifacts are proven to be blemished, reproduced, or counterfeited. The painful and disheartening feeling is hard for outsiders to understand.

Fortunately, my wife always encourages and gives me moral support even though she does not totally agree with my behavior. She is willing to participate in my collecting activity and comforts me when I am upset, giving out advices when I am confused. Besides, she volunteers to gather references and information for me. She is the best wife ever. Therefore, I decided to have someone privately customize an inlay turquoise cross Chinese-knots necklace as my gift in return.

After listening to several friends' recommendations and comparison of knotworks, I met Mr. Wong Qi-Rong, a Chinese knotting artist, about five years ago. The style of Mr. Wong's practice is fresh and refined. Beautifully fusing modern design with traditional knotting art, Wong successfully transforms period pieces into astonishing artworks in combination of classicality and modernity. Thus I sincerely invited Mr. Wong to be my working partner to start our journey of designing and weaving turquoise necklaces.

The only word I could use to describe my feeling when I saw the first batch of Mr. Wong's works is "astounding." At the very moment I made up my mind to temporarily put other collectibles aside and focus on collecting turquoises afterward. Meanwhile I requested Mr. Wong's constant involvement in design and knotting. My plan was to have an exhibition to share the achievement with antique aficionados until the works reached a certain amount.

Thereafter, I've visited antique retailers more often at my leisure time to search and acquire objects fit the exhibition needs with expectation. I unwillingly put away some turquoises I love for their irrelevancy and carefully collected golden accessories, which of the price has continuously marked high. Finally, finished works come

out in succession by means of massive efforts, time, and finely planned financial manipulation. Incorporation of ties and knots turned scattered turquoises and accessories to multiple elegant artworks of diverse features. I knew I was few steps away from making the dream come true.

I was like trending on the ice in preparation of this exhibition. Since I am not an antique expert, my judgment of division history into period of my collection may not get full approval. Nonetheless, I earnestly request scholars and old-timer researchers to excuse my amateur knowledge. Please concentrate on pure beauty and aesthetic spirit of the knotworks.

On the verge of disclosing of the exhibition, I would like to sincerely thank Professor Hsiung Yi-Chung for his preface and inscription, Mr. Huang Chun-Sung for overall planning, knotting artist Mr. Wong for his great job and assistance of editing catalogue, painter Chen Tong-Liang for his creation of oil paintings, and my every single friend for his/her hard work. It's all because of them that we could release the exhibition on schedule and publish catalogues without a hitch. Of course, I am grateful to National Chiang Kai-Shek Memorial Hall for giving me the precious chance, providing exhibition space, along with all staff supports and on-site equipments. Most importance of all, I am deeply appreciative of the unconditional support from my whole family, my beloved wife and daughters, Wei and Ting, so that I will be able to accomplish the mission nearly impossible in addition to my daily heavy medical practice.

The life experience is composed of many intriguingly coincidences which share a lot of similarities with antique collecting. I've purchased numerous pieces that supposed to in same origin under different time and space context. The frog-shaped pieces, such as "A Croaking Frog" and "Frog; Prayer For Rain," and few fish-shaped ones like "Happy Swimming Fishes" are great examples. The presence of all distinguished guests to our exhibition is also the destiny. I hope I could've kept sowing seeds of goodness to glorify the delicate tradition craft of tying knots and shared my treasured

王婷 2007
陳彤亮
78cm × 64cm

王瑋 2007
陳彤亮
78cm × 64cm

collectibles with more collectors. Above all, I expect this exhibition can make people understand that historical artifacts carrying with vitality, simplicity, and spirituality of ancient craftsmen are worthy to be cherished. With art reproduction, they could transform into a new art form so as to be passed down from generation to generation instead of fading in the long drown history.

The host of chun-ya studio

Wang Hsien-Chao

2012.02.18

圖　版
PLATES

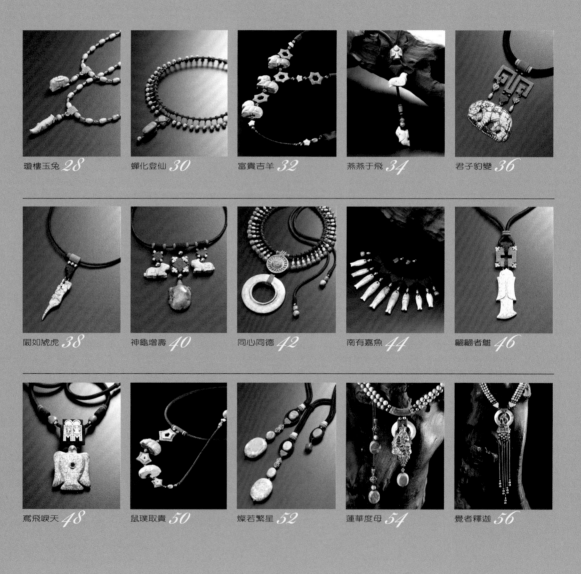

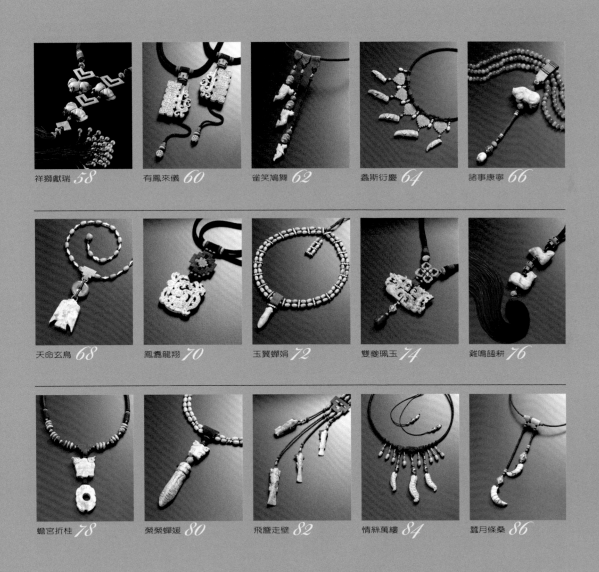

圖　版

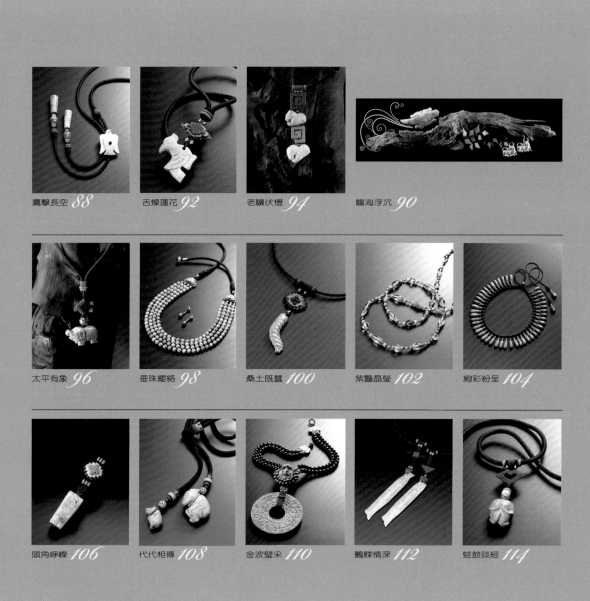

24

雞鳴起舞 *148*

若龍而黃 *150*

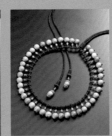
珠圓玉潤 *152*

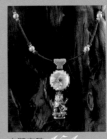
六臂文殊 *154*

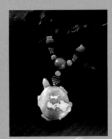
伏龜浴日 *156*

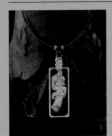
翹袖折腰 *158*

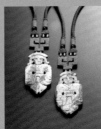
戰國粉黛 *160*

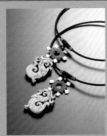
鳳凰于飛 *162*

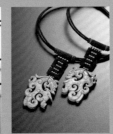
雙龍出海 *164*

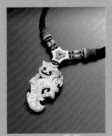
王者氣概 *166*

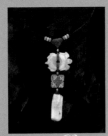
衣錦榮歸 *168*

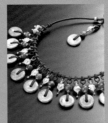
金璧交輝 *170*

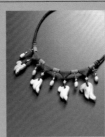
關關雎鳩 *172*

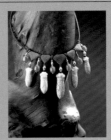
仲夏鳴蟬 *174*

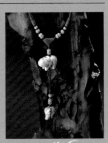
力作勤耕 *176*

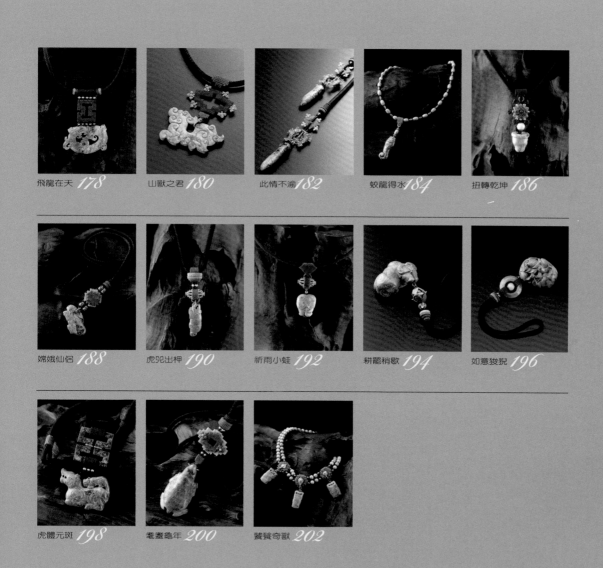

飛龍在天 *178*　　山獸之君 *180*　　此情不渝 *182*　　蛟龍得水 *184*　　扭轉乾坤 *186*

嫦娥仙侶 *188*　　虎兒出柙 *190*　　祈雨小蛙 *192*　　耕龍稍歇 *194*　　如意猭猊 *196*

虎體元斑 *198*　　耄耋龜年 *200*　　矯矯奇獸 *202*

瓊樓玉兔
moon rabbit
西周 Western Zhou Dynasty (1046 - 771 B.C.)

綠松石兔形墜 turquoise hare-shaped pendant
Length: 20mm Width: 11mm Height: 6mm

綠松石橢圓珠 turquoise oval beads × 29
Length: 5mm Width: 5mm Height: 7mm

黃金管珠 golden coil & dots tube beads × 29
Length: 2mm Width: 2mm Height: 3mm

黃金點圈隔珠 golden coil & dots spacer beads × 2
Length: 4mm Width: 4mm Height: 2mm

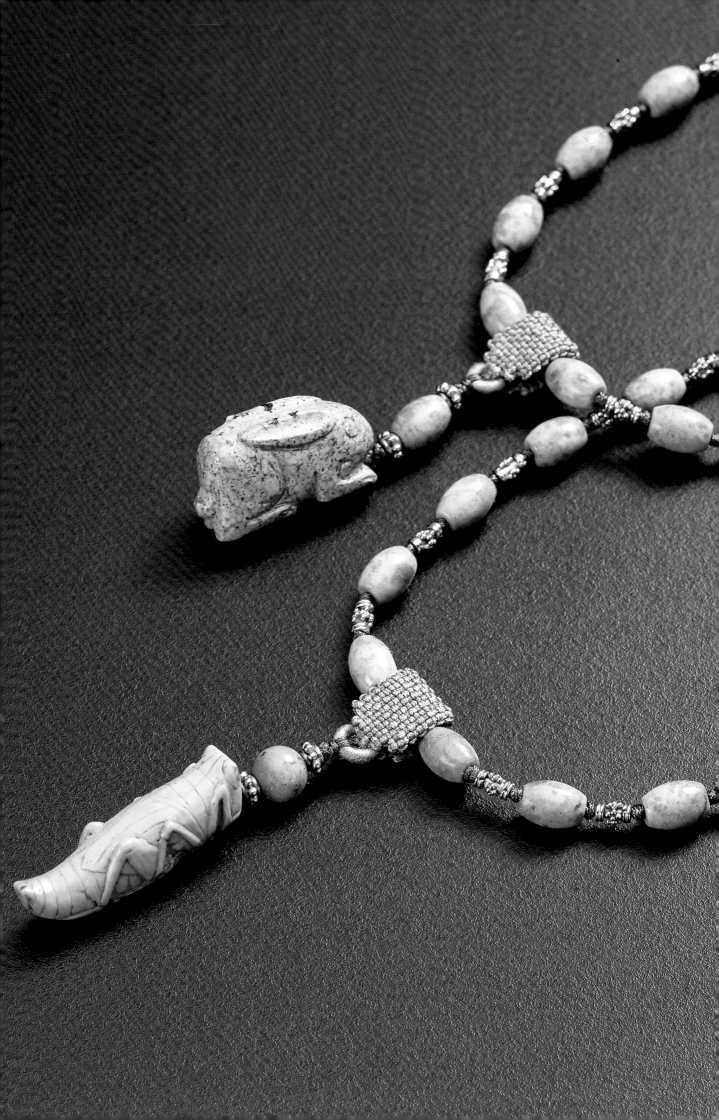

蟬化登仙
exuviations of the cicada
商 Shang Dynasty (c.1700 - 1046 B.C.)

綠松石蟬形墜 turquoise cicada-shaped pendant
Length: 22mm Width: 11mm Height: 7mm

綠松石圓珠 turquoise round beads × 47
Length: 5mm Width: 5mm Height: 5mm

黃金管珠 golden coil & dots tube beads × 51
Length: 2mm Width: 2mm Height: 3mm

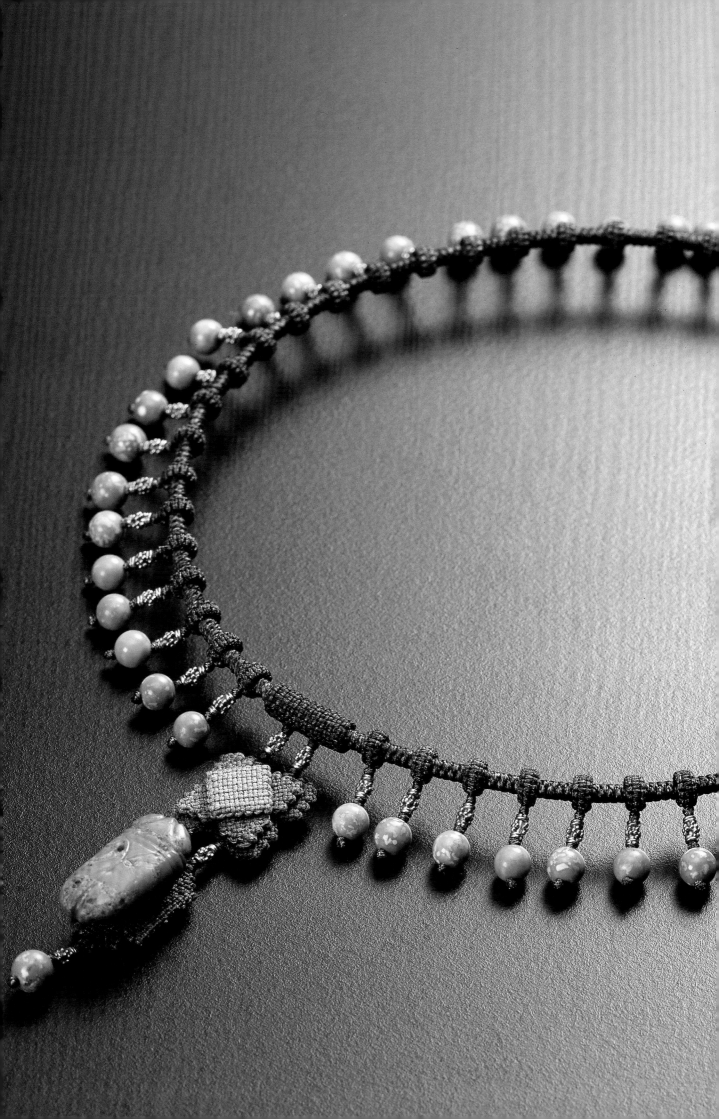

富貴吉羊
sheeps; mascot

東漢 Eastern Han Dynasty (25 - 220 A.D.)

綠松石羊形墜 turquoise sheep-shaped pendants × 3
Length: 30mm Width: 23mm Height: 12mm
Length: 33mm Width: 22mm Height: 12mm
Length: 27mm Width: 22mm Height: 12mm

黃金華飾隔珠 golden ornate spacer beads × 13
Length: 4mm Width: 4mm Height: 5mm

黃金圈緣隔珠 golden coil edge spacer beads × 2
Length: 3mm Width: 3mm Height: 4mm

黃金點圈隔珠 golden coil & dots spacer beads × 2
Length: 3mm Width: 3mm Height: 2mm

六角瑪瑙勒 agate hex tube
Length: 12mm Width: 12mm Height: 23mm

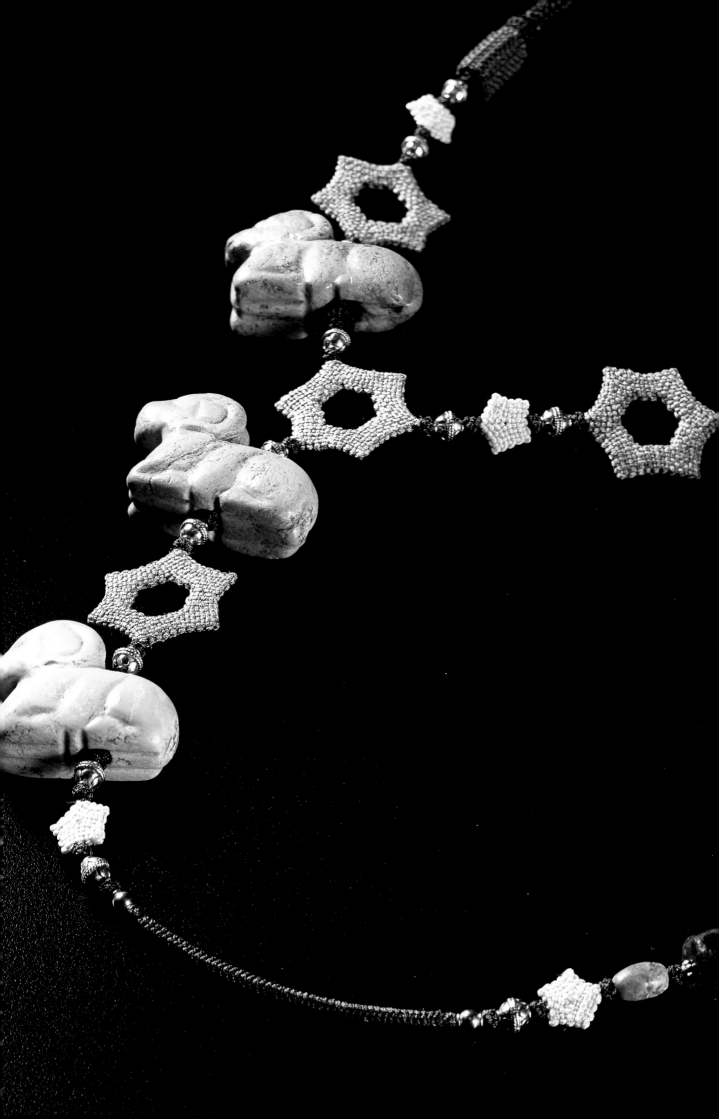

燕燕于飛
accompanying swallows

商 Shang Dynasty (c.1700 - 1046 B.C.)

綠松石鳥形墜 turquoise bird-shaped pendants × 3
Length: 24mm Width: 20mm Height: 7mm
Length: 35mm Width: 23mm Height: 15mm
Length: 37mm Width: 22mm Height: 12mm

黃金珠帽 golden bead caps × 2
Length: 8mm Width: 8mm Height: 5mm

黃金點圈隔珠 golden coil & dots spacer beads × 2
Length: 4mm Width: 4mm Height: 2mm

瑪瑙珠 agate beads × 2
Length: 9mm Width: 9mm Height: 9mm

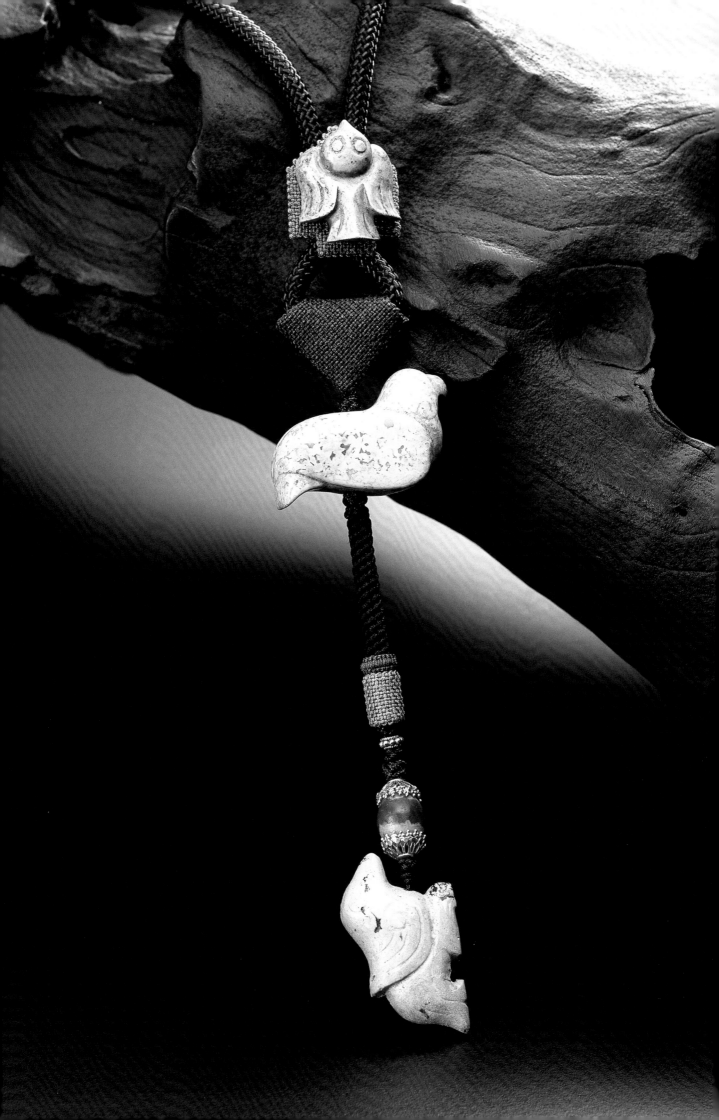

君子豹變
leopard; being a gentleman

遼 Liao Period (916 - 1125 A.D.)

綠松石豹形珮 turquoise leopard-shaped pendant
Length: 65mm Width: 41mm Height: 3mm

綠松石算盤珠 turquoise abacus bead
Length: 12mm Width: 12mm Height: 6mm

綠松石橢圓珠 turquoise oval beads × 2
Length: 5mm Width: 5mm Height: 8mm

黃金花式組件 golden fancy connectors × 2
Length: 16mm Width: 10mm Height: 1mm

黃金點圈隔珠 golden coil & dots spacer beads × 4
Length: 4mm Width: 4mm Height: 2mm

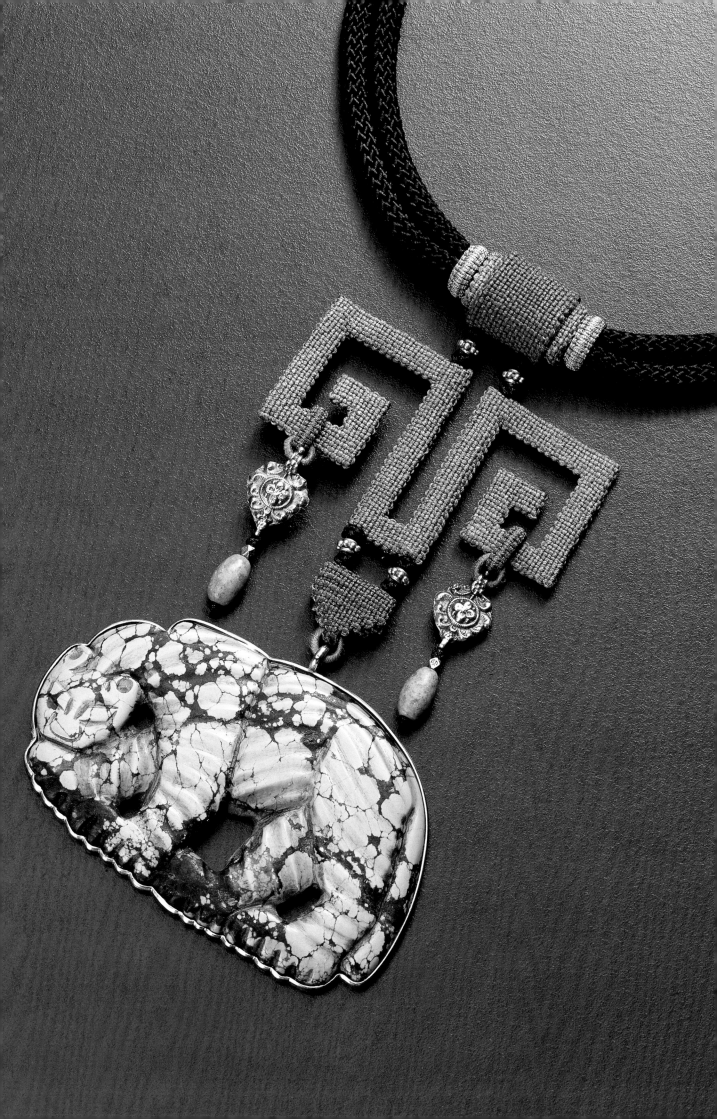

闞如虓虎
brave tiger

西周 Western Zhou Dynasty (1046 - 771 B.C.)

綠松石虎形璏 turquoise tiger-shaped pendant
Length: 52mm Width: 11mm Height: 5mm

綠松石算盤珠 turquoise abacus bead
Length: 10mm Width: 10mm Height: 3mm

黃金球形珠 golden smooth round spacer beads × 3
Length: 4mm Width: 4mm Height: 4mm

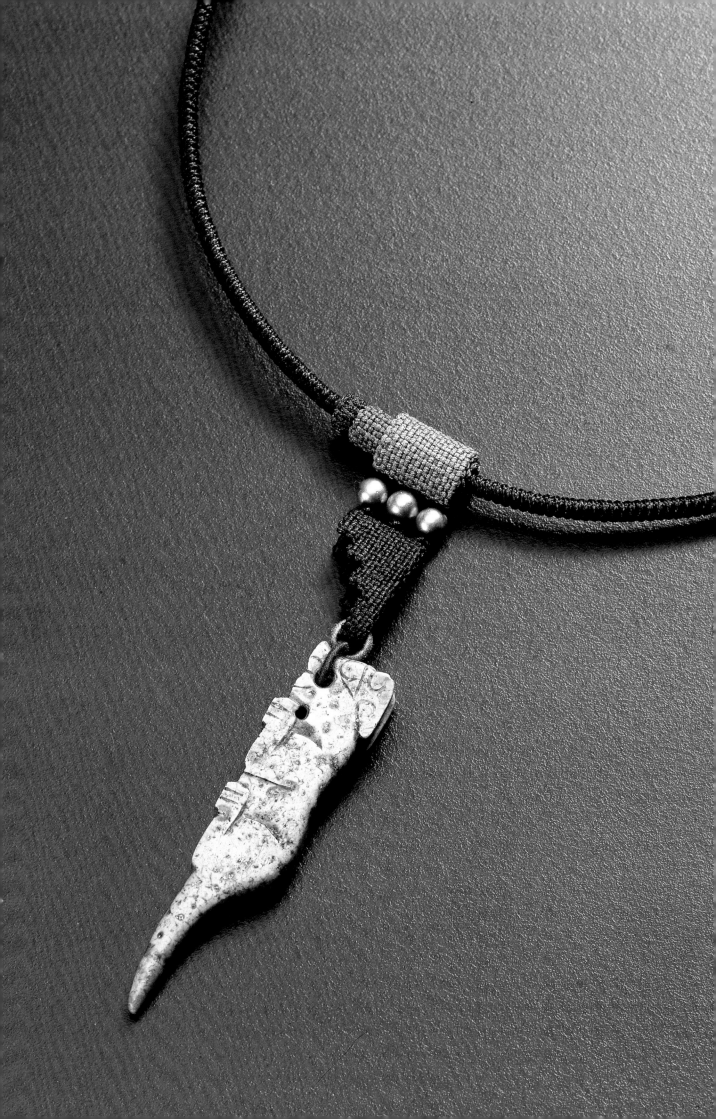

神龜增壽
turtle; a symbol of longevity

西周 Western Zhou Dynasty (1046 - 771 B.C.)

綠松石龜形墜 turquoise turtle-shaped pendant
Length: 33mm Width: 24mm Height: 8mm

綠松石虎形墜 turquoise tiger-shaped pendants × 2
Length: 27mm Width: 14mm Height: 7mm
Length: 27mm Width: 13mm Height: 7mm

黃金圈形珠 golden donut spacer beads × 4
Length: 5mm Width: 5mm Height: 4mm

黃金珠 golden disc spacer beads × 12
Length: 2mm Width: 2mm Height: 1mm

瑪瑙珠 agate bead
Length: 10mm Width: 10mm Height: 6mm

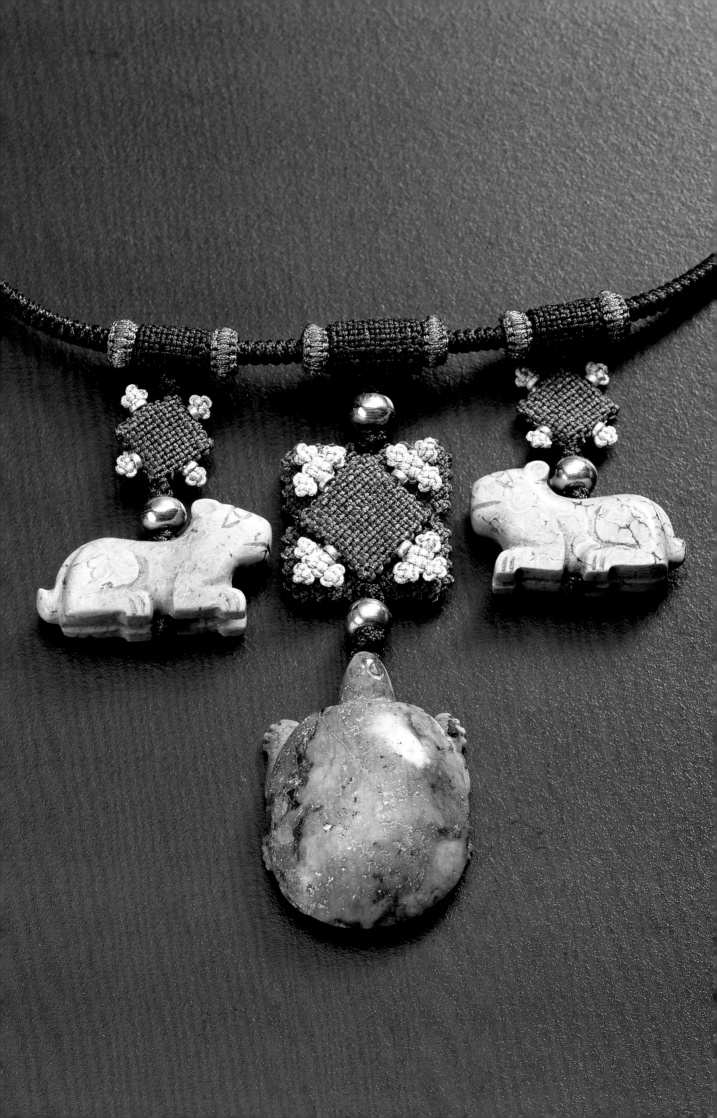

同心同德
a huge ring of nephrite

西周 Western Zhou Dynasty (1046 - 771 B.C.)

綠松石瑗 turquoise loop
Length: 75mm Width: 75mm Height: 8mm

綠松石橢圓珠 turquoise oval beads × 45
Length: 3mm Width: 3mm Height: 7mm

綠松石圓珠 turquoise round beads beads × 2
Length: 10mm Width: 10mm Height: 10mm

黃金環形吊墜 golden annulus pendant bail
Length: 38mm Width: 38mm Height: 2mm

黃金管珠 golden coil & dots tube beads × 45
Length: 2mm Width: 2mm Height: 3mm

珊瑚珠 coral beads × 47
Length: 7mm Width: 7mm Height: 5mm

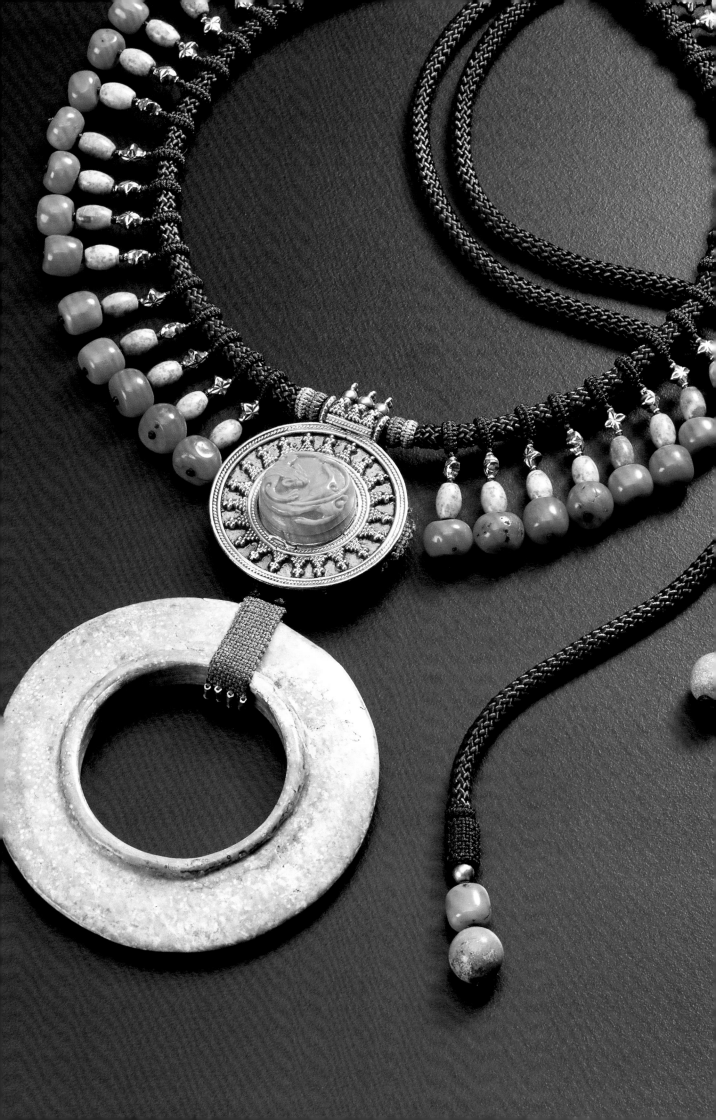

南有嘉魚
happy swimming fishes

西周 Western Zhou Dynasty (1046 - 771 B.C.)

綠松石魚形墜 turquoise fish-shaped pendants × 9
Length: 30mm Width: 12mm Height: 6mm
Length: 33mm Width: 12mm Height: 6mm
Length: 40mm Width: 12mm Height: 8mm
Length: 46mm Width: 13mm Height: 7mm
Length: 51mm Width: 13mm Height: 8mm
Length: 43mm Width: 13mm Height: 7mm
Length: 35mm Width: 12mm Height: 6mm
Length: 30mm Width: 11mm Height: 6mm
Length: 28mm Width: 11mm Height: 7mm

黃金圈形珠 golden donut spacer beads × 13
Length: 5mm Width: 5mm Height: 4mm

黃金珠帽 golden bead caps × 26
Length: 4mm Width: 4mm Height: 2mm

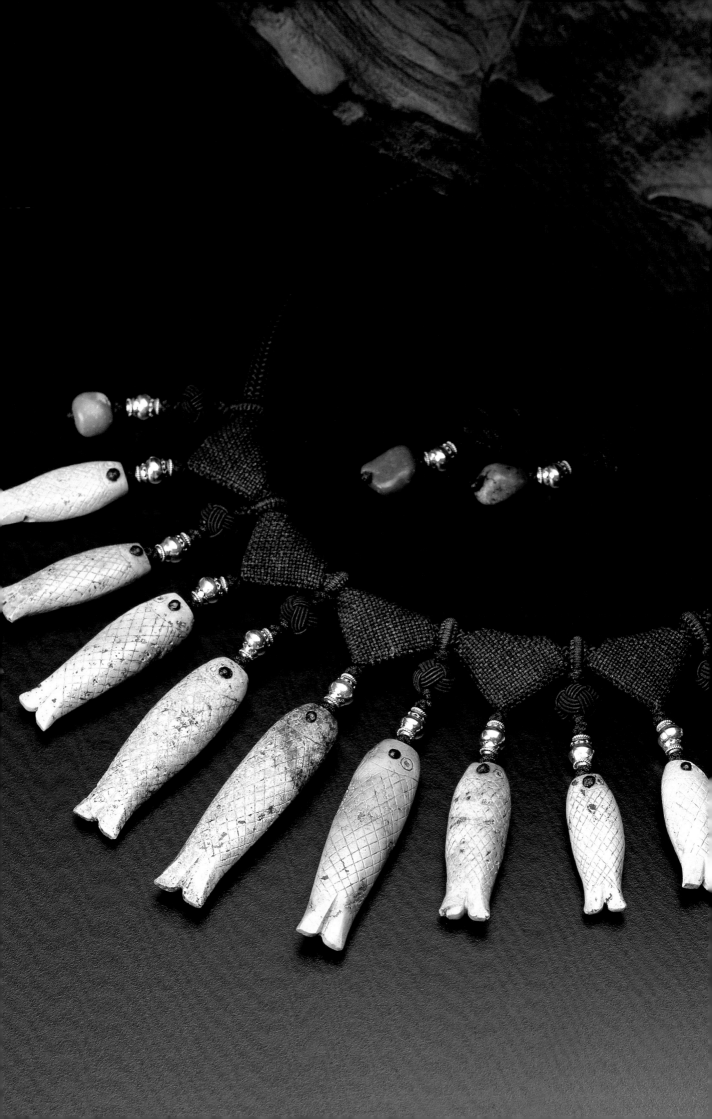

翩翩者雛
gliding pigeon

商 Shang Dynasty (c.1700 - 1046 B.C.)

綠松石鳥形器 turquoise bird-shaped utensil; knife
Length: 72mm Width: 28mm Height: 5mm

黃金圈緣隔珠 golden coil edge spacer beads × 4
Length: 3mm Width: 3mm Height: 4mm

瑪瑙圓珠 agate round bead
Length: 12mm Width: 12mm Height: 12mm

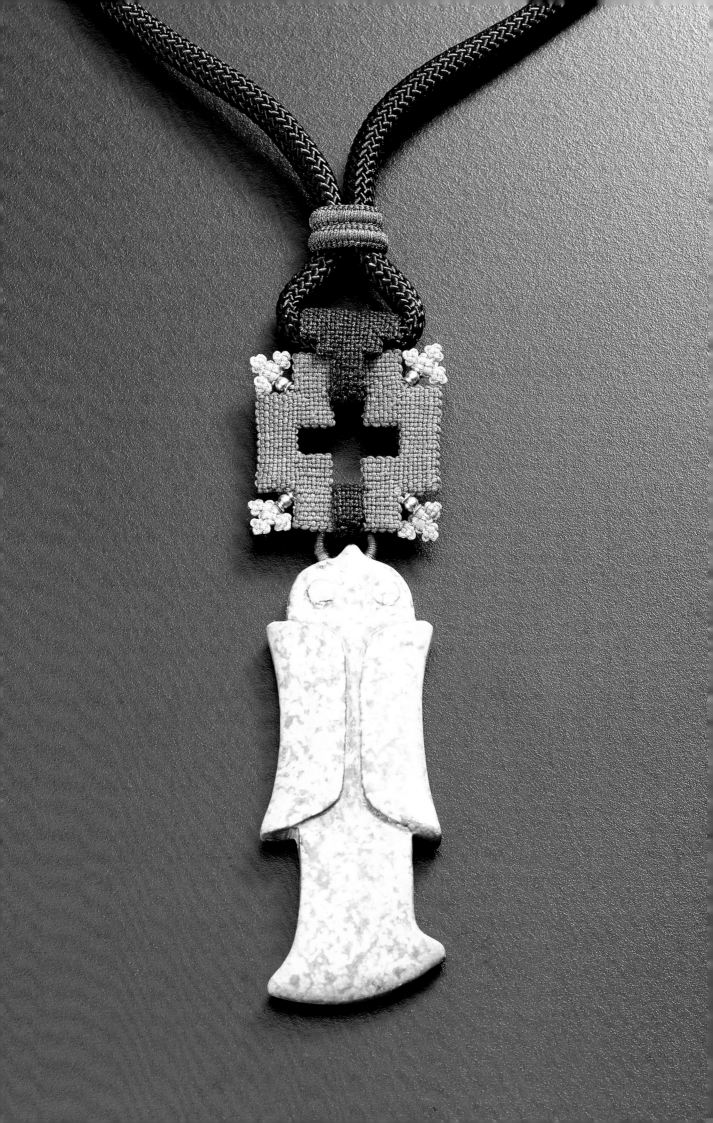

鳶飛唳天
whooping kite

西漢 Western Han Dynasty (202 B.C. - 9 A.D.)

綠松石鷹形墜 turquoise hawk-shaped pendant
Length: 48mm Width: 38mm Height: 10mm

綠松石橢圓珠 turquoise oval beads × 3
Length: 8mm Width: 6mm Height: 6mm

黃金二佛並坐浮雕 golden two buddhas sitting together embossment
Length: 27mm Width: 20mm Height: 2mm

黃金珠環墊片 golden beaded spacer bead
Length: 5mm Width: 5mm Height: 2mm

黃金珠帽 golden bead caps × 6
Length: 4mm Width: 4mm Height: 2mm

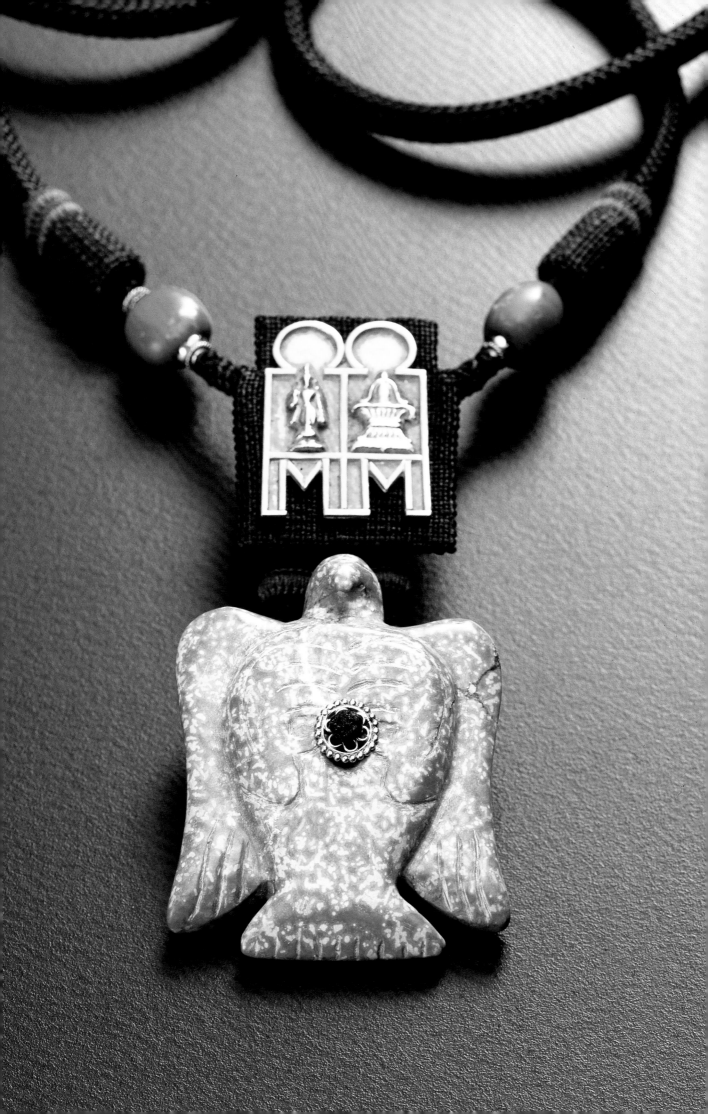

鼠璞取貴
rats; mascot

明 Ming Dynasty (1368 - 1644 A.D.)

綠松石鼠形墜 turquoise rat-shaped pendants × 2
Length: 31mm Width: 15mm Height: 13mm
Length: 29mm Width: 14mm Height: 12mm

綠松石算盤珠 turquoise abacus bead
Length: 10mm Width: 10mm Height: 3mm

綠松石橢圓珠 turquoise oval beads × 2
Length: 3mm Width: 3mm Height: 8mm

黃金三葉草形珠 golden clover beads × 6
Length: 5mm Width: 4mm Height: 2mm

黃金圈緣隔珠 golden coil edge spacer beads × 4
Length: 3mm Width: 3mm Height: 4mm

黃金點圈隔珠 golden coil & dots spacer beads × 2
Length: 3mm Width: 3mm Height: 2mm

瑪瑙圓珠 agate round bead
Length: 12mm Width: 12mm Height: 12mm

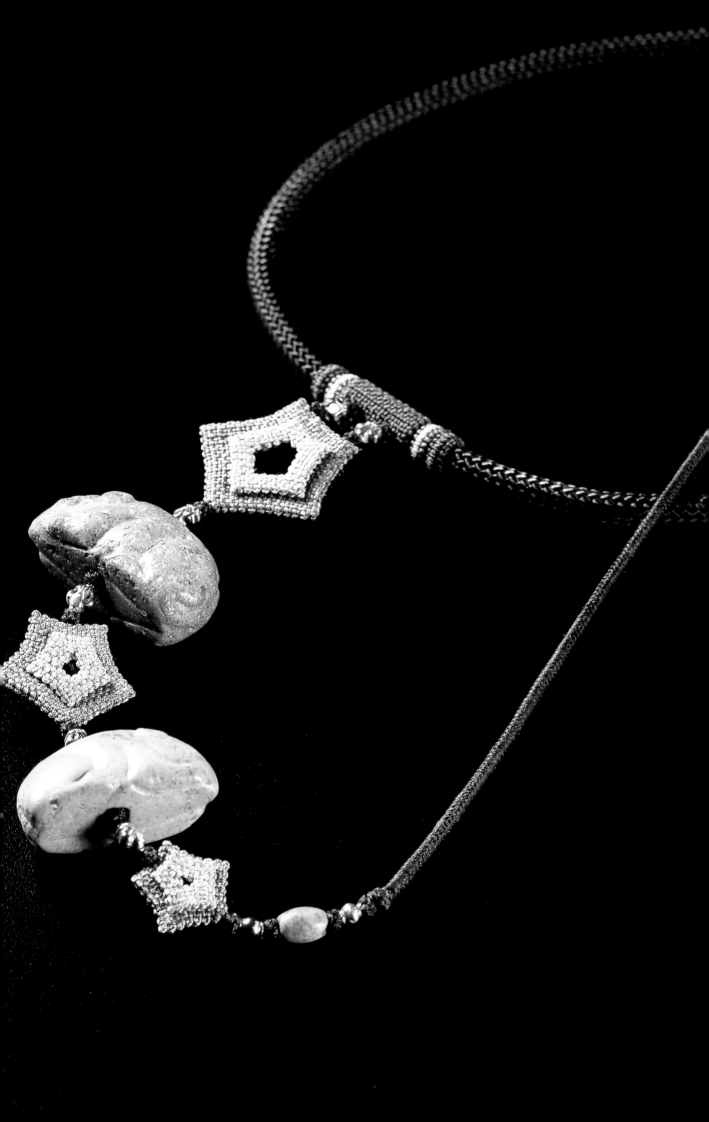

燦若繁星
splendid stars

戰國 Warring States Period (476 - 221 B.C.)

綠松石扁橢圓墜 turquoise flat oval pendants × 8
Length: 38mm Width: 28mm Height: 10mm
Length: 38mm Width: 28mm Height: 8mm
Length: 16mm Width: 8mm Height: 7mm × 6

黃金冠形珠 golden crown beads × 2
Length: 10mm Width: 10mm Height: 20mm

黃金點圈隔珠 golden coil & dots spacer beads × 10
Length: 4mm Width: 4mm Height: 2mm

琉璃圓片珠 glass disc spacer bead
Length: 13mm Width: 13mm Height: 6mm

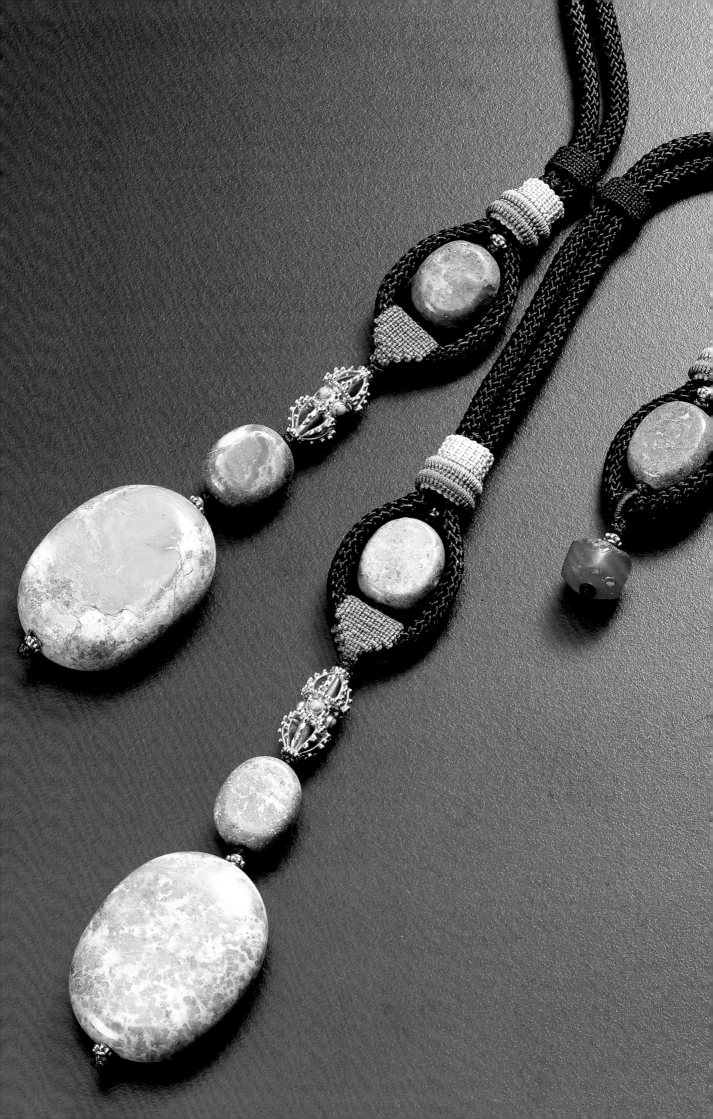

蓮華度母
lotus tara

清 Qing Dynasty (1644 - 1911 A.D.)

綠松石扁橢圓墜 turquoise flat oval pendants × 3
Length: 27mm Width: 14mm Height: 6mm

綠松石圓珠 turquoise round beads × 112
Length: 5mm Width: 5mm Height: 5mm

鎏金度母像 gilttarastatue
Length: 32mm Width: 25mm Height: 20mm

黃金花式組件 goldenfancyconnectors × 3
Length: 16mm Width: 10mm Height: 1mm

黃金球形珠 golden smooth round spacer beads × 6
Length: 4mm Width: 4mm Height: 4mm

黃金三葉草形珠 golden clover beads × 5
Length: 5mm Width: 4mm Height: 2mm

瑪瑙環 agate loop
Length: 32mm Width: 32mm Height: 4mm

瑪瑙圓珠 agate round bead
Length: 11mm Width: 11mm Height: 11mm

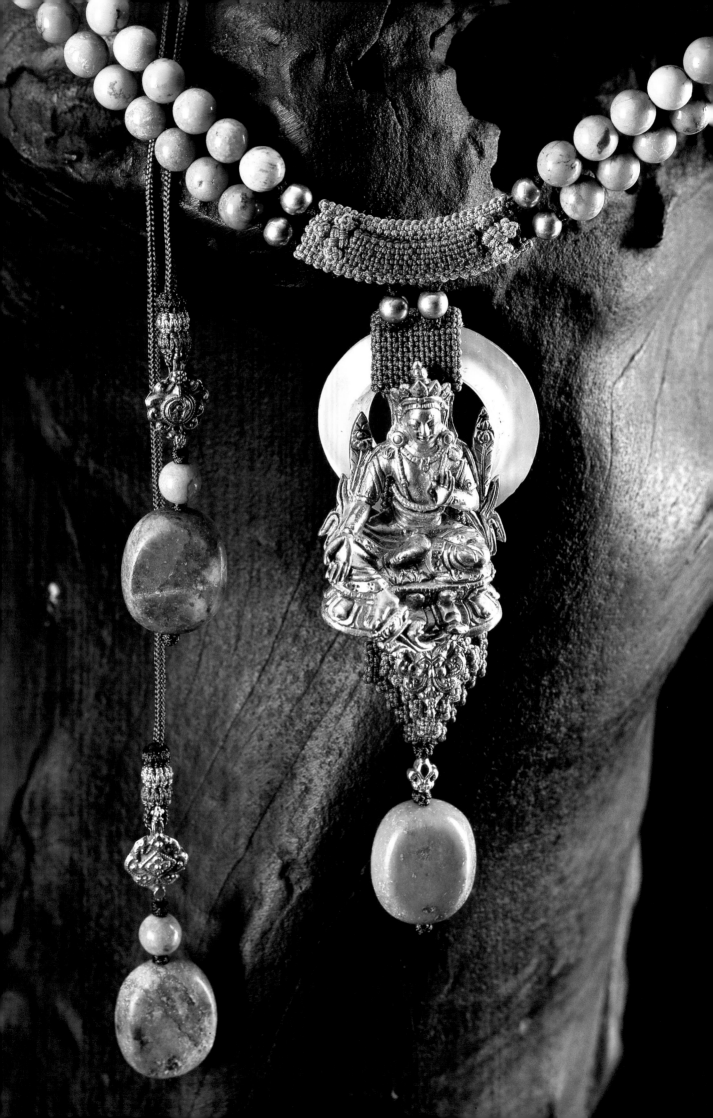

覺者釋迦
shakyamuni buddha

清 Qing Dynasty (1644 - 1911 A.D.)

綠松石圓珠 turquoise round beads × 159
Length: 5mm Width: 5mm Height: 5mm

鎏金釋迦牟尼像 gilt shakyamuni statue
Length: 53mm Width: 33mm Height: 20mm

黃金三葉草形珠 golden clover beads × 10
Length: 5mm Width: 4mm Height: 2mm

黃金點圈隔珠 golden coil & dots spacer beads × 16
Length: 4mm Width: 4mm Height: 2mm

瑪瑙環 agate loop
Length: 46mm Width: 46mm Height: 4mm

瑪瑙珠 agate bead
Length: 10mm Width: 10mm Height: 6mm

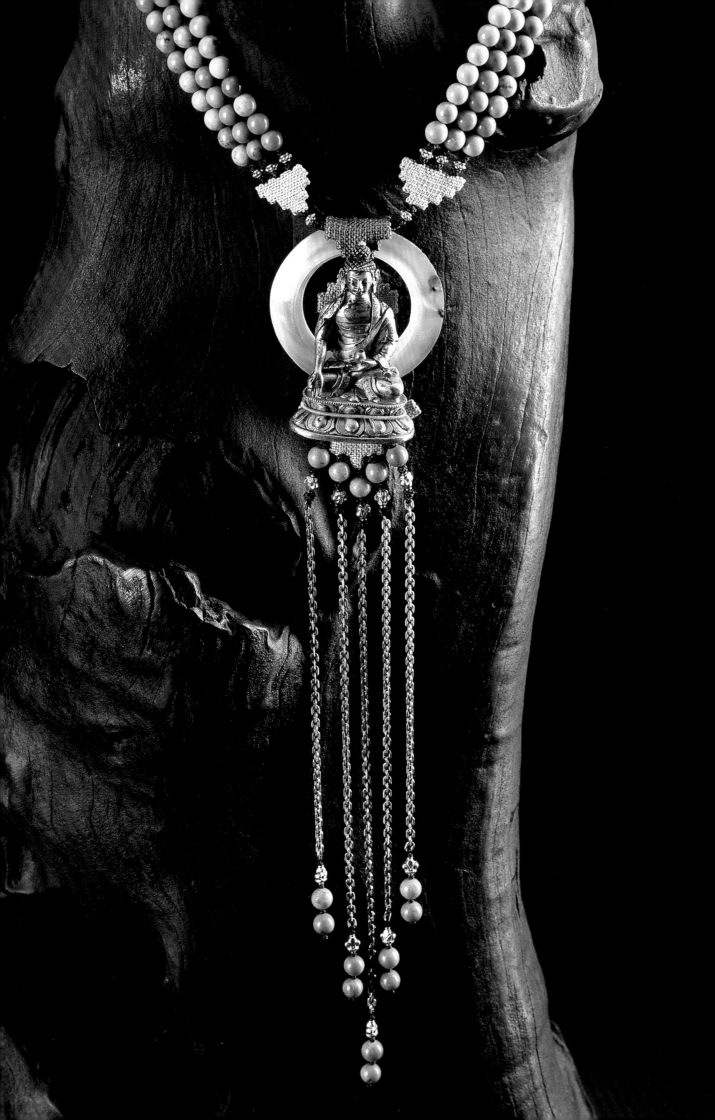

祥獅獻瑞
auspicious lions

明 Ming Dynasty (1368 - 1644 A.D.)

綠松石獅形墜 turquoise lion-shaped pendants × 3
Length: 35mm Width: 20mm Height: 13mm
Length: 35mm Width: 20mm Height: 15mm
Length: 35mm Width: 22mm Height: 15mm

綠松石算盤珠 turquoise abacus beads × 4
Length: 10mm Width: 10mm Height: 3mm

綠松石圓珠 turquoise round beads × 32
Length: 5mm Width: 5mm Height: 5mm

黃金珠帽 golden bead cap
Length: 8mm Width: 8mm Height: 5mm

黃金華飾隔珠 golden ornate spacer beads × 6
Length: 4mm Width: 4mm Height: 5mm

黃金管珠 golden coil & dots tube beads × 32
Length: 2mm Width: 2mm Height: 3mm

黃金點圈隔珠 golden coil & dots spacer beads × 7
Length: 4mm Width: 4mm Height: 2mm

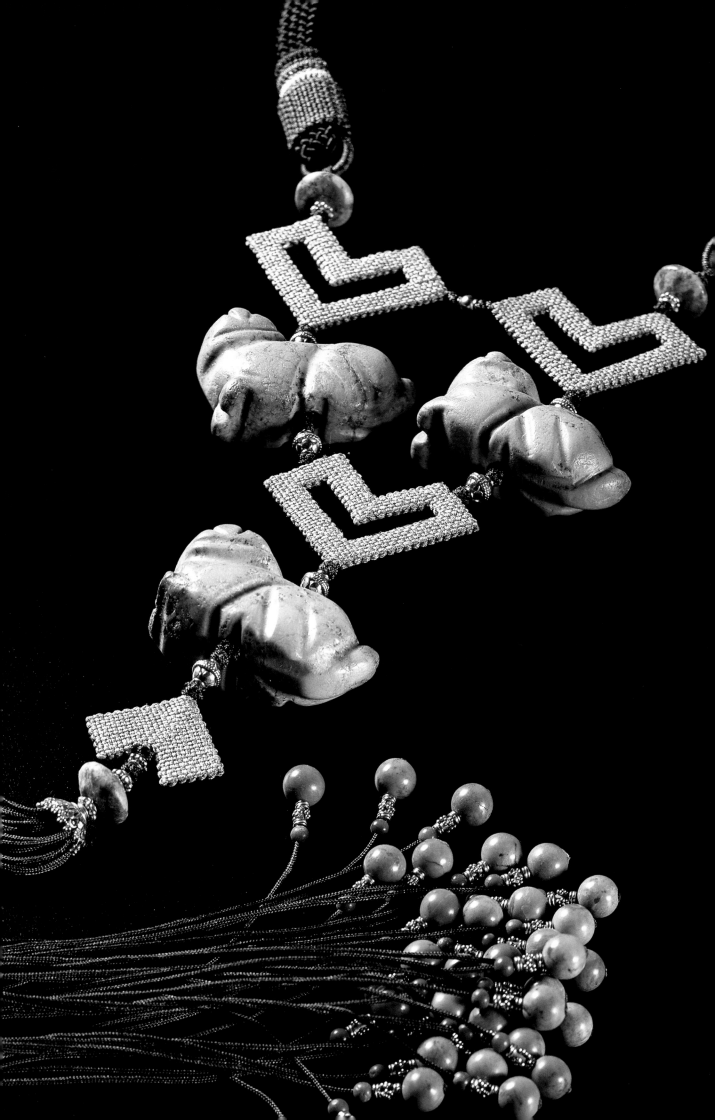

有鳳來儀
advent of the phoenix

戰國 Warring States Period (476 - 221 B.C.)

綠松石鳳形珮 turquoise phoenix-shaped pendants × 2
Length: 55mm Width: 40mm Height: 5mm
Length: 55mm Width: 40mm Height: 5mm

綠松石算盤珠 turquoise abacus beads × 2
Length: 10mm Width: 10mm Height: 3mm

黃金鏤空珠 golden hollow focal beads × 2
Length: 10mm Width: 10mm Height: 10mm

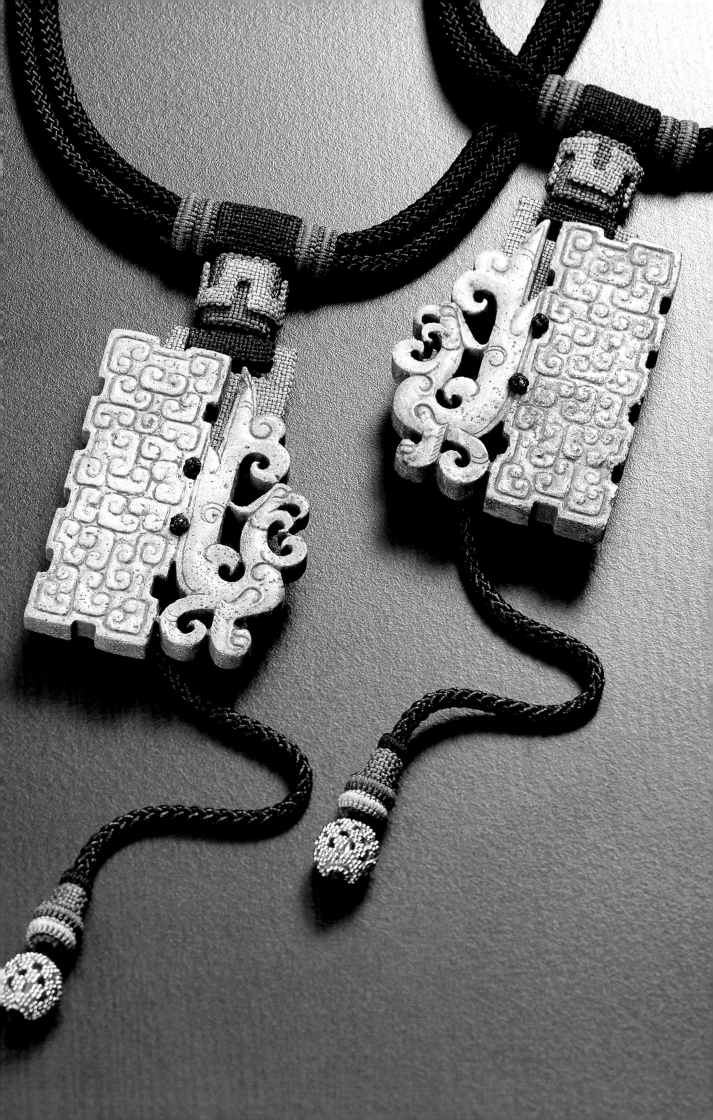

雀笑鳩舞
dancing pigeons

商 Shang Dynasty (c. 1700 - 1046 B.C.)

綠松石鳩形墜 turquoise bird-shaped pendants × 3
Length: 26mm Width: 13mm Height: 8mm
Length: 30mm Width: 15mm Height: 6mm
Length: 25mm Width: 10mm Height: 5mm

黃金珠帽 golden bead caps × 6
Length: 8mm Width: 8mm Height: 5mm

黃金三葉草形珠 golden clover beads × 3
Length: 5mm Width: 4mm Height: 2mm

黃金圈緣隔珠 golden coil edge spacer beads × 4
Length: 3mm Width: 3mm Height: 4mm

珊瑚珠 coral beads × 4
Length: 7mm Width: 7mm Height: 5mm

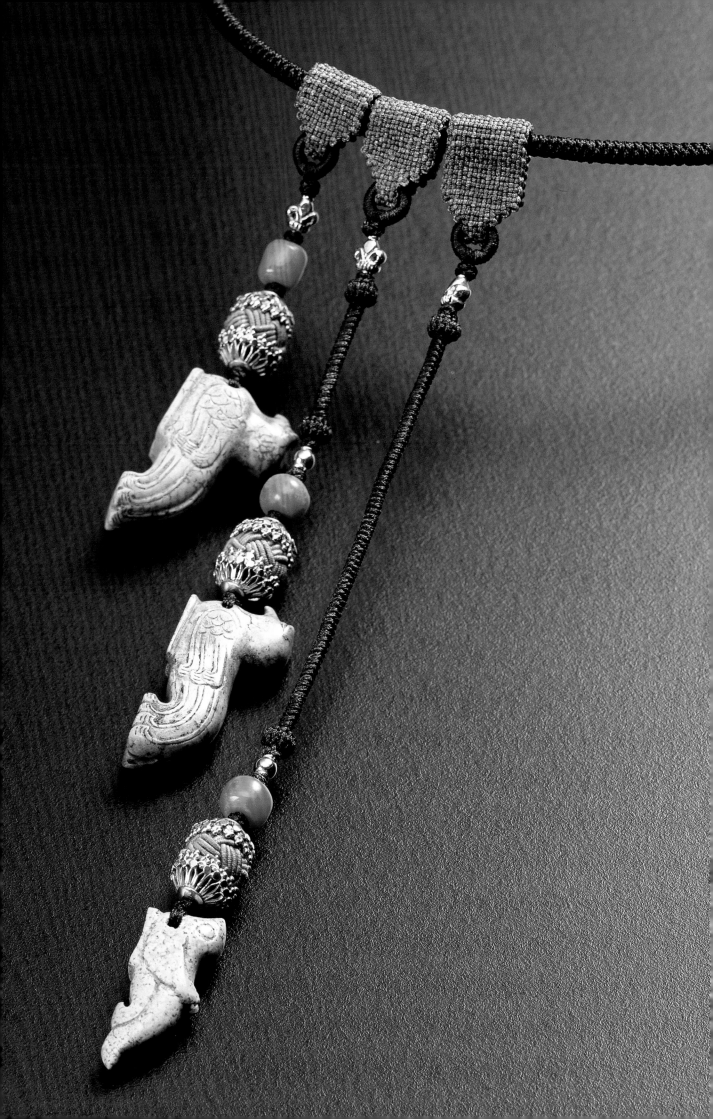

螽斯衍慶
longhorned grasshoppers

西周 Western Zhou Dynasty (1046 - 771 B.C.)

綠松石螽斯形墜 turquoise longhorned grasshopper-shaped pendants × 5
Length: 28mm Width: 6mm Height: 6mm
Length: 35mm Width: 8mm Height: 8mm
Length: 30mm Width: 8mm Height: 8mm
Length: 32mm Width: 8mm Height: 10mm
Length: 27mm Width: 6mm Height: 7mm

綠松石算盤珠 turquoise abacus bead
Length: 10mm Width: 10mm Height: 3mm

綠松石橢圓珠 turquoise oval beads × 6
Length: 5mm Width: 5mm Height: 7mm

黃金花生形珠 golden peanut spacer beads × 6
Length: 3mm Width: 3mm Height: 5mm

黃金三葉草形珠 golden clover beads × 5
Length: 5mm Width: 4mm Height: 2mm

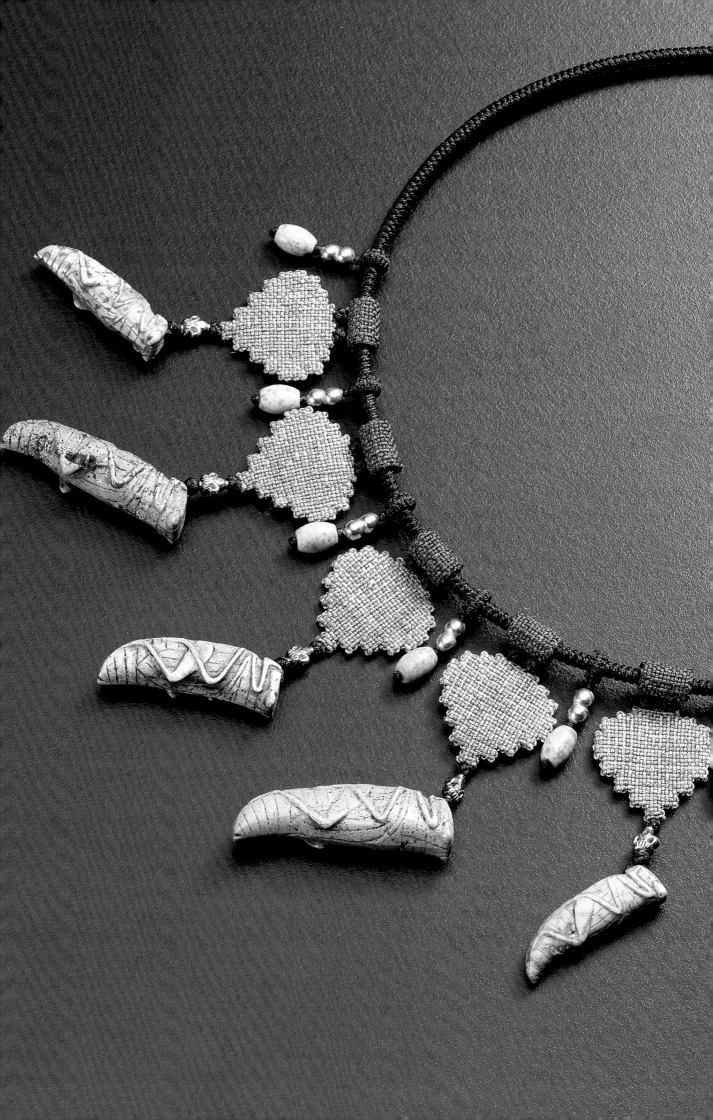

諸事康寧
swine; everything will be smooth

東漢 Eastern Han Dynasty (25 - 220 A.D.)

綠松石豬形墜 turquoise swine-shaped pendant
Length: 50mm Width: 25mm Height: 20mm

黃金鏤空珠 golden hollow focal bead
Length: 10mm Width: 10mm Height: 10mm

黃金立體切面珠 golden faceted cube spacer bead
Length: 4mm Width: 4mm Height: 4mm

黃金點圈隔珠 golden coil & dots spacer beads × 24
Length: 4mm Width: 4mm Height: 2mm

瑪瑙算盤珠 agate abacus beads × 2
Length: 10mm Width: 10mm Height: 5mm

瑪瑙圓珠 agate round beads × 147
Length: 5mm Width: 5mm Height: 5mm

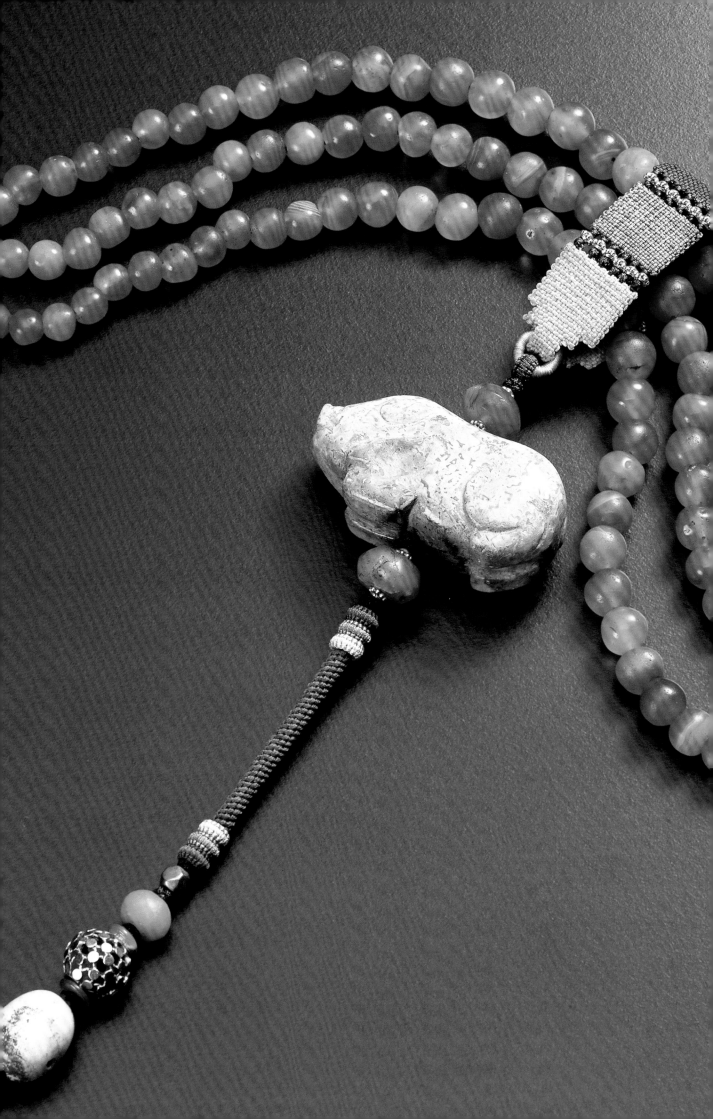

天命玄鳥
a mythical swallow

商 Shang Dynasty (c. 1700 - 1046 B.C.)

綠松石燕形珮 turquoise swallow-shaped pendant
Length: 35mm Width: 25mm Height: 9mm

綠松石璧 a piece of flat turquoise with hole in center
Length: 19mm Width: 19mm Height: 3mm

綠松石橢圓珠 turquoise oval beads × 22
Length: 5mm Width: 5mm Height: 7mm

黃金菱形管珠 golden rhombus bugle beads × 23
Length: 3mm Width: 2mm Height: 9mm

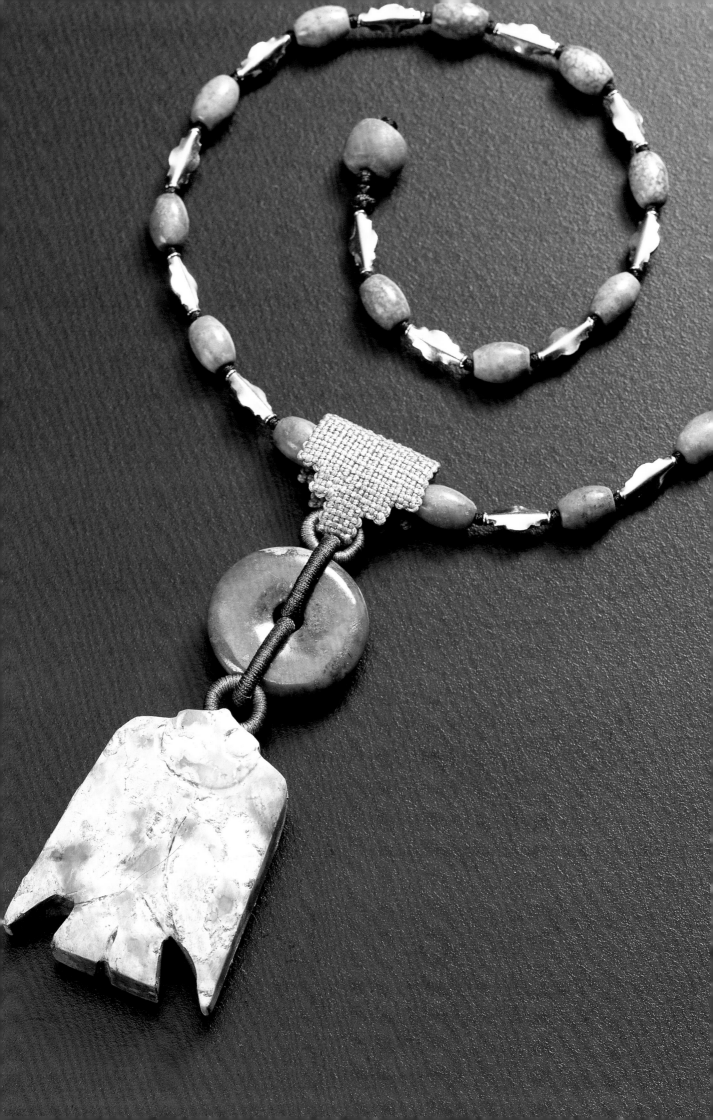

鳳翥龍翔
soaring phoenix, flying dragon

西漢 Western Han Dynasty (202 B.C. - 9 A.D.)

綠松石龍鳳珮 turquoise dragon & phoenix-shaped pendant
Length: 44mm Width: 44mm Height: 6mm

綠松石算盤珠 turquoise abacus bead
Length: 10mm Width: 10mm Height: 3mm

黃金點圈隔珠 golden coil & dots spacer beads × 6
Length: 4mm Width: 4mm Height: 2mm

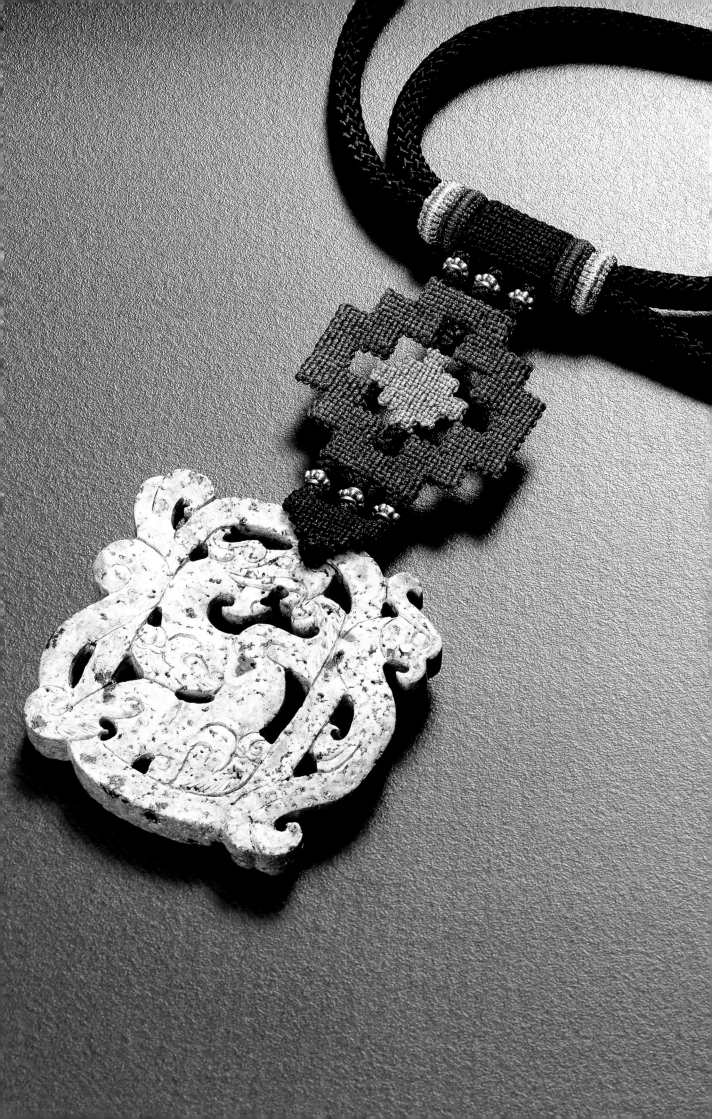

玉翼蟬娟
cicada; metaphor for beautiful ladies
商 Shang Dynasty (c. 1700 - 1046 B.C.)

綠松石蟬形墜 turquoise cicada-shaped pendant
Length: 32mm Width: 11mm Height: 7mm

綠松石橢圓珠 turquoise oval beads × 82
Length: 5mm Width: 5mm Height: 7mm

黃金多孔切面墊片 golden multi-hole faceted cube spacers
Length: 14mm Width: 2.5mm Height: 2.5mm

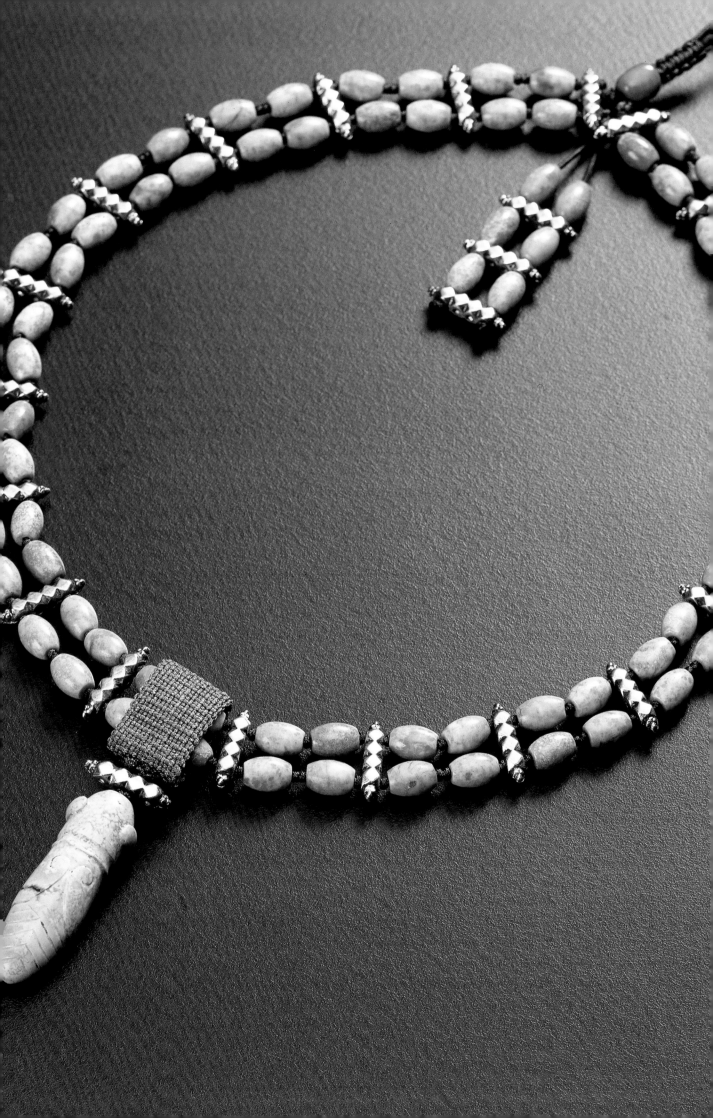

雙夔珮玉
auspicious fairy one-horned monsters

戰國 Warring States Period (476 - 221 B.C.)

綠松石雙夔珮 turquoise one-horned monsters-shaped pendant
Length: 60mm Width: 30mm Height: 5mm

綠松石算盤珠 turquoise abacus beads × 2
Length: 10mm Width: 10mm Height: 3mm

黃金花式組件 golden fancy connector
Length: 16mm Width: 10mm Height: 1mm

黃金三葉草形珠 golden clover beads × 4
Length: 5mm Width: 4mm Height: 2mm

黃金點圈隔珠 golden coil & dots spacer beads × 4
Length: 4mm Width: 4mm Height: 2mm

黃金圓片珠 golden disc spacer bead
Length: 2mm Width: 2mm Height: 1mm

瑪瑙桶形珠 agate barrel bead
Length: 12mm Width: 12mm Height: 17mm

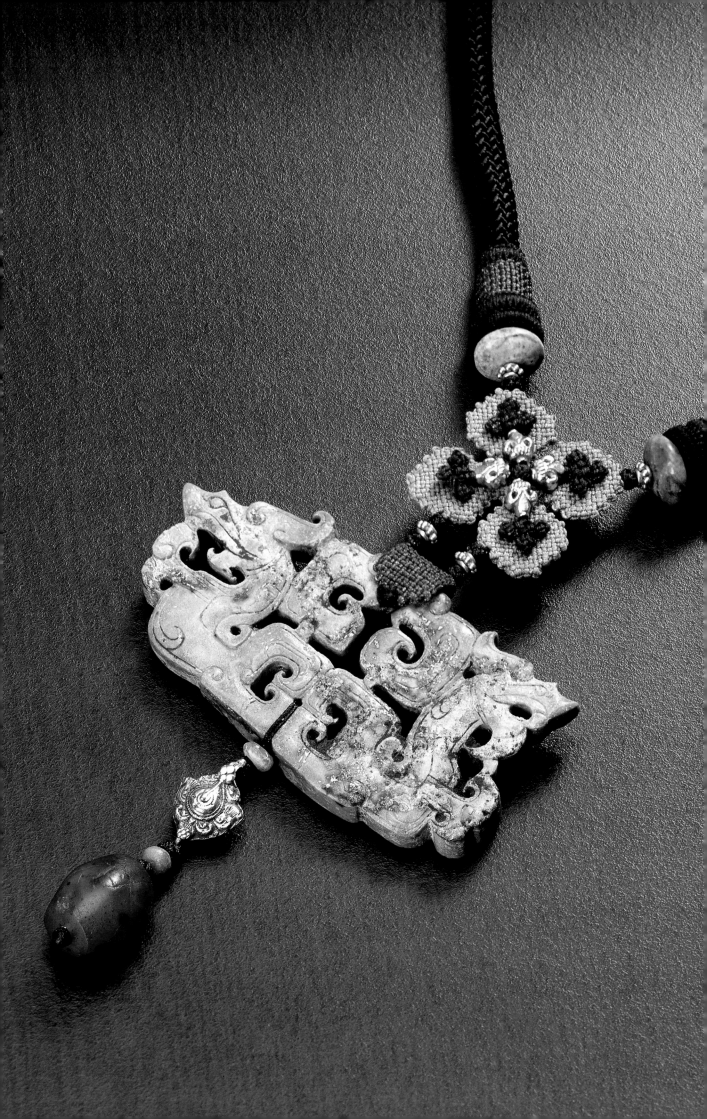

雞鳴饁耕
rooster wakeup call

明 Ming Dynasty (1368 - 1644 A.D.)

綠松石雞形墜 turquoise chicken-shapedpendants × 2
Length: 32mm Width: 26mm Height: 12mm
Length: 34mm Width: 30mm Height: 12mm

綠松石算盤珠 turquoise abacus bead
Length: 10mm Width: 10mm Height: 3mm

黃金點圈隔珠 golden coil & dots spacer beads × 5
Length: 4mm Width: 4mm Height: 2mm

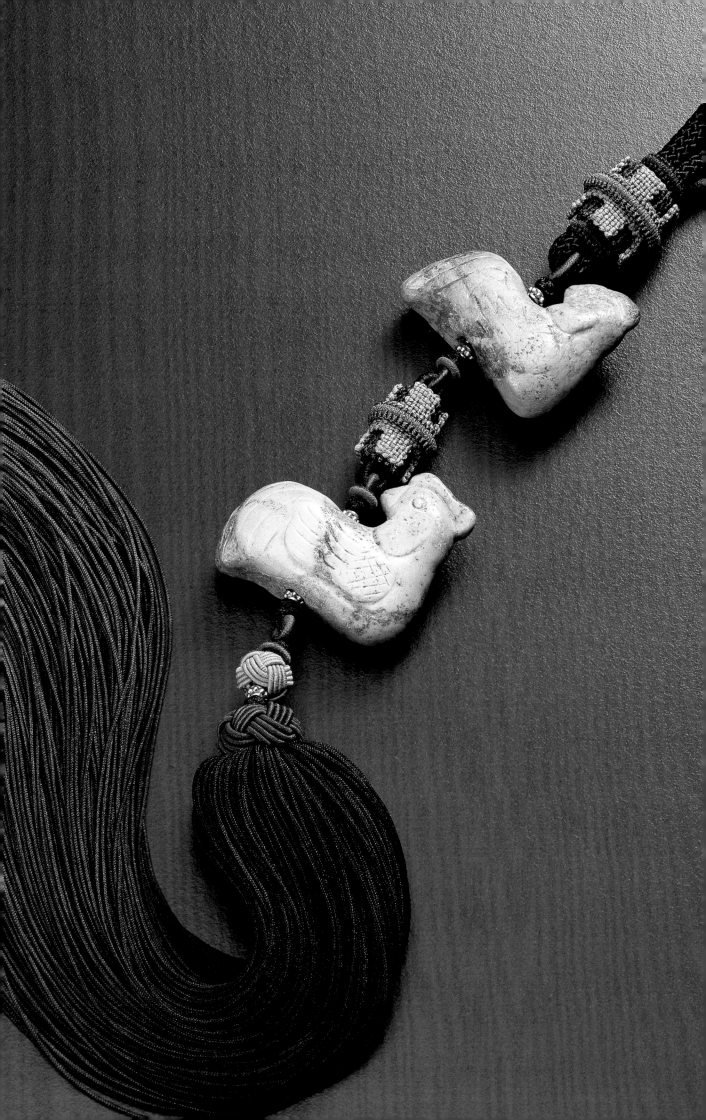

蟾宮折桂
toad; passing the imperial examination

商 Shang Dynasty (c. 1700 - 1046 B.C.)

綠松石蟾蜍形器 turquoise toad-shaped utensil
Length: 35mm Width: 27mm Height: 6mm

綠松石獸面墜 turquoise animal totem pendant
Length: 32mm Width: 27mm Height: 9mm

綠松石算盤珠 turquoise abacus beads × 19
Length:10mm Width: 10mm Height: 3mm

黃金圈形珠 golden donut spacer beads × 4
Length: 5mm Width: 5mm Height: 4mm

黃金珠帽 golden bead caps × 4
Length: 4mm Width: 4mm Height: 2mm

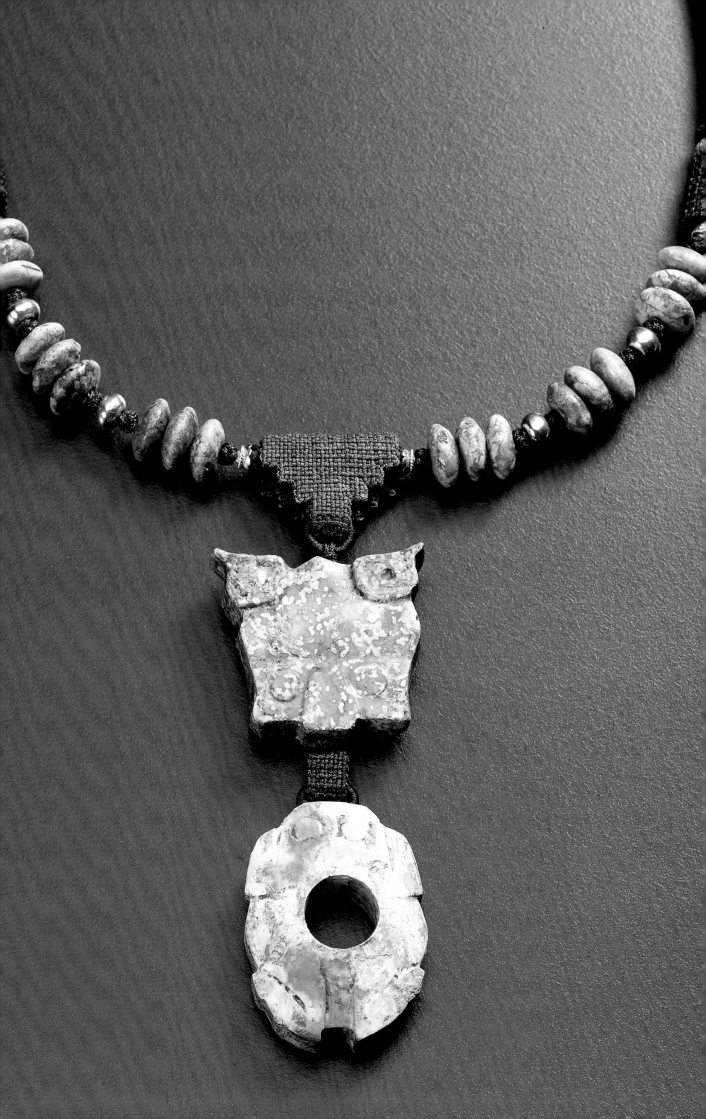

縈縈蟬媛
cicada; woman's sentiment
商 Shang Dynasty (c. 1700 - 1046 B.C.)

綠松石蟬形墜 turquoise cicada-shaped pendant
Length: 63mm Width: 15mm Height: 10mm

綠松石獸面墜 turquoise animal totem pendant
Length: 22mm Width: 27mm Height: 7mm

綠松石橢圓珠 turquoise oval beads × 93
Length: 5mm Width: 5mm Height: 7mm

黃金花生形珠 golden peanut spacer beads × 8
Length: 3mm Width: 3mm Height: 5mm

黃金珠帽 golden bead caps × 2
Length: 4mm Width: 4mm Height: 2mm

珊瑚珠 coral beads × 2
Length: 8mm Width: 8mm Height: 6mm

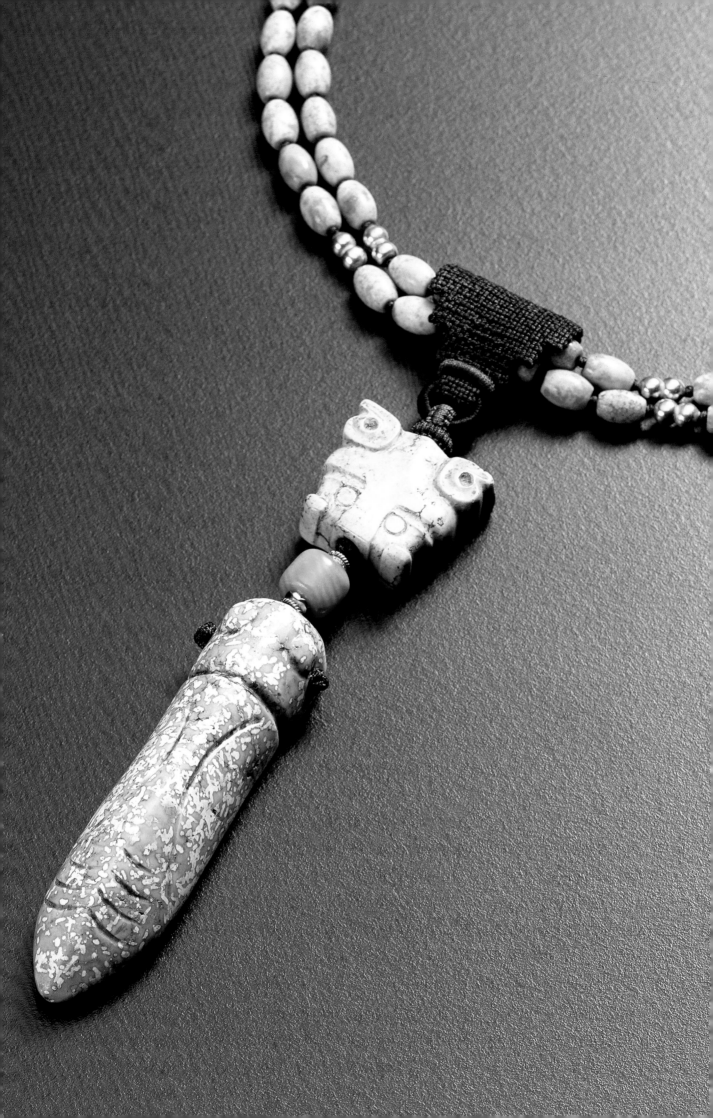

飛簷走壁
salamander

商 Shang Dynasty (c. 1700 - 1046 B.C.)

綠松石蠑螈形墜 turquoise salamander-shaped pendants × 4
Length: 36mm Width: 13mm Height: 7mm
Length: 55mm Width: 15mm Height: 6mm
Length: 43mm Width: 10mm Height: 5mm
Length: 39mm Width: 10mm Height: 5mm

綠松石橢圓珠 turquoise oval beads × 7
Length: 5mm Width: 5mm Height: 7mm

黃金三葉草形珠 golden clover beads × 4
Length: 5mm Width: 4mm Height: 2mm

黃金點圈隔珠 golden coil & dots spacer beads × 18
Length: 4mm Width: 4mm Height: 2mm

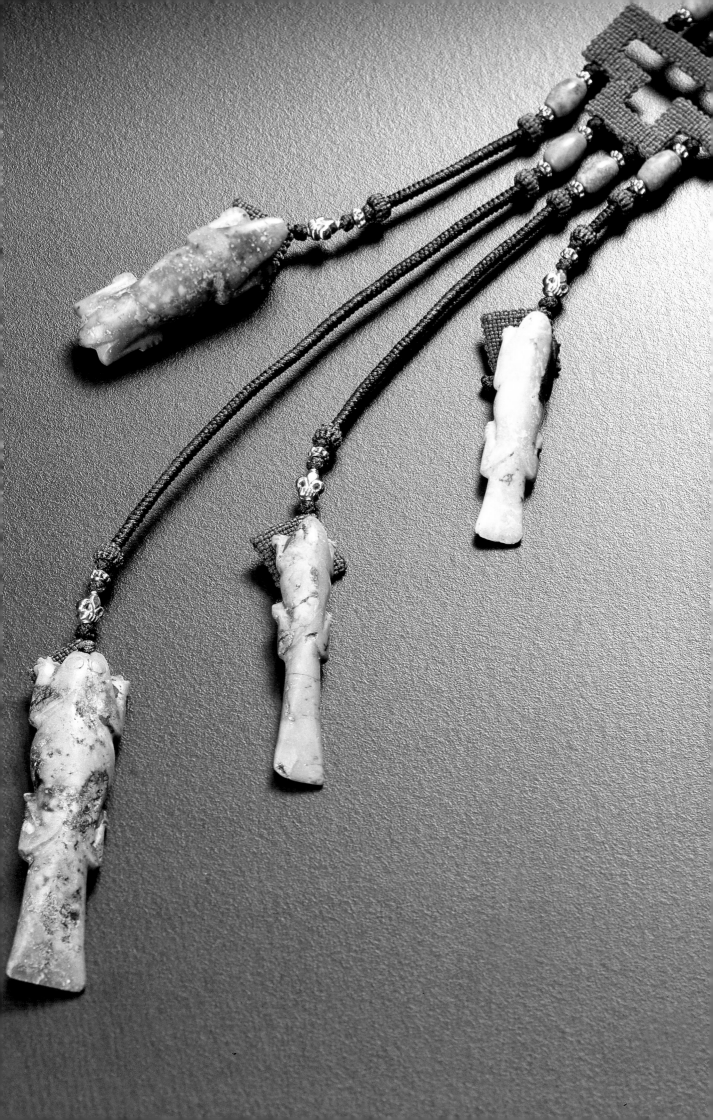

情絲萬縷
silkworm spits silk

西周 Western Zhou Dynasty (1046 - 771 B.C.)

綠松石蠶形墜 turquoise silkworm-shaped pendants × 3
Length: 27mm Width: 7mm Height: 5mm
Length: 38mm Width: 9mm Height: 7mm
Length: 27mm Width: 7mm Height: 5mm

綠松石橢圓珠 turquoise oval beads × 10
Length: 5mm Width: 5mm Height: 7mm

黃金球形珠 golden smooth round spacer beads × 5
Length: 5mm Width: 5mm Height: 5mm

黃金珠帽 golden bead caps × 10
Length: 4mm Width: 4mm Height: 2mm

黃金長管珠 golden bugle beads × 11
Length: 2mm Width: 2mm Height: 5mm

黃金圓片珠 golden disc spacer beads × 20
Length: 2mm Width: 2mm Height: 1mm

蜜蠟圓珠 amber round beads × 13
Length: 4mm Width: 4mm Height: 4mm

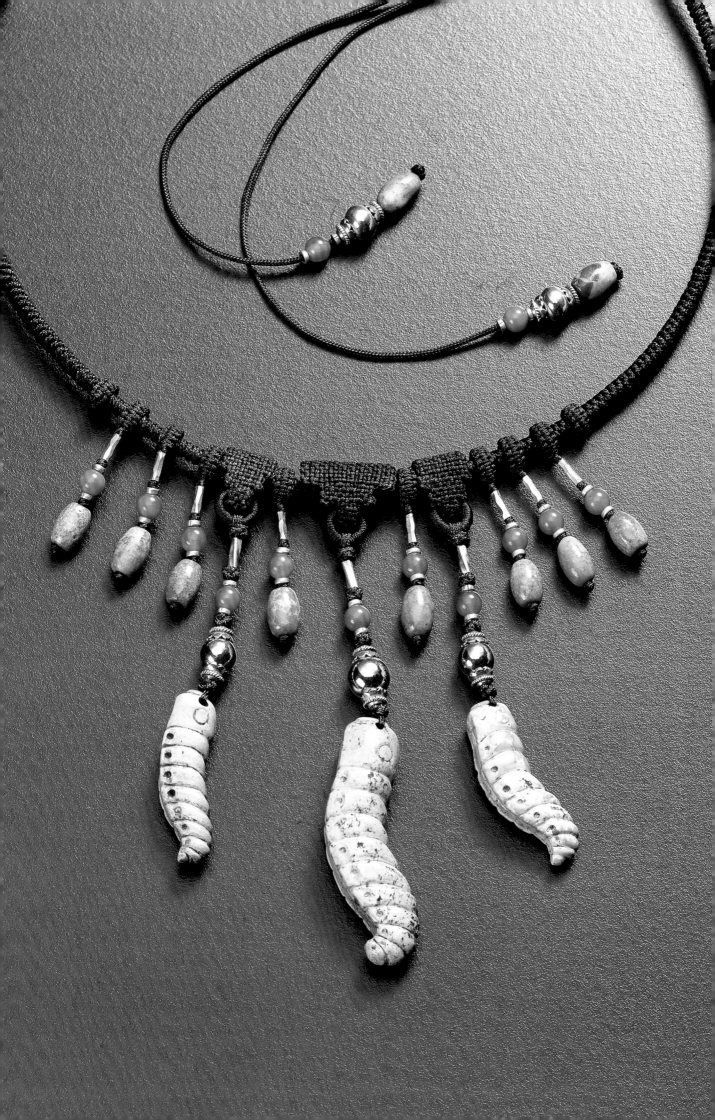

蠶月條桑
feeding silkworm with mulberry leaves

西周 Western Zhou Dynasty (1046 - 771 B.C.)

綠松石蠶形墜 turquoise silkworm-shaped pendants × 2
Length: 35mm Width: 8mm Height: 8mm
Length: 30mm Width: 7mm Height: 9mm

綠松石算盤珠 turquoise abacus bead
Length: 10mm Width: 10mm Height: 3mm

黃金花式組件 golden fancy connectors × 2
Length: 16mm Width: 10mm Height: 1mm

黃金點圈隔珠 golden coil & dots spacer beads × 4
Length: 4mm Width: 4mm Height: 2mm

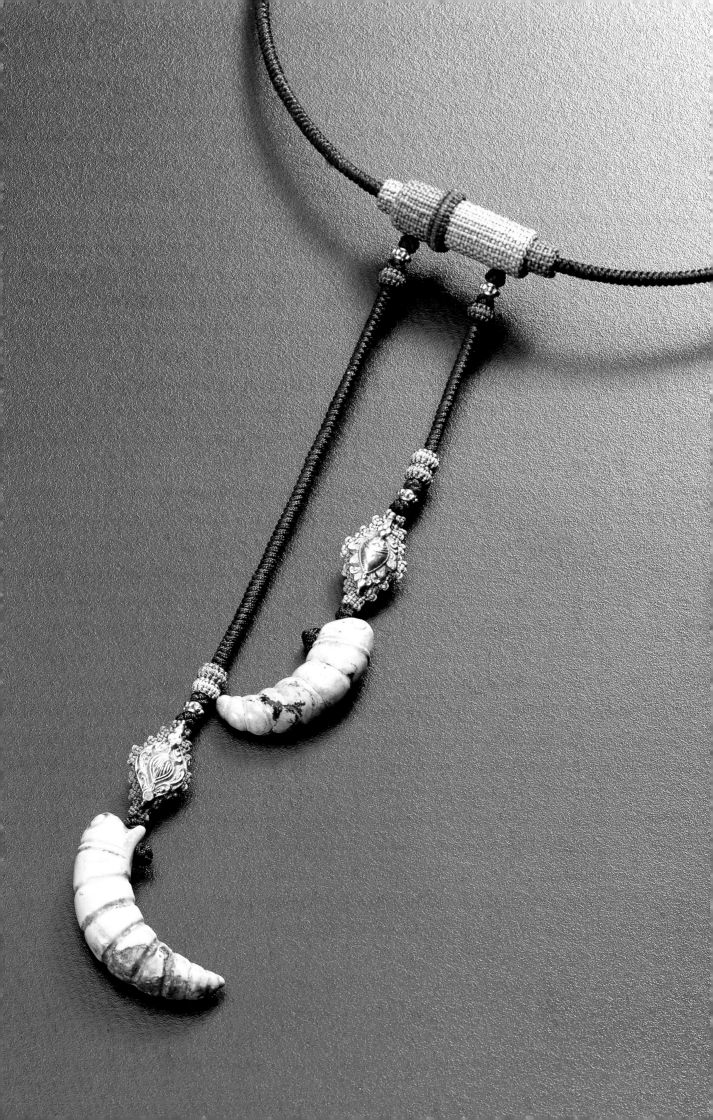

鷹擊長空
hovering hawk

西漢 Western Han Dynasty (202 B.C. - 9 A.D.)

綠松石鷹形墜 turquoise hawk-shaped pendant
Length: 46mm Width: 32mm Height: 8mm

綠松石穀紋勒 turquoise tubes with rice pattern × 2
戰國 Warring States Period (476 - 221 B.C.)
Length: 14mm Width: 14mm Height: 33mm

黃金珠帽 golden bead caps × 4
Length: 14mm Width: 14mm Height: 12mm × 2
Length: 10mm Width: 10mm Height: 5mm × 2

瑪瑙圓珠 agate round beads × 2
Length: 12mm Width: 12mm Height: 12mm

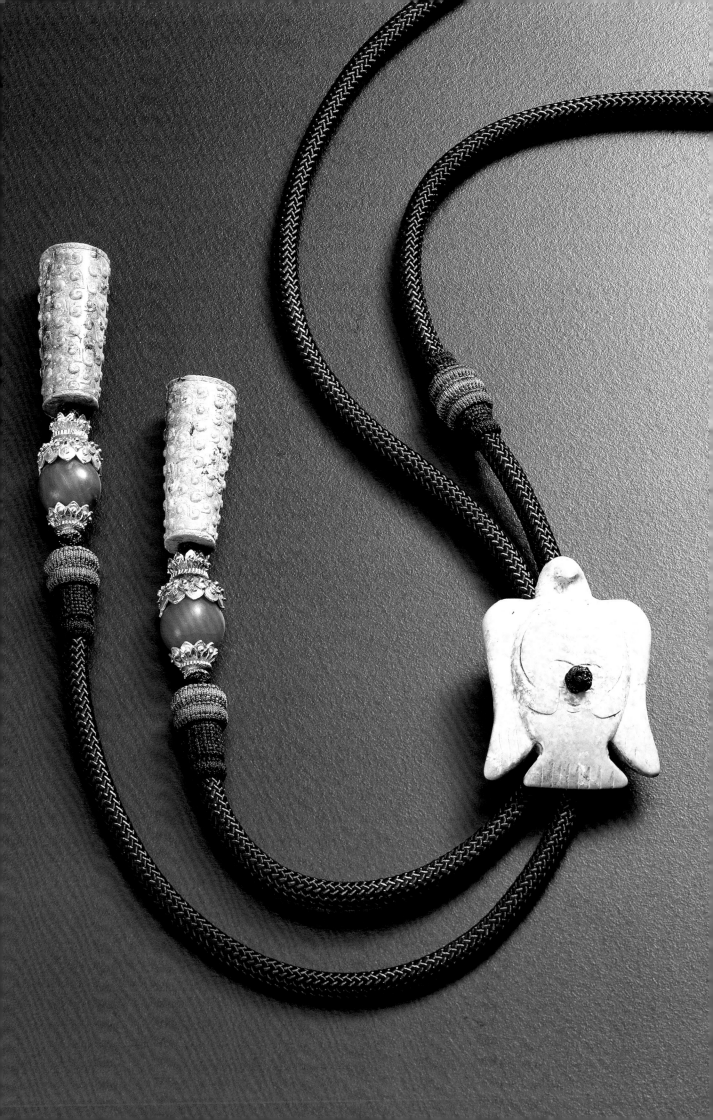

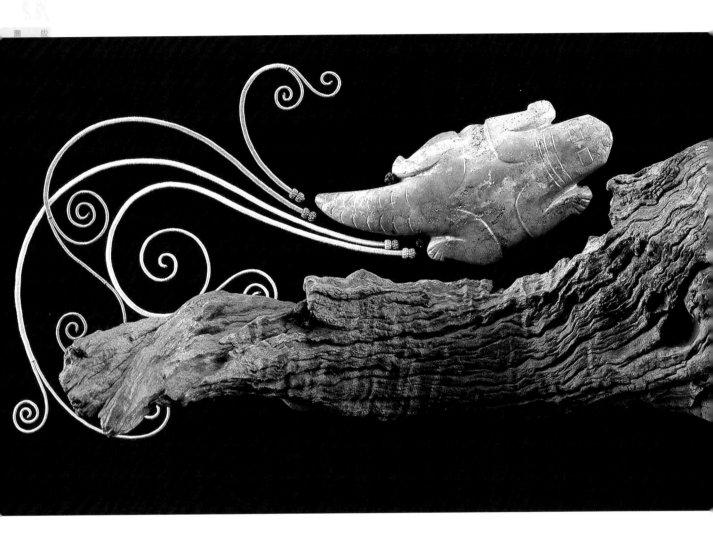

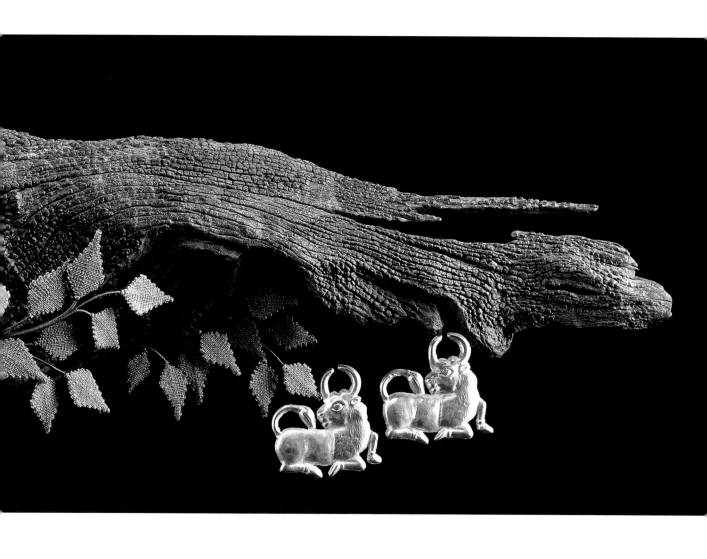

鼉海浮沉
tough alligator

商 Shang Dynasty (c. 1700 - 1046 B.C.)

綠松石鼉形墜 turquoise alligator-shaped pendant
Length: 135mm Width: 60mm Height: 10mm

黃金牛形飾件 golden buffalo-shaped charms × 2
Length: 45mm Width: 42mm Height: 1mm

舌燦蓮花
parrot

西周 Western Zhou Dynasty (1046 - 771 B.C.)

綠松石鸚鵡形墜 turquoise parrot-shaped pendant
Length: 32mm Width: 40mm Height: 9mm

綠松石算盤珠 turquoise abacus bead
Length: 10mm Width: 10mm Height: 3mm

黃金三葉草形珠 golden clover beads × 4
Length: 5mm Width: 4mm Height: 2mm

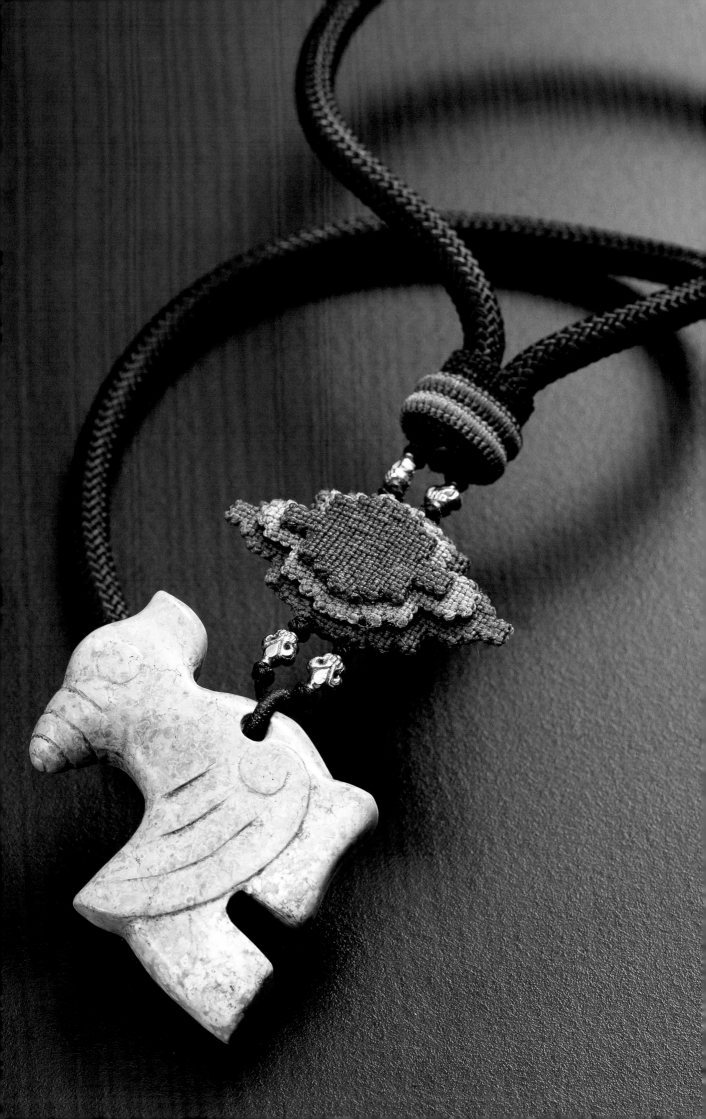

老驥伏櫪
prone horses

明 Ming Dynasty (1368 - 1644 A.D.)

綠松石馬形墜 turquoise horse-shaped pendants × 2
Length: 34mm Width: 22mm Height: 13mm
Length: 36mm Width: 26mm Height: 12mm

綠松石算盤珠 turquoise abacus bead
Length: 10mm Width: 10mm Height: 3mm

黃金點圈隔珠 golden coil & dots spacer beads × 6
Length: 4mm Width: 4mm Height: 2mm

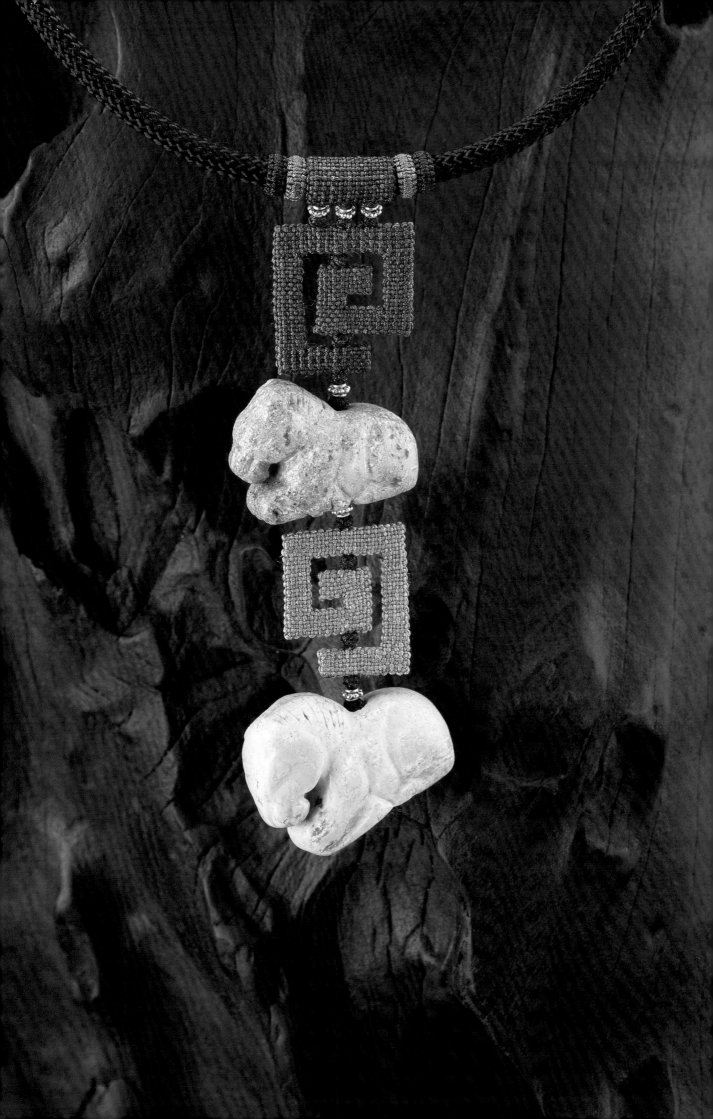

太平有象
elephant

商 Shang Dynasty (c. 1700 - 1046 B.C.)

綠松石象形墜 turquoise elephant-shaped pendant
Length: 55mm Width: 27mm Height: 18mm

綠松石算盤珠 turquoise abacus bead
Length: 10mm Width: 10mm Height: 3mm

黃金華飾焦點珠 golden ornate focal bead
Length: 12mm Width: 12mm Height: 13mm

黃金圓片珠 golden disc spacer beads × 4
Length: 2mm Width: 2mm Height: 1mm

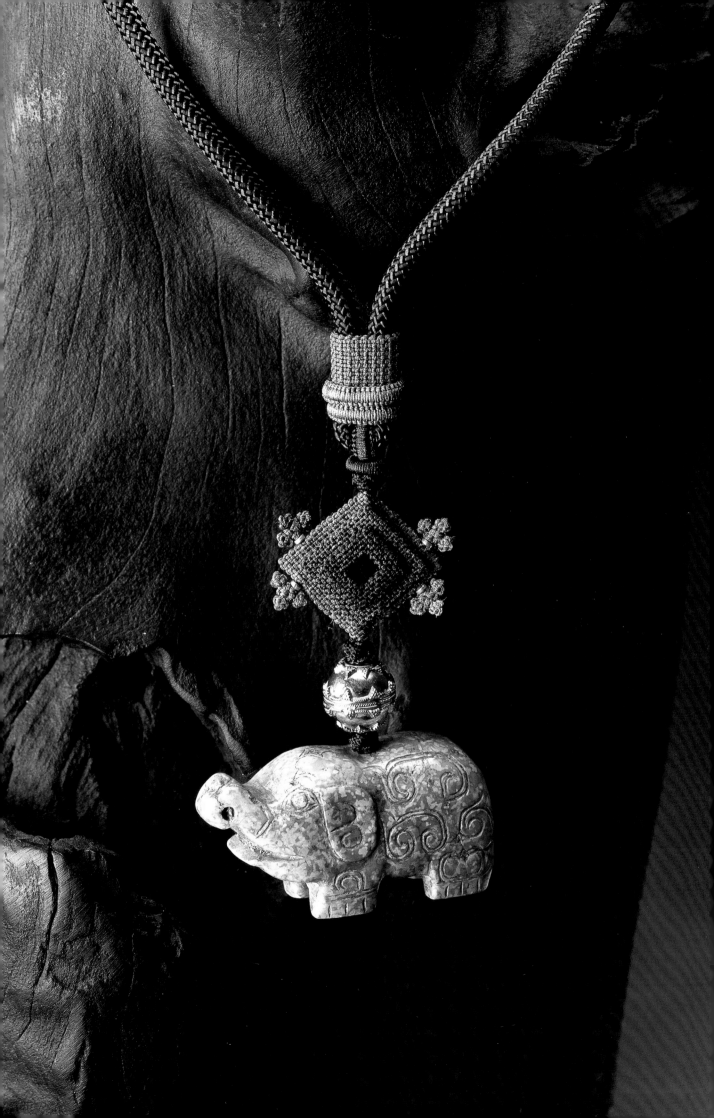

垂珠纓絡
turquoise beads necklace

明 Ming Dynasty (1368 - 1644 A.D.)

綠松石圓珠 turquoise round beads × 170
Length: 5mm Width: 5mm Height: 5mm

黃金華飾隔珠 golden ornate spacer beads × 2
Length: 4mm Width: 4mm Height: 5mm

黃金三葉草形珠 golden clover beads × 8
Length: 5mm Width: 4mm Height: 2mm

黃金圈緣隔珠 golden coil edge spacer beads × 2
Length: 3mm Width: 3mm Height: 4mm

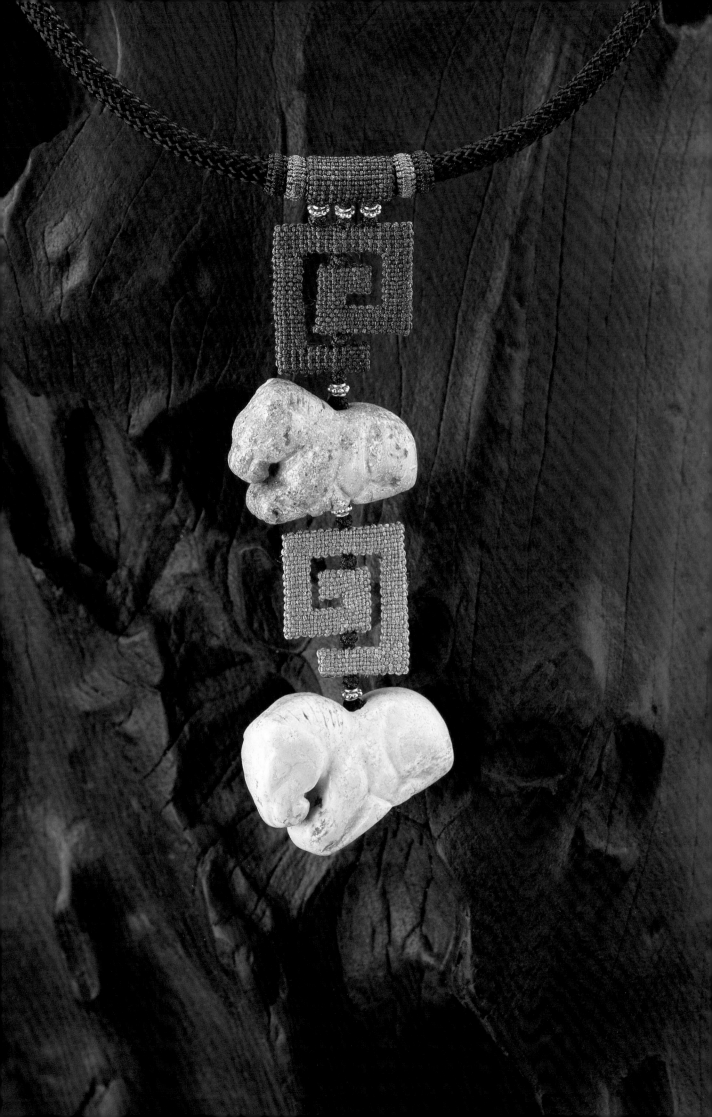

太平有象
elephant

商 Shang Dynasty (c. 1700 - 1046 B.C.)

綠松石象形墜 turquoise elephant-shaped pendant
Length: 55mm Width: 27mm Height: 18mm

綠松石算盤珠 turquoise abacus bead
Length: 10mm Width: 10mm Height: 3mm

黃金華飾焦點珠 golden ornate focal bead
Length: 12mm Width: 12mm Height: 13mm

黃金圓片珠 golden disc spacer beads × 4
Length: 2mm Width: 2mm Height: 1mm

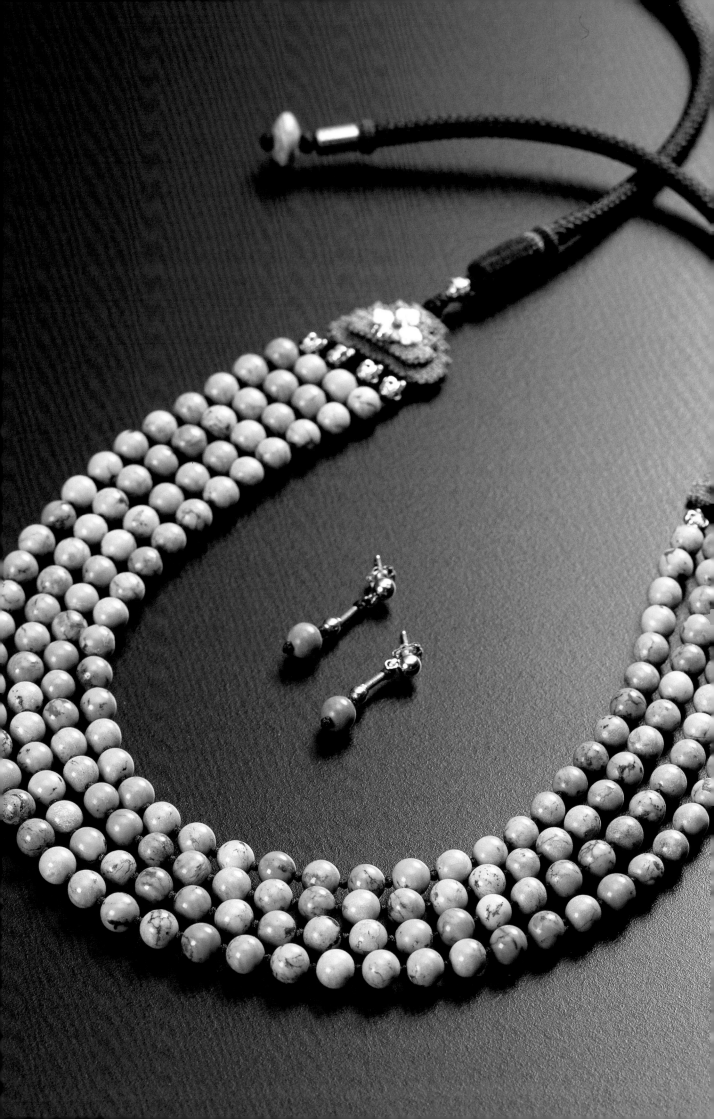

桑土既蠶
planting mulberry tree to raise silkworms

西周 Western Zhou Dynasty (1046 - 771 B.C.)

綠松石蠶形墜 turquoise silkworm-shaped pendant
Length: 41mm Width: 13mm Height: 10mm

綠松石算盤珠 turquoise abacus bead
Length: 10mm Width: 10mm Height: 3mm

黃金華飾隔珠 golden ornate spacer beads × 3
Length: 4mm Width: 4mm Height: 5mm

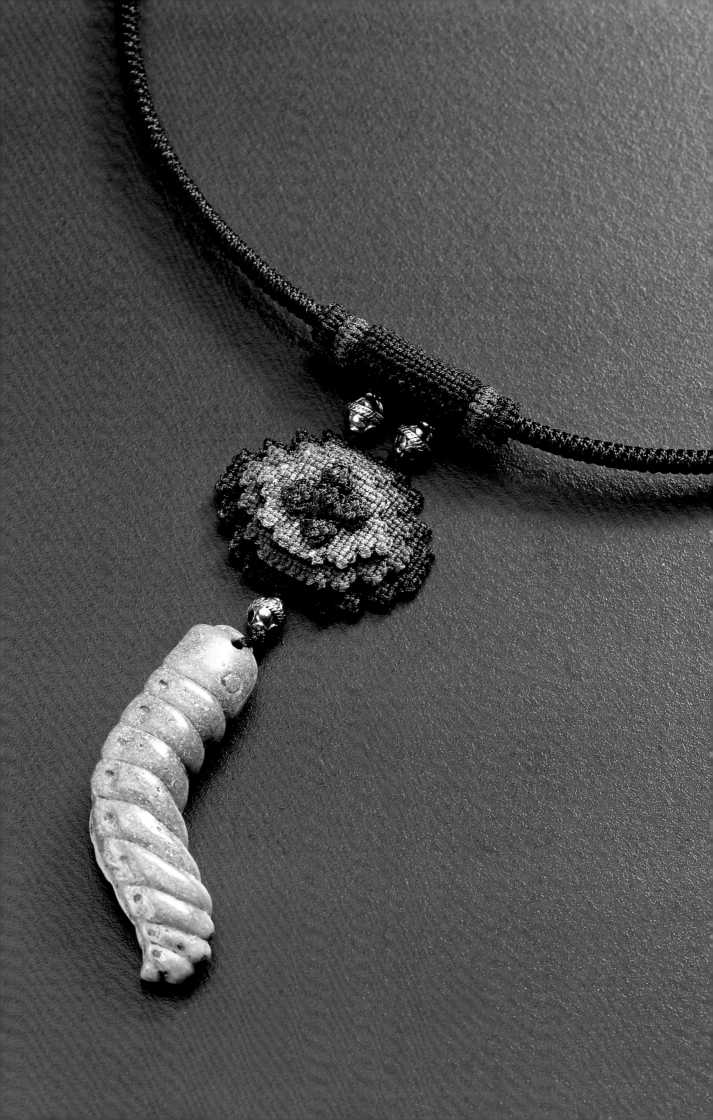

紫豔晶瑩
amethyst beads & turquoise beads necklace

戰國 Warring States Period (476 - 221 B.C.)

綠松石圓珠 turquoise round beads × 64
Length: 5mm Width: 5mm Height: 5mm

紫水晶珠 amethyst beads × 32
Length: 6~8mm Width: 6~8mm Height: 6~22mm

黃金三葉草形珠 golden clover beads × 32
Length: 5mm Width: 4mm Height: 2mm

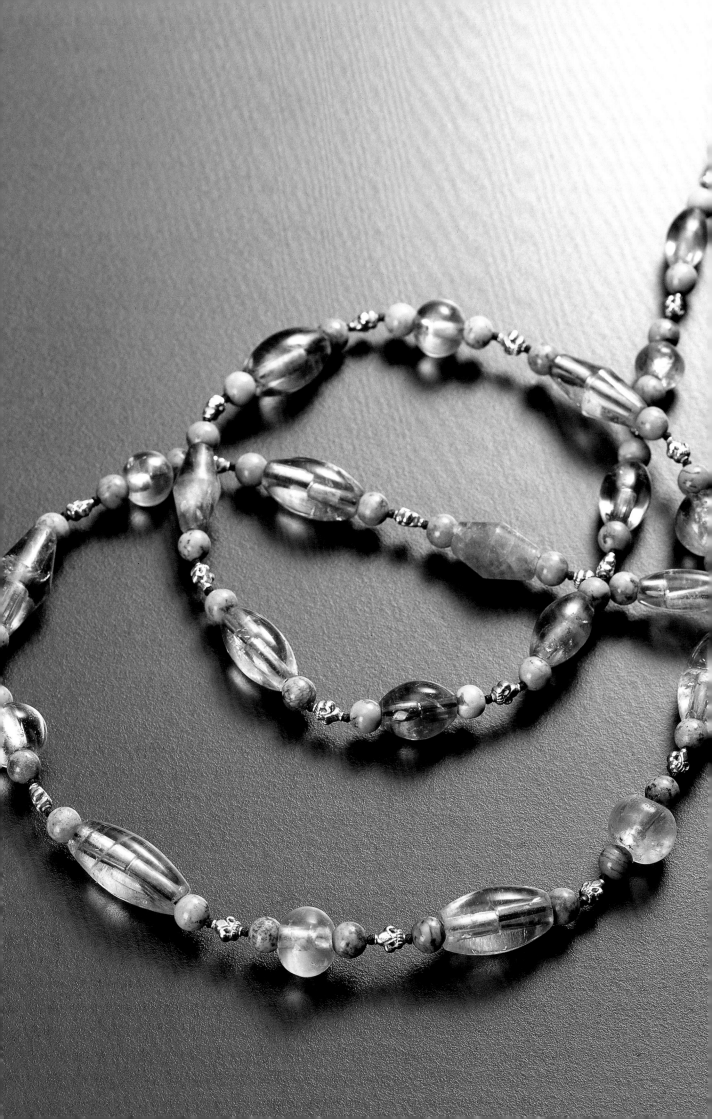

絢彩紛呈
water-drop-shaped turquoise string necklace
西周 Western Zhou Dynasty (1046 - 771 B.C.)

綠松石水滴形墜 turquoise teardrop-shaped pendants × 45
Length: 8mm Width: 8mm Height: 18mm

黃金花蓋 golden flower bead caps × 47
Length: 7mm Width: 7mm Height: 7mm

黃金圓片珠 golden disc spacer beads × 47
Length: 3mm Width: 3mm Height: 1mm

瑪瑙圓珠 agate round beads × 47
Length: 4mm Width: 4mm Height: 4mm

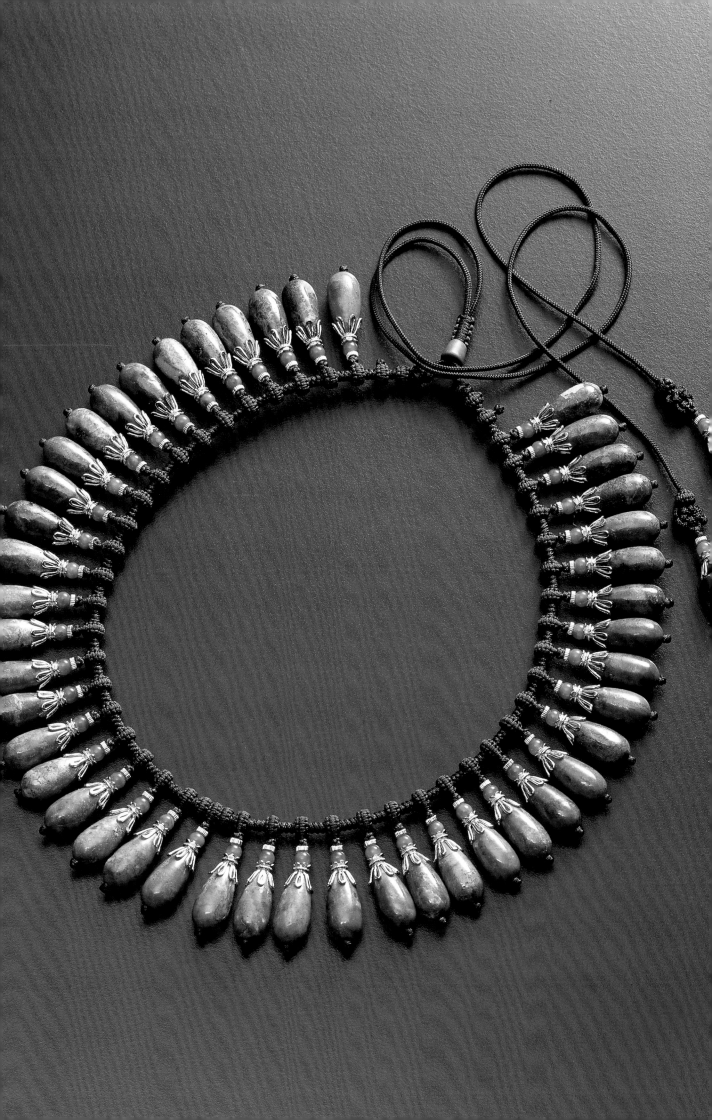

頭角崢嶸
totem of buffalo head

商 Shang Dynasty (c. 1700 - 1046 B.C.)

綠松石牛首墜 turquoise buffalo head pendant
Length: 15mm Width: 15mm Height: 35mm

黃金管珠 golden coil & dots tube beads ╳ 6
Length: 2mm Width: 2mm Height: 3mm

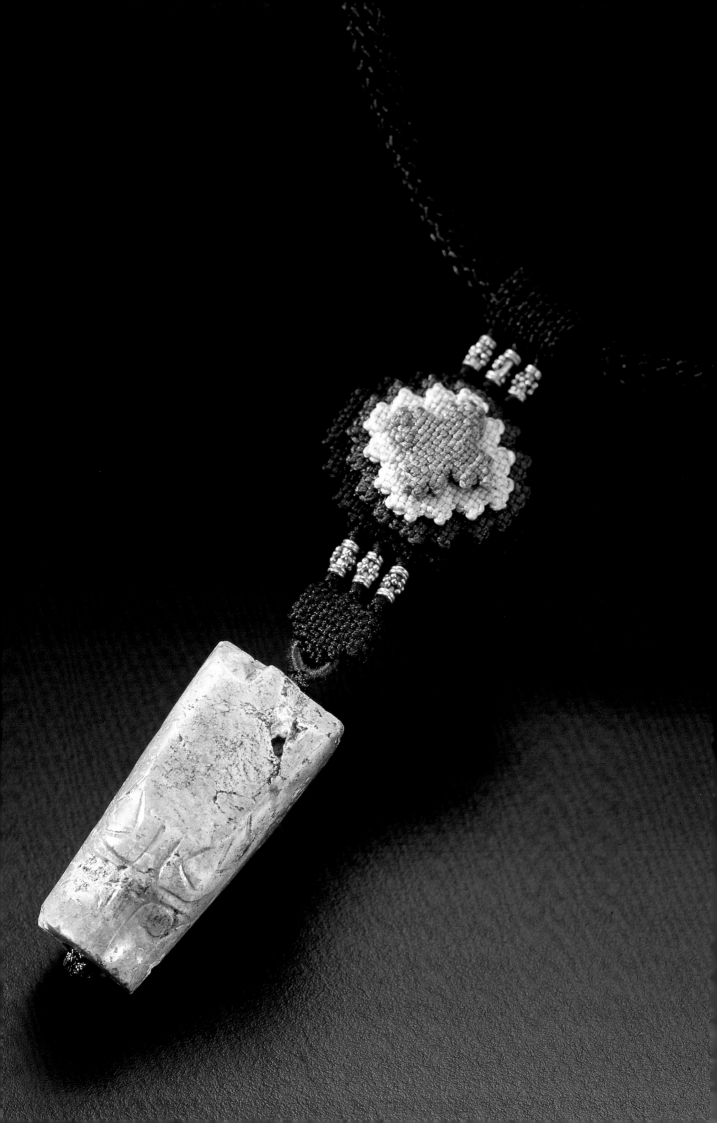

代代相傳
the moon bears; hand down from generation to generation

商 Shang Dynasty (c. 1700 - 1046 B.C.)

綠松石熊形墜 turquoise bear-shaped pendants × 2
Length: 42mm Width: 33mm Height: 16mm
Length: 28mm Width: 18mm Height: 15mm

黃金鏤空珠 golden hollow focal beads × 2
Length: 10mm Width: 10mm Height: 10mm

黃金點圈隔珠 golden coil & dots spacer beads × 2
Length: 4mm Width: 4mm Height: 2mm

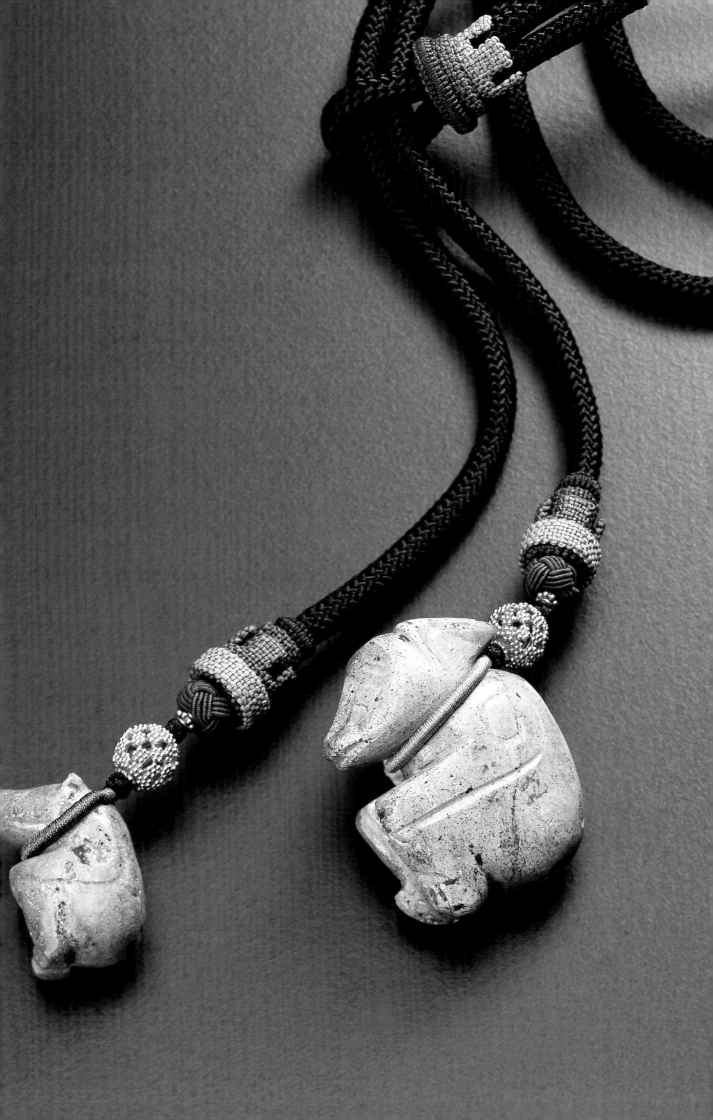

金波璧采
ceremonial jade; heaven worship

春秋 Spring and Autumn Period (770 - 476 B.C.)

綠松石雲紋璧 a piece of flat turquoise with cloud pattern
Length: 90mm Width: 90mm Height: 7mm

印度黃金飾墜 indian golden pendant
Length: 45mm Width: 40mm Height: 17mm

珊瑚珠 coral beads × 11
Length: 8mm Width: 8mm Height: 6mm × 5
Length: 5mm Width: 5mm Height: 4mm × 6

紫檀木珠 sandalwood beads × 90
Length: 8mm Width: 8mm Height: 6mm

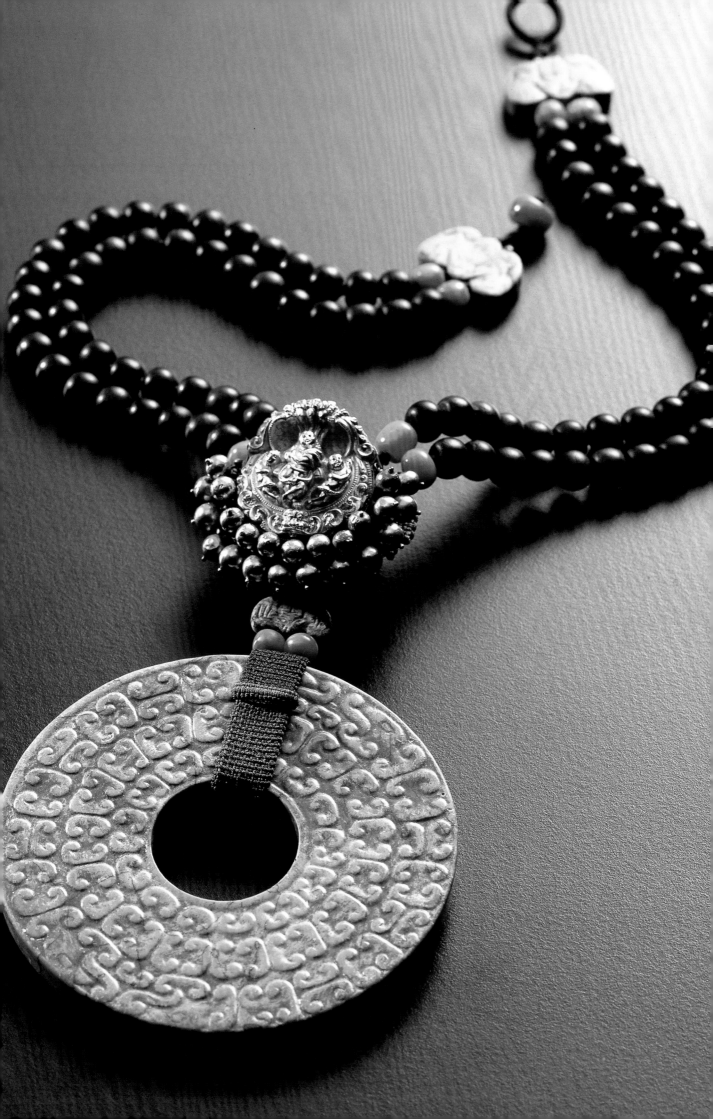

西周 Western Zhou Dynasty (1046 - 771 B.C.)

綠松石魚形墜 turquoise fish-shaped pendants × 2

黃金點圈隔珠 golden coil & dots spacer beads × 7

鶼鰈情深
beloved couple

西周 Western Zhou Dynasty (1046 - 771 B.C.)

綠松石魚形墜 turquoise fish-shaped pendants × 2
Length: 85mm Width: 13mm Height: 3mm
Length: 80mm Width: 13mm Height: 3mm

黃金點圈隔珠 golden coil & dots spacer beads × 7
Length: 4mm Width: 4mm Height: 2mm

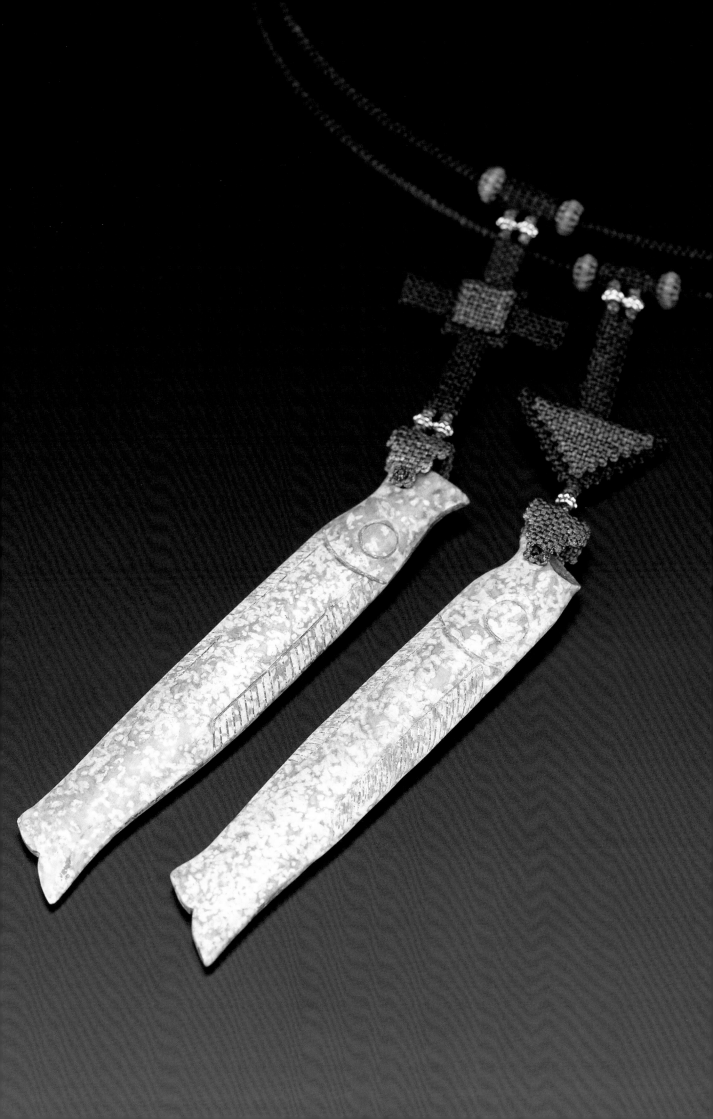

蛙鼓談經
croaking frog

商 Shang Dynasty (c. 1700 - 1046 B.C.)

綠松石蛙形墜 turquoise frog-shaped pendant
Length: 28mm Width: 26mm Height: 12mm

黃金珠帽 golden bead caps × 2
Length: 8mm Width: 8mm Height: 5mm

黃金圈緣隔珠 golden coil edge spacer beads × 2
Length: 3mm Width: 3mm Height: 4mm

閃玉圓珠 nephrite round beads × 2
Length: 10mm Width: 10mm Height: 10mm

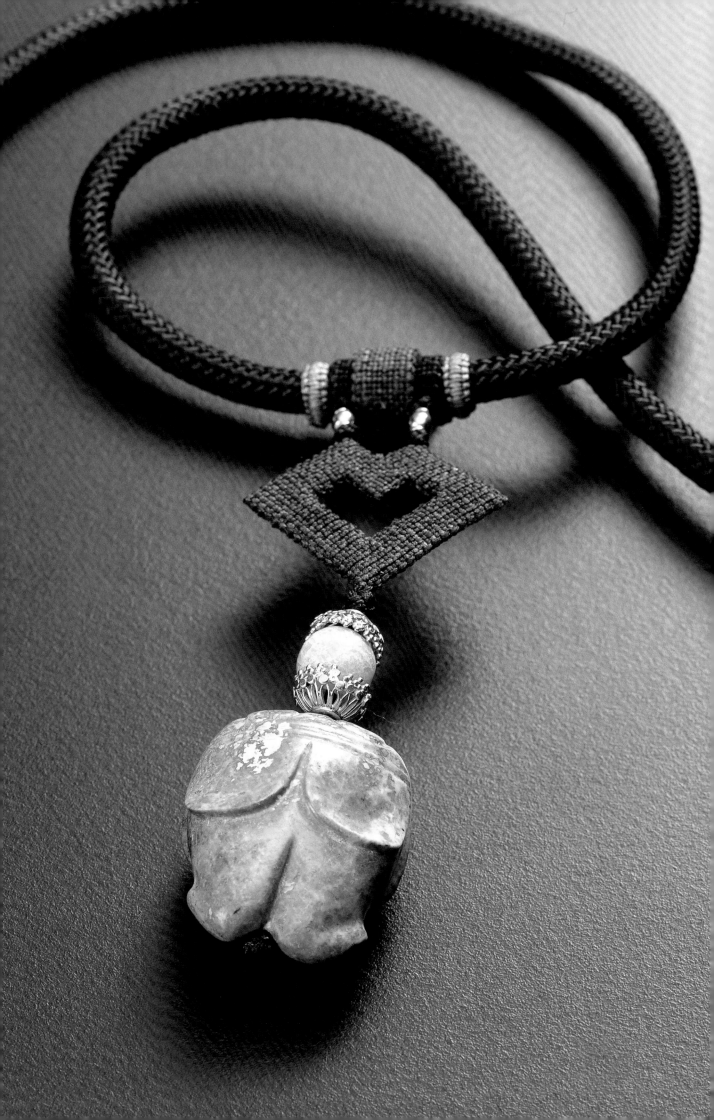

廣寒兔輝
rabbit; moonbeam

西周 Western Zhou Dynasty (1046 - 771 B.C.)

綠松石兔形珮 turquoise hare-shaped pendant
Length: 58mm Width: 33mm Height: 11mm

黃金珠帽 golden bead caps × 2
Length: 8mm Width: 8mm Height: 3mm

瑪瑙珠 agate bead
Length: 13mm Width: 13mm Height: 10mm

蜜蠟珠 amber bead
Length: 12mm Width: 12mm Height: 9mm

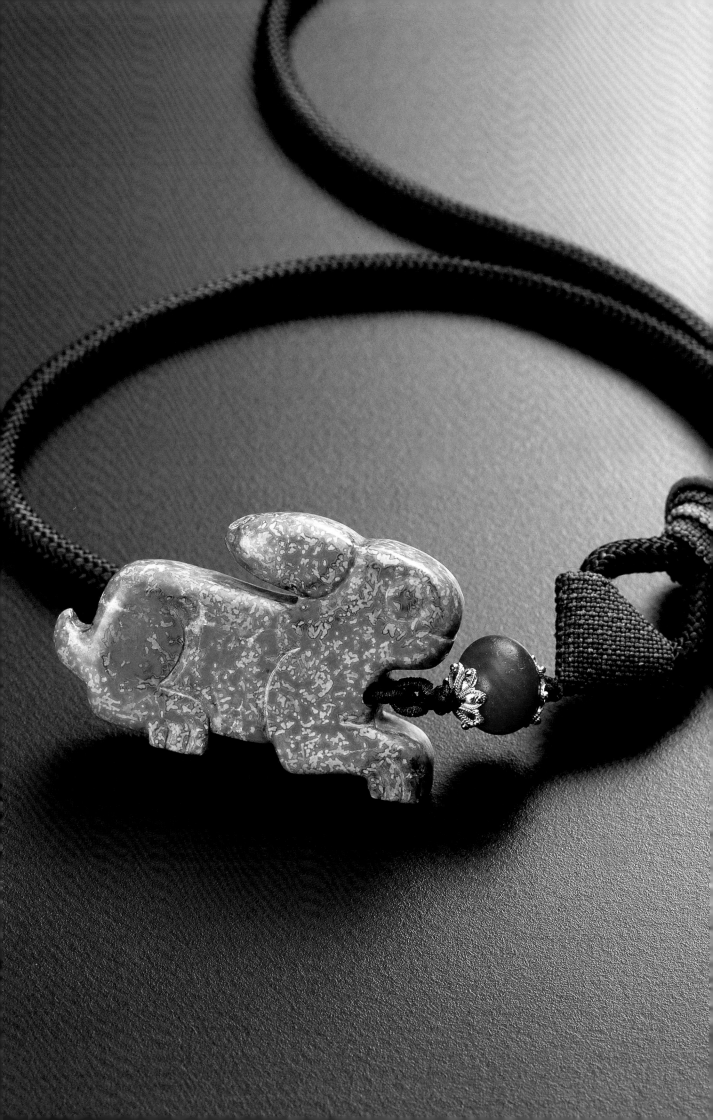

食蘋之鹿
running deer

西周 Western Zhou Dynasty (1046 - 771 B.C.)

綠松石鹿形墜 turquoise deer-shaped pendants × 3
Length: 38mm Width: 38mm Height: 9mm
Length: 58mm Width: 38mm Height: 11mm
Length: 58mm Width: 38mm Height: 10mm

綠松石算盤珠 turquoise abacus beads × 3
Length: 10mm Width: 10mm Height: 3mm

黃金立體切面珠 golden faceted cube spacer beads × 11
Length: 4mm Width: 4mm Height: 4mm

黃金圈緣隔珠 golden coil edge spacer beads × 18
Length: 3mm Width: 3mm Height: 4mm

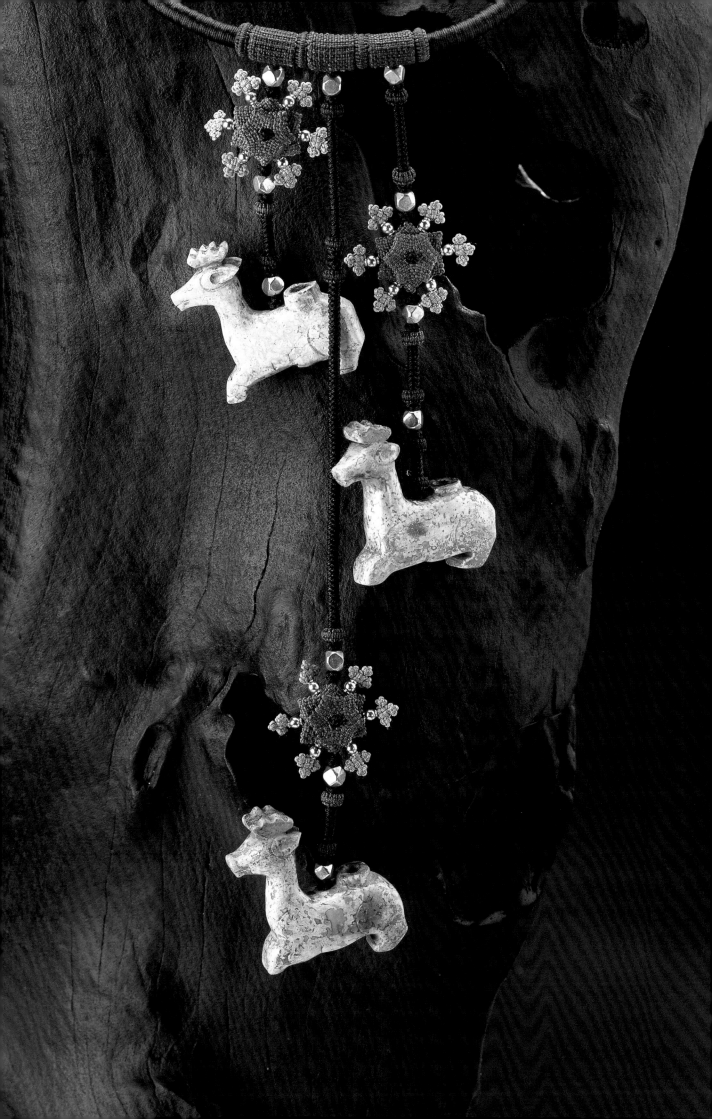

鹿鳴呦呦
deer vocalization
西周 Western Zhou Dynasty (1046 - 771 B.C.)

綠松石鹿形墜 turquoise deer-shaped pendants × 3
Length: 29mm Width: 23mm Height: 8mm
Length: 36mm Width: 25mm Height: 12mm
Length: 28mm Width: 20mm Height: 8mm

綠松石算盤珠 turquoise abacus bead
Length: 10mm Width: 10mm Height: 3mm

黃金珠帽 golden bead caps × 6
Length: 8mm Width: 8mm Height: 5mm

珊瑚珠 coral beads × 3
Length: 8mm Width: 8mm Height: 10mm

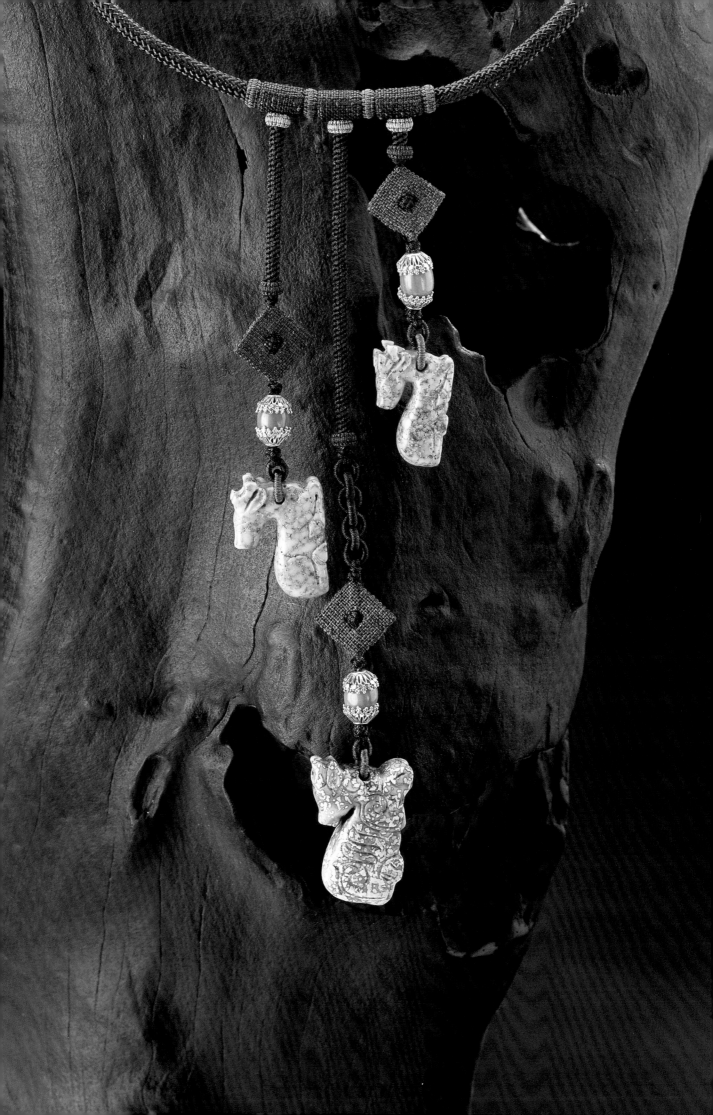

鳴蜩嘒嘒
singing cicada

西周 Western Zhou Dynasty (1046 - 771 B.C.)

綠松石蟬形墜 turquoise cicada-shaped pendant
Length: 50mm Width: 20mm Height: 12mm

綠松石兔形墜 turquoise hare-shaped pendants × 2
Length: 12mm Width: 25mm Height: 6mm
Length: 15mm Width: 26mm Height: 7mm

黃金華飾隔珠 golden ornate spacer beads × 3
Length: 4mm Width: 4mm Height: 5mm

黃金點圈隔珠 golden coil & dots spacer beads × 3
Length: 3mm Width: 3mm Height: 2mm

琉璃珠 glass bead
Length: 11mm Width: 11mm Height: 7mm

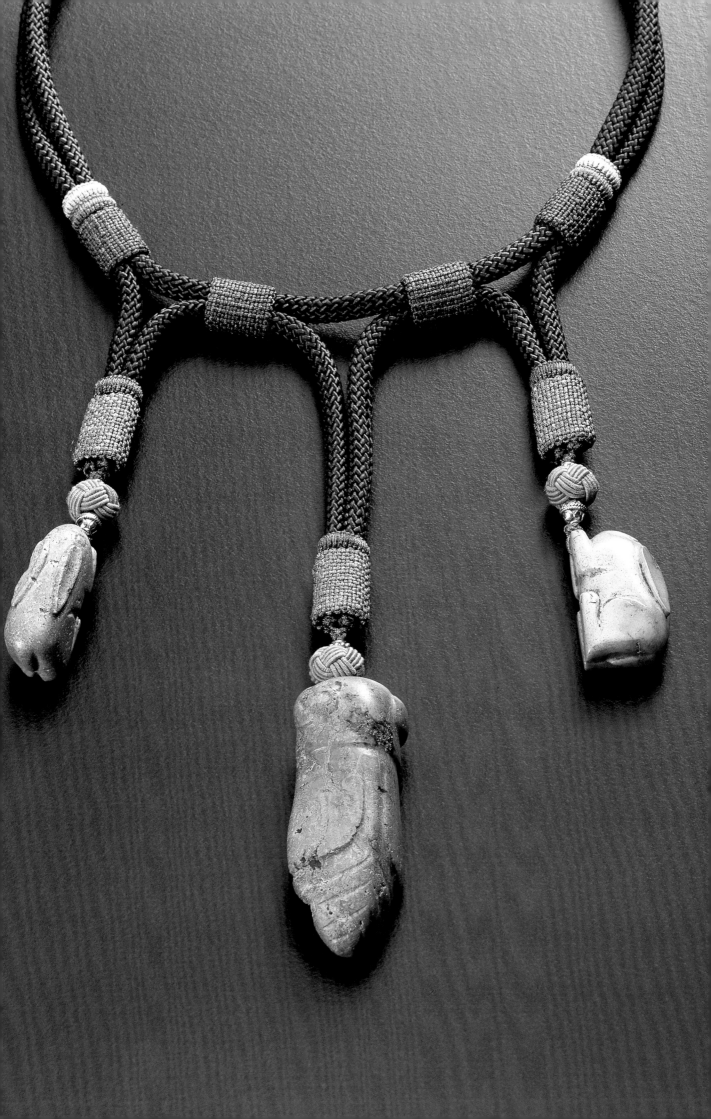

黃金鏤空珠 golden hollow focal bead

閃玉圓珠 nephrite round beads × 9

聖潔之鴿
bird of peace

西周 Western Zhou Dynasty (1046 - 771 B.C.)

綠松石鴿形墜 turquoise pigeon-shaped pendant
Length: 53mm Width: 32mm Height: 18mm

黃金鏤空珠 golden hollow focal bead
Length: 11mm Width: 11mm Height: 11mm

黃金圈緣隔珠 golden coil edge spacer beads × 16
Length: 3mm Width: 3mm Height: 4mm

閃玉圓珠 nephrite round beads × 9
Length: 10mm Width: 10mm Height: 10mm

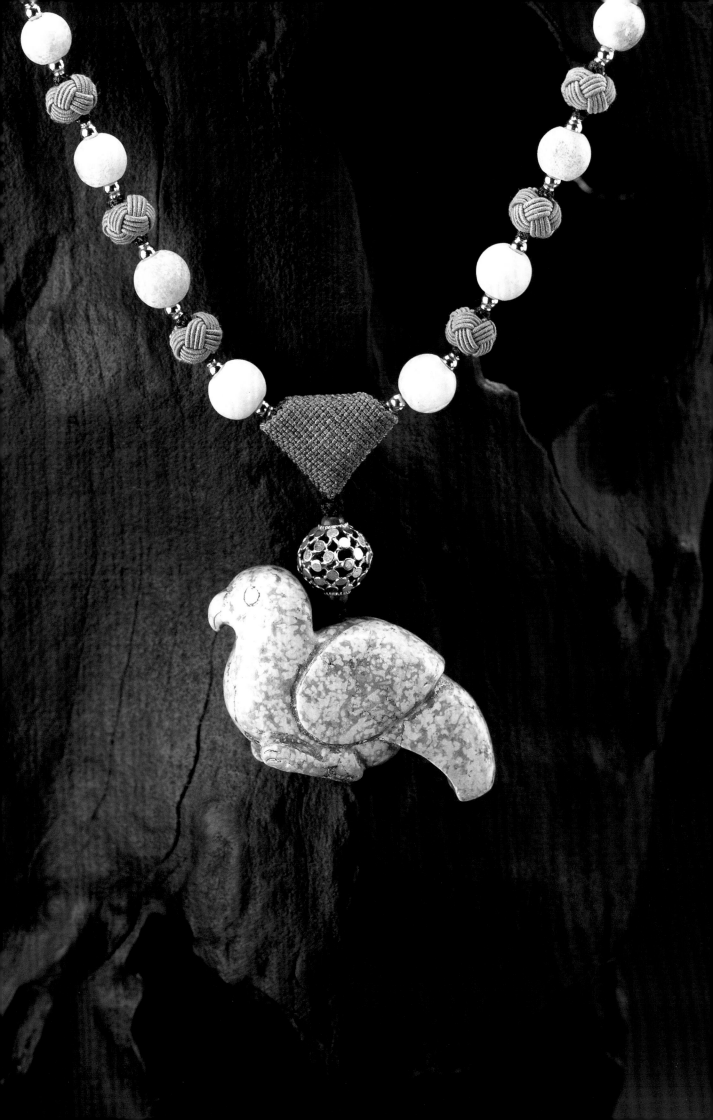

寧為牛首
tiger chasing buffalo

西周 Western Zhou Dynasty (1046 - 771 B.C.)

綠松石牛形墜 turquoise buffalo-shaped pendant
Length: 48mm Width: 25mm Height: 10mm

綠松石虎形墜 turquoise tiger-shaped pendant
Length: 35mm Width: 13mm Height: 8mm

黃金三葉草形珠 golden clover beads × 6
Length: 5mm Width: 4mm Height: 2mm

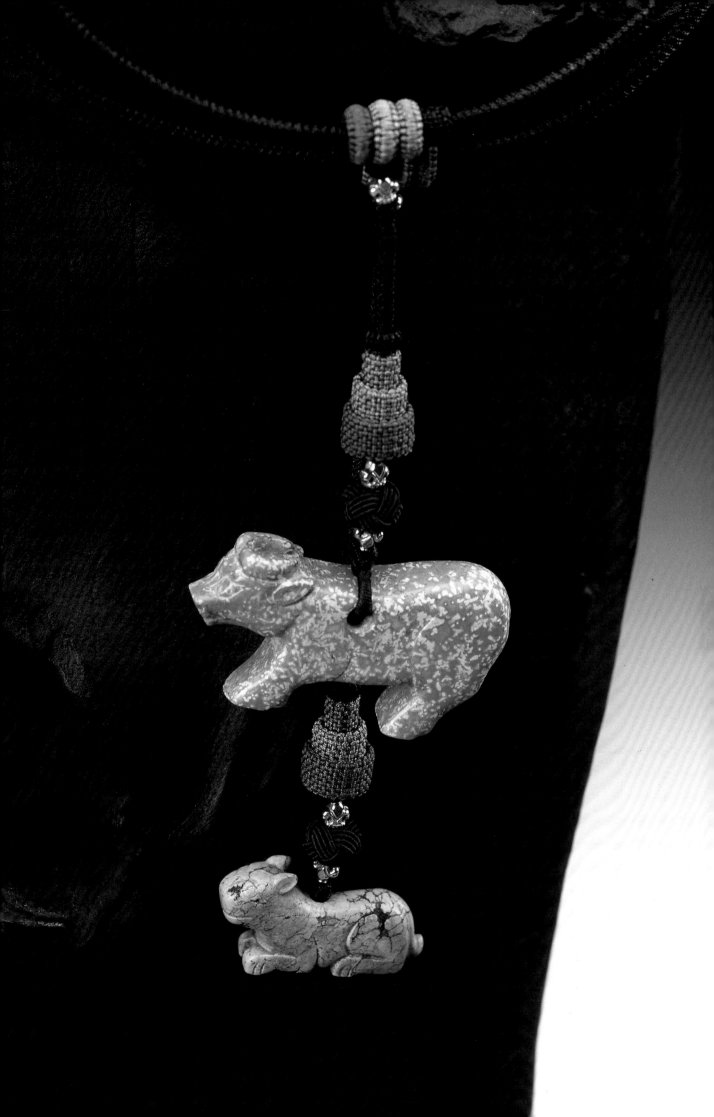

權傾天下
dog; a dominant position

明 Ming Dynasty (1368 - 1644 A.D.)

綠松石犬形墜 turquoise dog-shaped pendants × 2
Length: 35mm Width: 19mm Height: 12mm
Length: 35mm Width: 19mm Height: 12mm

黃金珠帽 golden bead caps × 2
Length: 8mm Width: 8mm Height: 5mm

黃金華飾隔珠 golden ornate spacer beads × 8
Length: 4mm Width: 4mm Height: 5mm

黃金圈緣隔珠 golden coil edge spacer beads × 2
Length: 3mm Width: 3mm Height: 4mm

瑪瑙珠 agate beads × 2
Length: 9mm Width: 9mm Height: 20mm
Length: 10mm Width: 10mm Height: 5mm

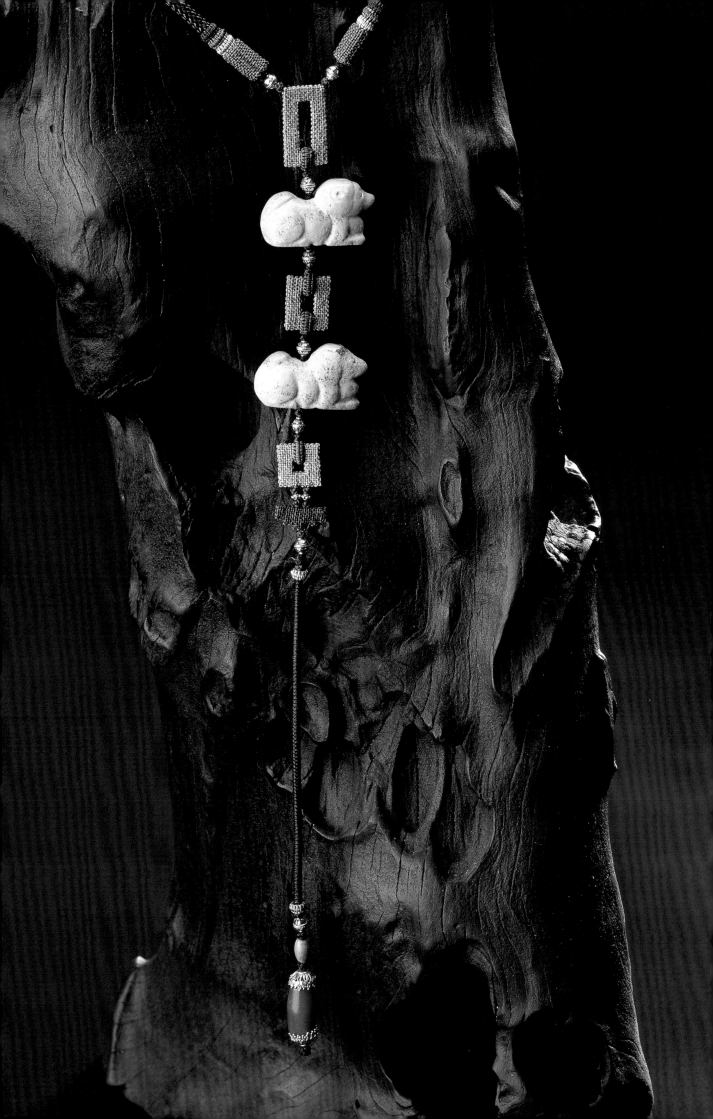

黃金點圈隔珠 golden coil & dots spacer beads × 8
Length: 3mm Width: 3mm Height: 2mm

虎嘯風生
tiger hero

戰國 Warring States Period (476 - 221 B.C.)

綠松石虎形珮 turquoise tiger-shaped pendant
Length: 53mm Width: 30mm Height: 5mm

綠松石算盤珠 turquoise abacus bead
Length: 10mm Width: 10mm Height: 3mm

黃金點圈隔珠 golden coil & dots spacer beads × 8
Length: 3mm Width: 3mm Height: 2mm

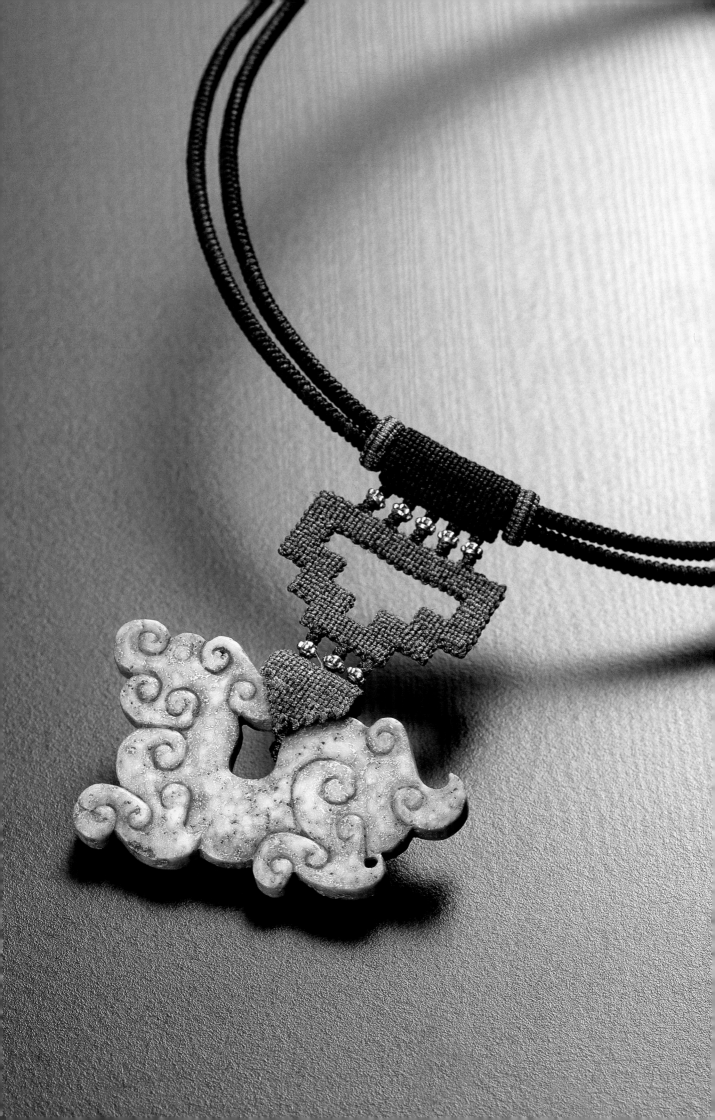

高古儺人
ancient sorcerer

紅山文化 Hongshan Culture (c. 4700 - c. 2900 B.C.)

綠松石神人墜 turquoise sorcerer-shaped pendant
Length: 25mm Width: 25mm Height: 18mm

黃金冠形珠 golden crown bead
Length: 10mm Width: 10mm Height: 20mm

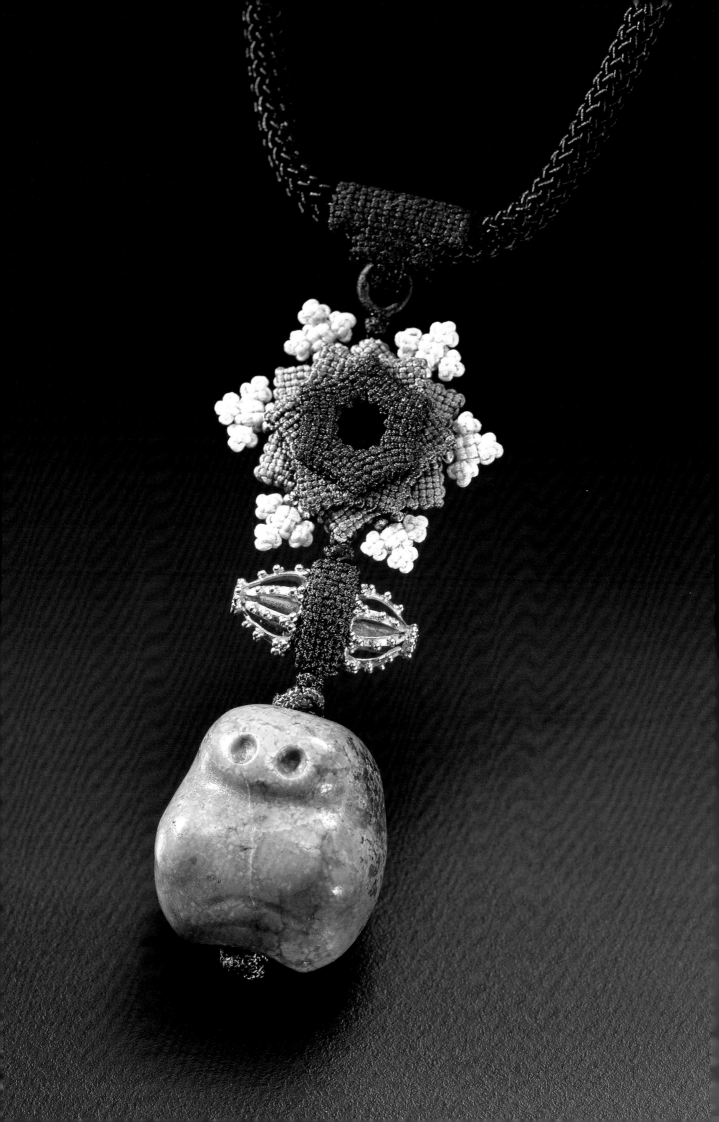

珠聯玉映
eye-shaped turquoise beads necklace

戰國 Warring States Period (476 - 221 B.C.)

綠松石勒 eye-shaped turquoise tubes × 10
Length: 9mm Width: 9mm Height: 30mm

黃金圈形珠 golden donut spacer beads × 2
Length: 5mm Width: 5mm Height: 4mm

黃金點圈隔珠 golden coil & dots spacer beads × 12
Length: 4mm Width: 4mm Height: 3mm

蜜蠟珠 amber beads × 3
Length: 8mm Width: 8mm Height: 7mm

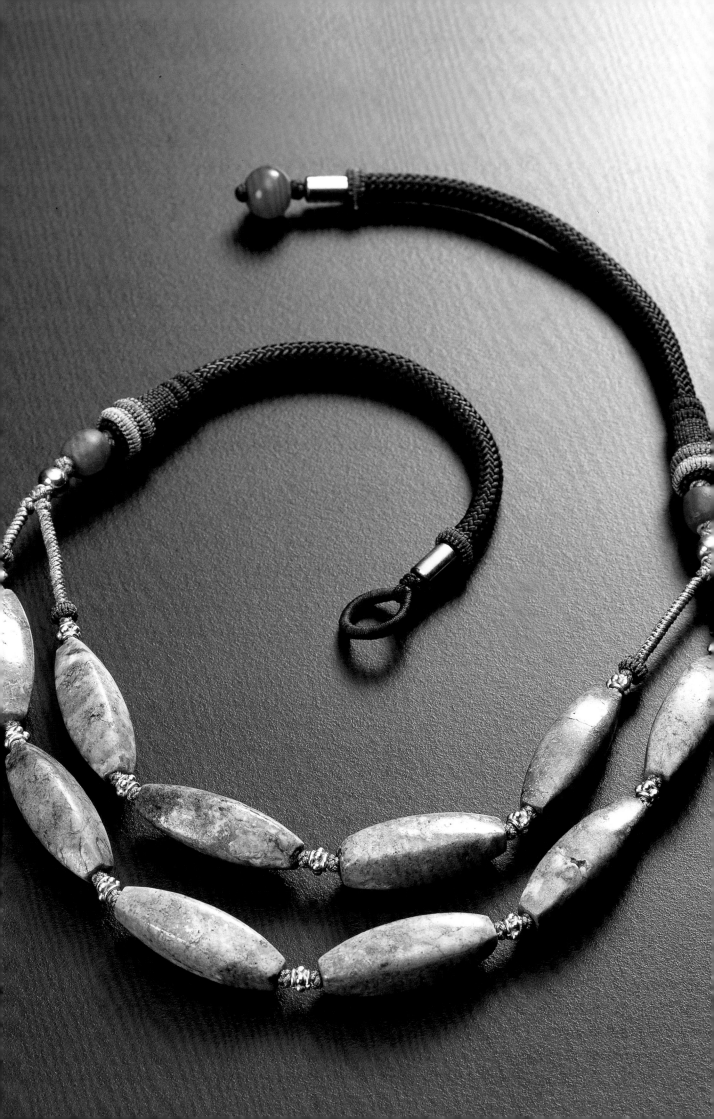

華美繽紛
round turquoise beads and cloud pattern pendant necklace

戰國 Warring States Period (476 - 221 B.C.)

綠松石雲紋勒 turquoise tube with cloud pattern
Length: 12mm Width: 7mm Height: 28mm

綠松石算盤珠 turquoise abacus bead
Length: 10mm Width: 10mm Height: 3mm

綠松石圓珠 turquoise round beads × 58
Length: 5mm Width: 5mm Height: 5mm

黃金圈緣隔珠 golden coil edge spacer beads × 60
Length: 3mm Width: 3mm Height: 4mm

黃金管珠 golden coil & dots tube beads × 12
Length: 2mm Width: 2mm Height: 3mm

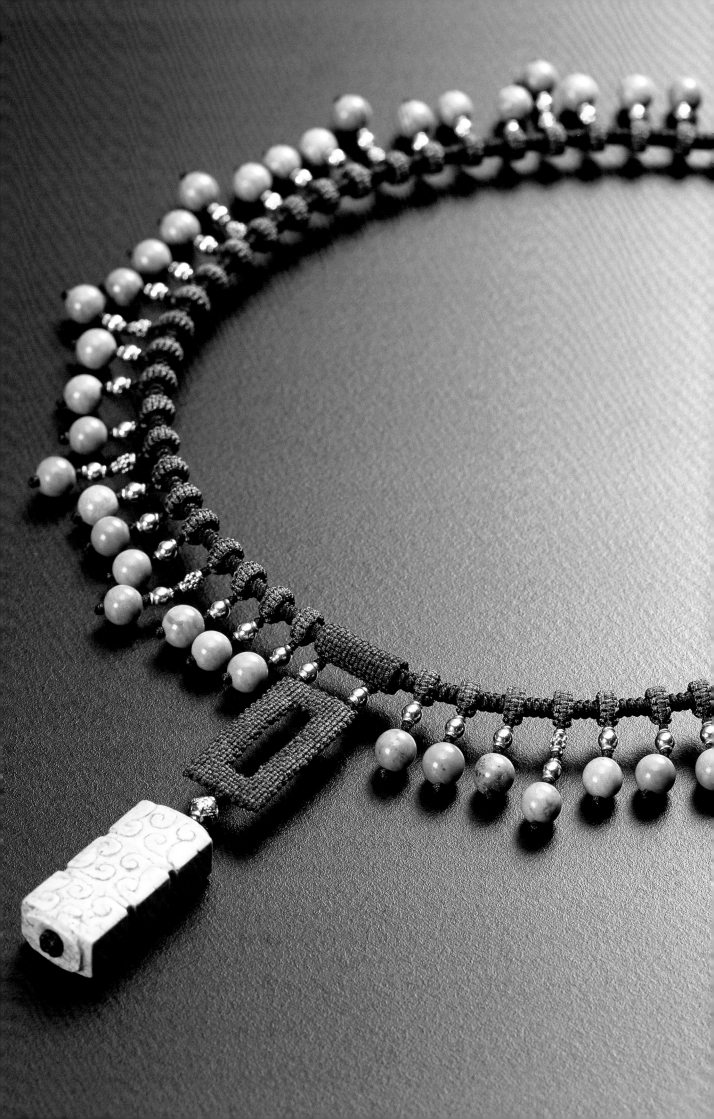

魚躍龍門
paddlefish makes a big splash

商 Shang Dynasty (c. 1700 - 1046 B.C.)

綠松石魚形璜 turquoise fish-shaped ornament
Length: 50mm Width: 15mm Height: 3mm

綠松石Y型器 turquoise Y-shaped utensil; knife
Length: 53mm Width: 17mm Height: 6mm

黃金三葉草形珠 golden clover beads × 2
Length: 5mm Width: 4mm Height: 2mm

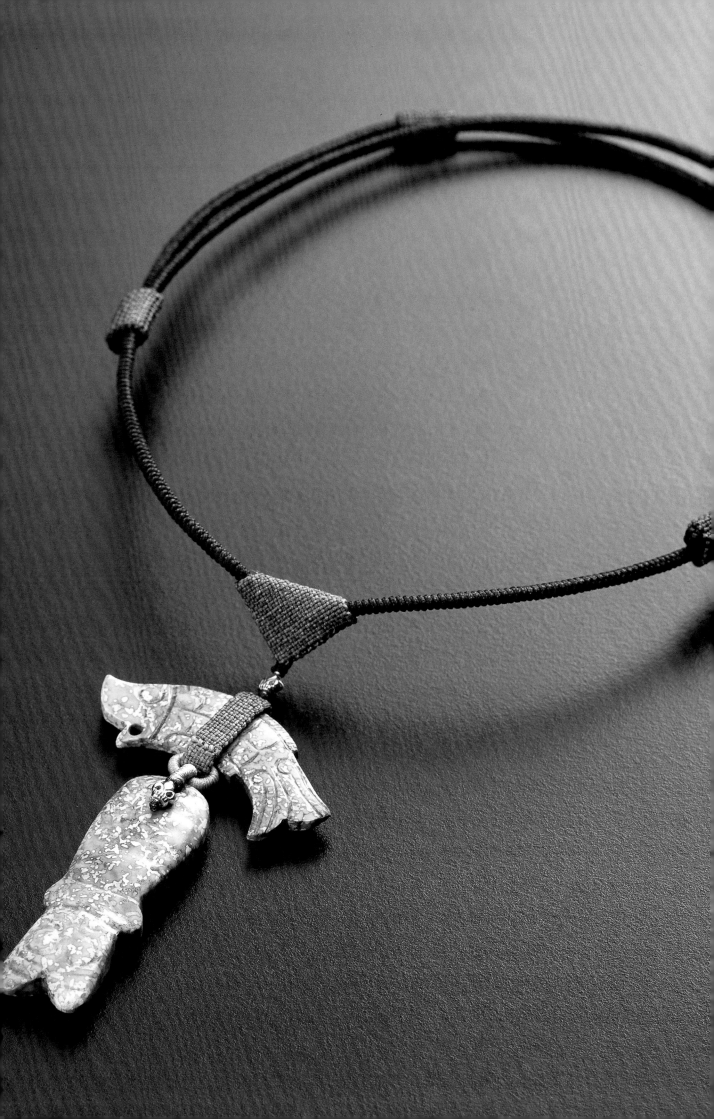

綠松石虎形珮 turquoise tiger-shaped pendant

黃金點圈隔珠 golden coil & dots spacer beads

西漢 Western Han Dynasty (202 B.C. - 9 A.D.)

眈眈虎視
eye of the tiger

西漢 Western Han Dynasty (202 B.C. - 9 A.D.)

綠松石虎形珮 turquoise tiger-shaped pendant
Length: 66mm Width: 25mm Height: 6mm

綠松石算盤珠 turquoise abacus bead
Length: 10mm Width: 10mm Height: 3mm

黃金點圈隔珠 golden coil & dots spacer beads × 11
Length: 3mm Width: 3mm Height: 2mm

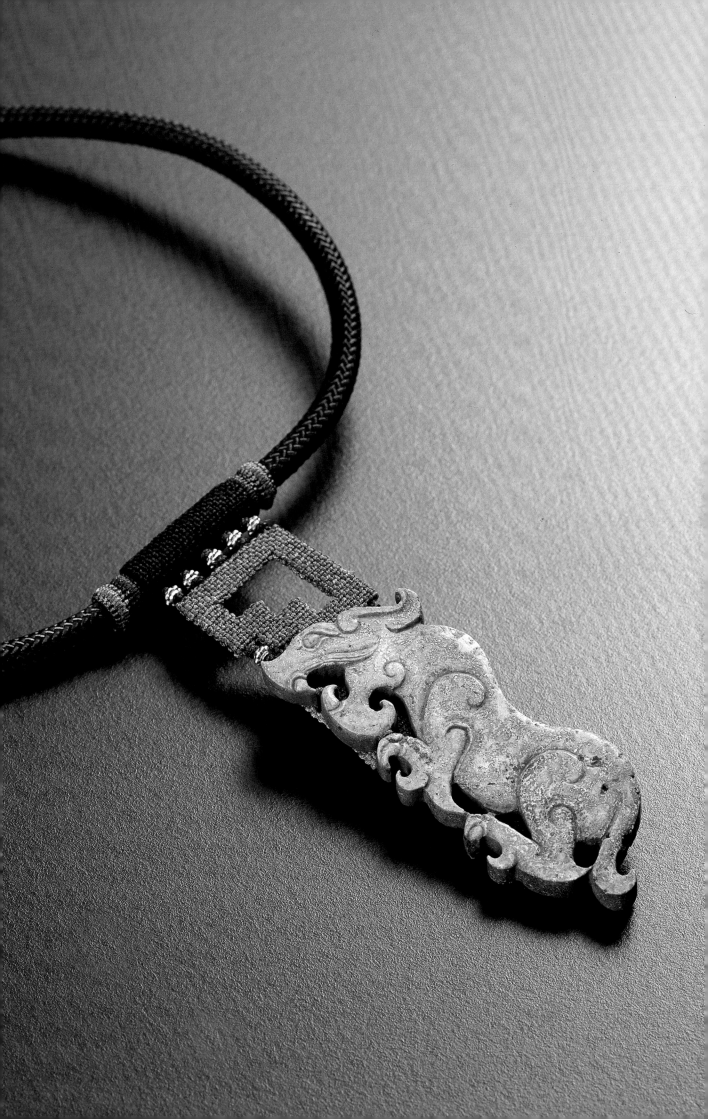

喜雨蛙聲
croaking frogs

明 Ming Dynasty (1368 - 1644 A.D.)

綠松石蛙形墜 turquoise frog-shaped pendants × 3
Length: 40mm Width: 25mm Height: 20mm
Length: 42mm Width: 30mm Height: 15mm
Length: 42mm Width: 30mm Height: 25mm

黃金花式組件 golden fancy connectors × 4
Length: 16mm Width: 10mm Height: 1mm

黃金雙尖珠 golden bicone beads × 6
Length: 4mm Width: 4mm Height: 8mm

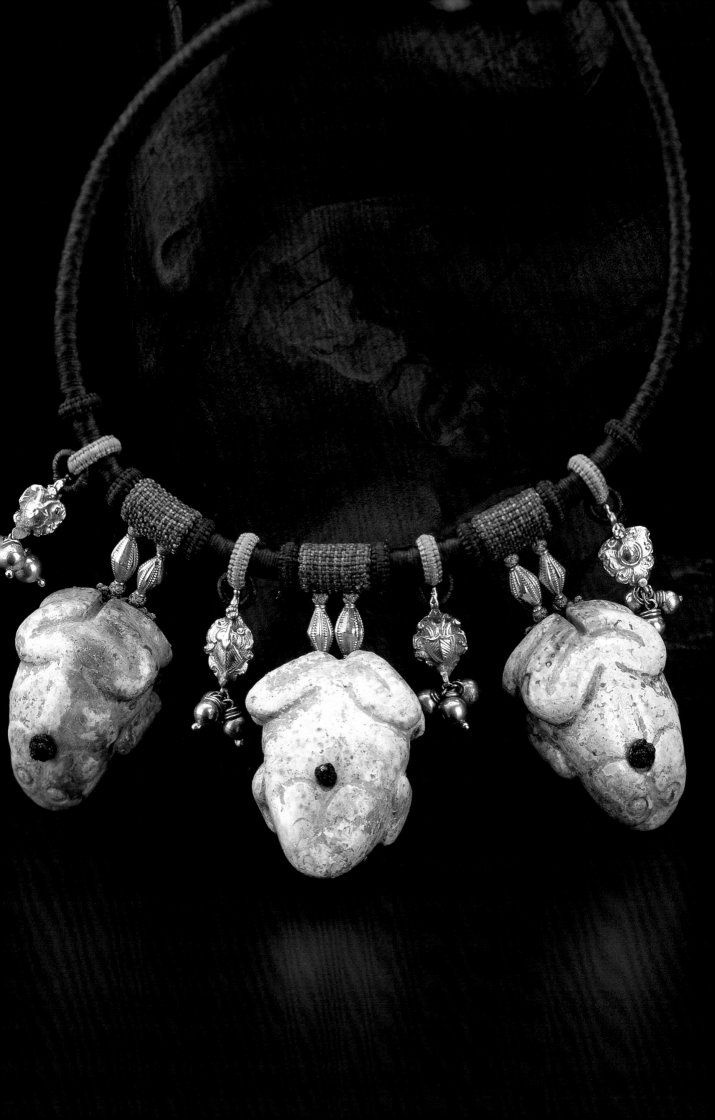

居高飲露
cicadas suck sap

商 Shang Dynasty (c. 1700 - 1046 B.C.)

綠松石蟬形墜 turquoise cicada-shaped pendant
Length: 30mm Width: 14mm Height: 10mm

綠松石算盤珠 turquoise abacus bead
Length: 10mm Width: 10mm Height: 3mm

黃金華飾隔珠 golden ornate spacer beads × 2
Length: 4mm Width: 4mm Height: 5mm

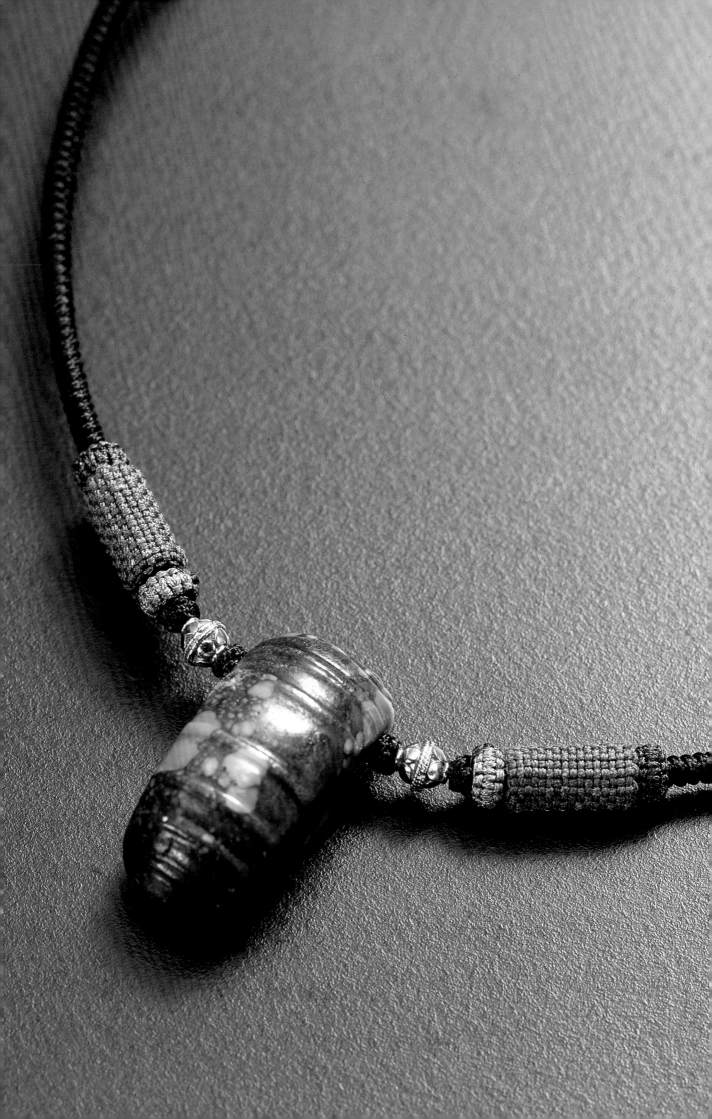

潛龍在淵
dragon in the abyss

商 Shang Dynasty (c. 1700 - 1046 B.C.)

綠松石龍形墜 turquoise dragon-shaped pendant
Length: 63mm Width: 32mm Height: 10mm

綠松石算盤珠 turquoise abacus bead
Length: 10mm Width: 10mm Height: 3mm

黃金鏤空珠 golden hollow focal bead
Length: 10mm Width: 10mm Height: 10mm

黃金三葉草形珠 golden clover beads × 4
Length: 5mm Width: 4mm Height: 2mm

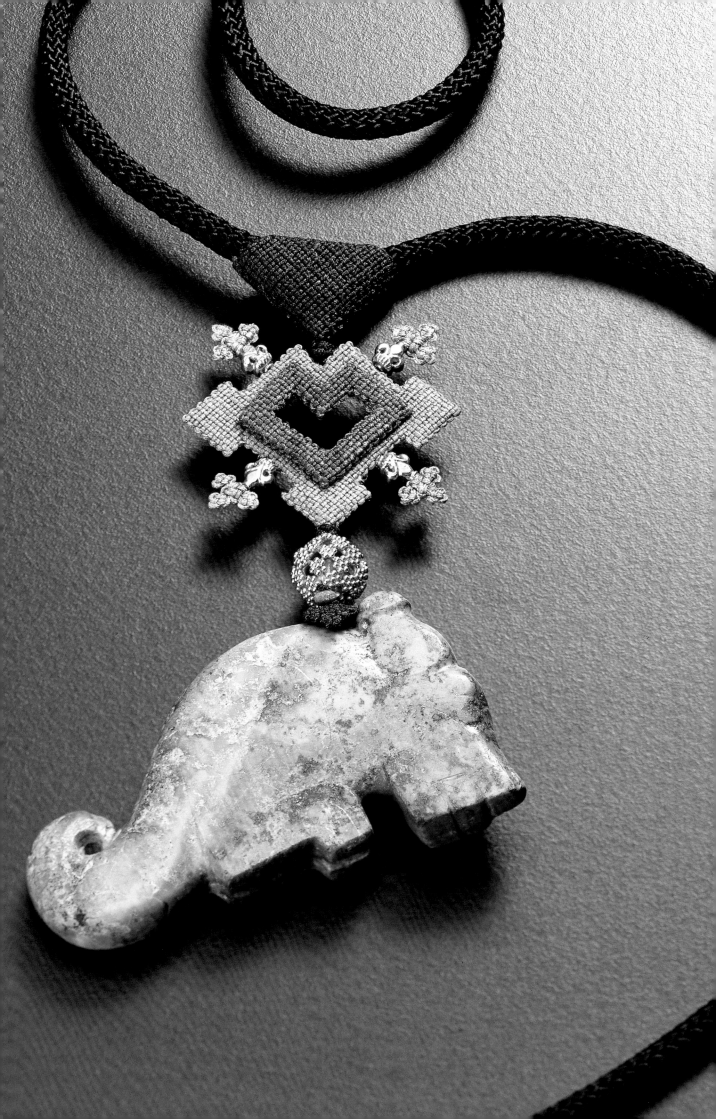

雞鳴起舞
dancing rooster

東漢 Eastern Han Dynasty (25 - 220 A.D.)

綠松石雞首墜 turquoise rooster head pendants × 3
Length: 15mm Width: 12mm Height: 8mm

黃金冠形珠 golden crown bead
Length: 10mm Width: 10mm Height: 20mm

黃金長管珠 golden bugle beads × 5
Length: 2mm Width: 2mm Height: 5mm

黃金三葉草形珠 golden clover beads × 2
Length: 5mm Width: 4mm Height: 2mm

黃金立體切面珠 golden faceted cube spacer beads × 2
Length: 4mm Width: 4mm Height: 4mm

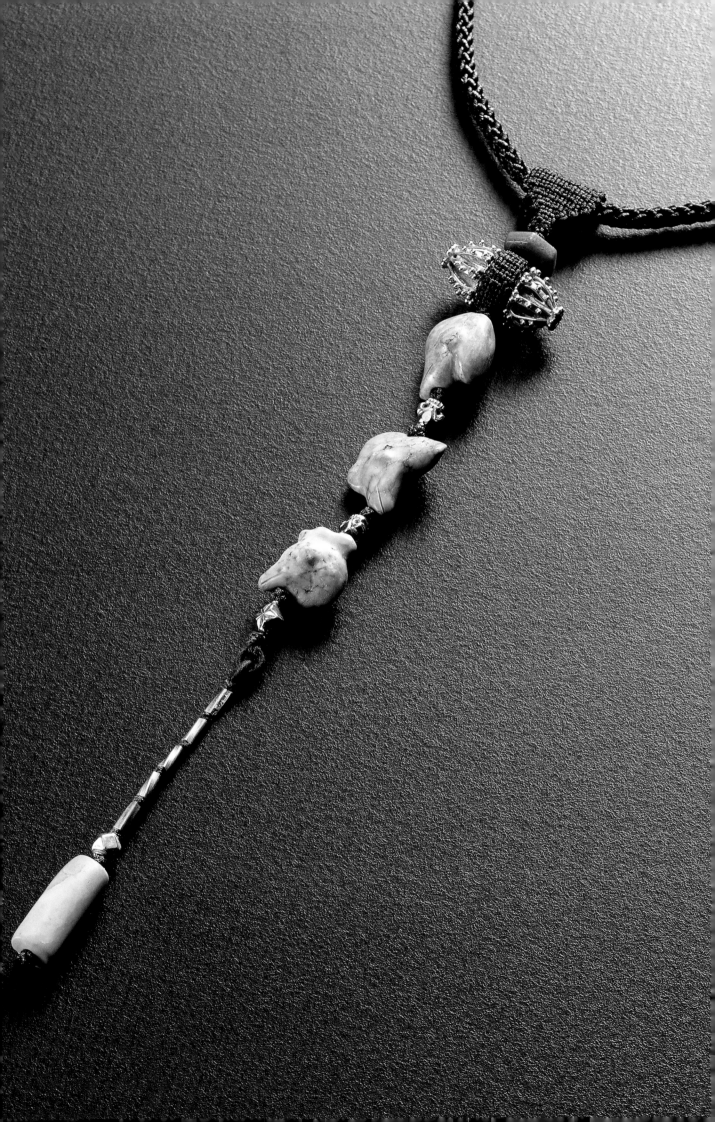

若龍而黃
auspicious fairy serpent

西漢 Western Han Dynasty (202 B.C. - 9 A.D.)

綠松石螭龍珮 turquoise serpent-shaped pendant
Length: 69mm Width: 47mm Height: 5mm

綠松石算盤珠 turquoise abacus bead
Length: 10mm Width: 10mm Height: 3mm

綠松石圓珠 turquoise round beads × 4
Length: 5mm Width: 5mm Height: 5mm

黃金三葉草形珠 golden clover beads × 6
Length: 5mm Width: 4mm Height: 2mm

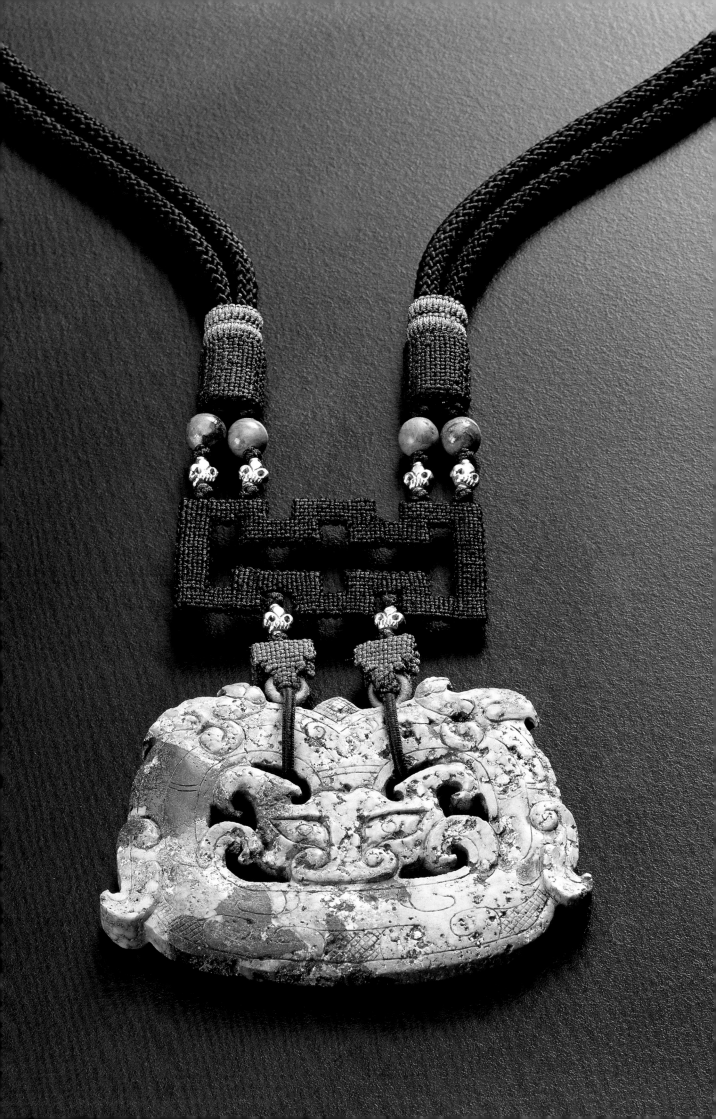

黃金珠帽 golden bead caps × 4

黃金三葉草形珠 golden clover beads × 43

珠圓玉潤
round and lustrous turquoise beads necklace

明 Ming Dynasty (1368 - 1644 A.D.)

綠松石圓珠 turquoise round beads × 43
Length: 10mm Width: 10mm Height: 10mm

黃金珠帽 golden bead caps × 4
Length: 8mm Width: 8mm Height: 5mm

黃金三葉草形珠 golden clover beads × 43
Length: 5mm Width: 4mm Height: 2mm

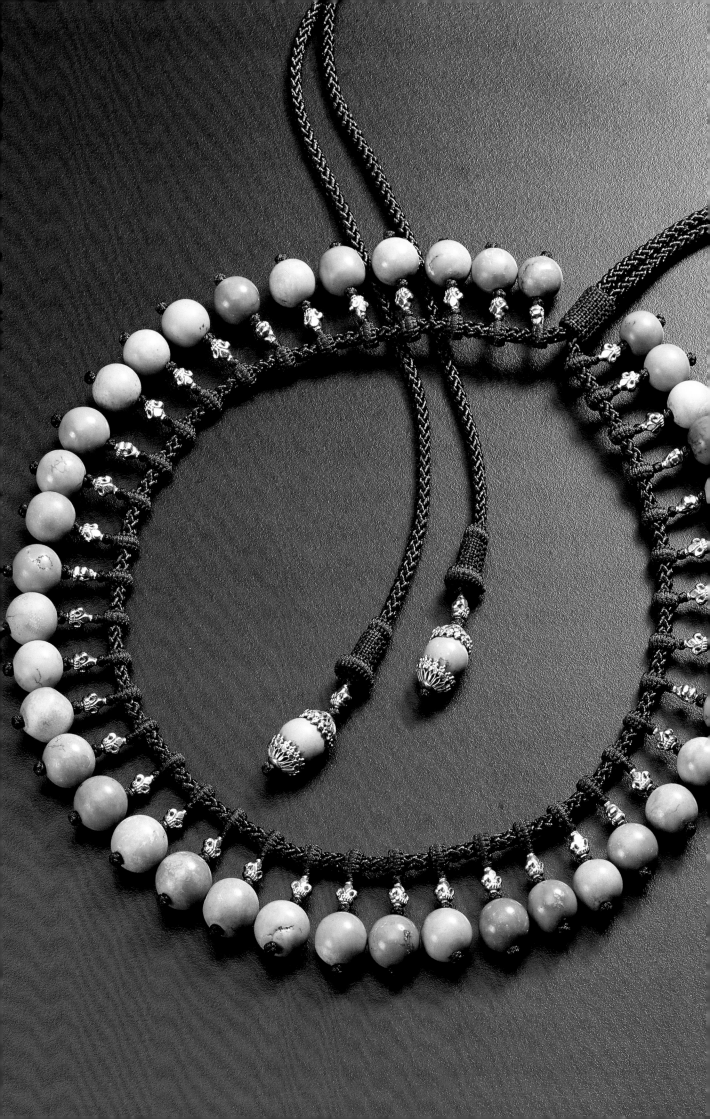

六臂文殊
six-armed manjushri

清 Qing Dynasty (1644 - 1911 A.D.)

鎏金六臂文殊像 gilt six-armed manjushri statue
Length: 29mm Width: 20mm Height: 7mm

綠松石圓珠 turquoise round beads × 10
Length: 5mm Width: 5mm Height: 5mm

黃金點圈隔珠 golden coil & dots spacer beads × 11
Length: 3mm Width: 3mm Height: 2mm

閃玉璧 a piece of flat nephrite with hole in center
Length: 19mm Width: 19mm Height: 3mm

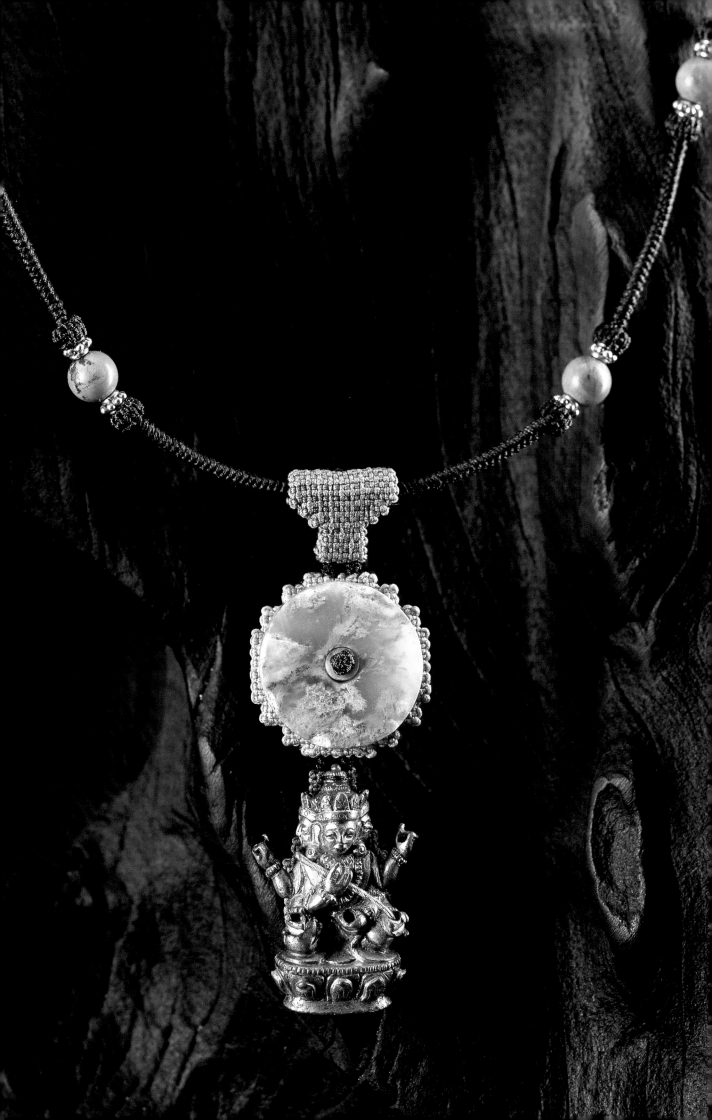

伏龜浴日
sunbathing turtle

西周 Western Zhou Dynasty (1046 - 771 B.C.)

綠松石龜形墬 turquoise turtle-shaped pendant
Length: 75mm Width: 55mm Height: 20mm

綠松石桶形珠 turquoise barrel bead
Length: 21mm Width: 21mm Height: 25mm

黃金鏤空珠 golden hollow focal beads
Length: 10mm Width:10mm Height: 10mm × 3

黃金球形珠 golden smooth round spacer bead
Length: 4mm Width: 4mm Height: 4mm

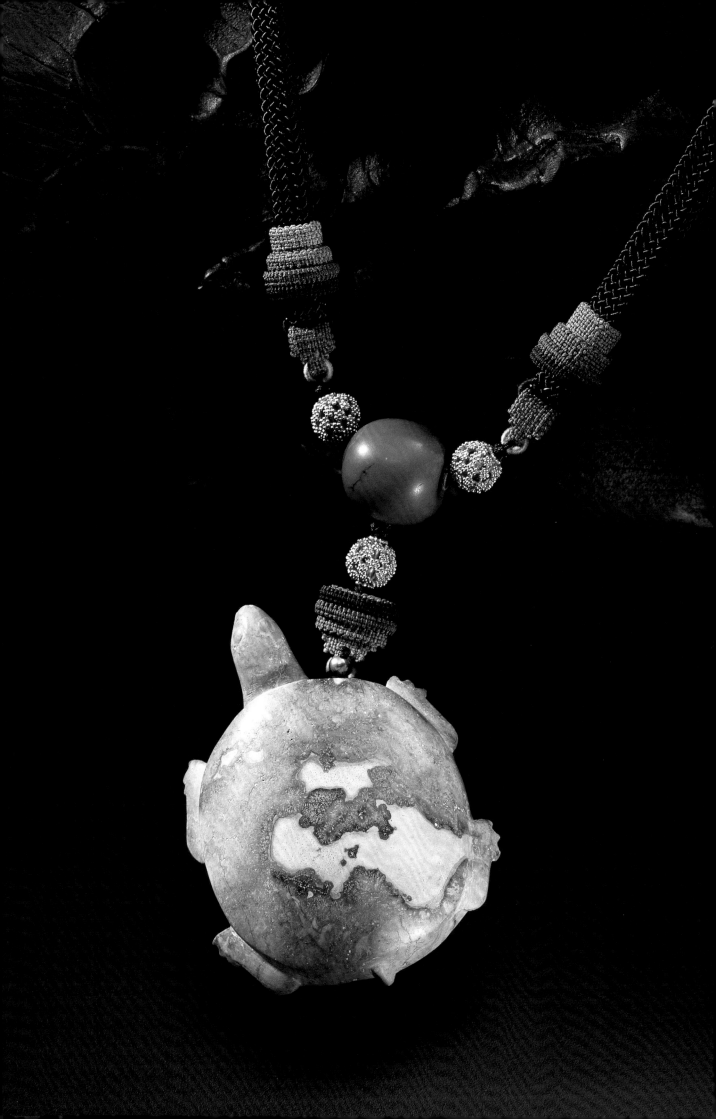

黃金點圈隔珠 golden coil & dots spacer beads × 2
Length: 3mm Width: 3mm Height: 2mm

閃玉珠 nephrite beads × 2
Length: 8mm Width: 8mm Height: 6mm

翹袖折腰
dancer

西漢 Western Han Dynasty (202 B.C. - 9 A.D.)

綠松石舞人珮 turquoise dancer pendant
Length: 56mm Width: 20mm Height: 3mm

黃金邊框 golden frame
Length: 65mm Width: 26mm Height: 5mm

黃金點圈隔珠 golden coil & dots spacer beads × 2
Length: 3mm Width: 3mm Height: 2mm

閃玉珠 nephrite beads × 2
Length: 8mm Width: 8mm Height: 6mm

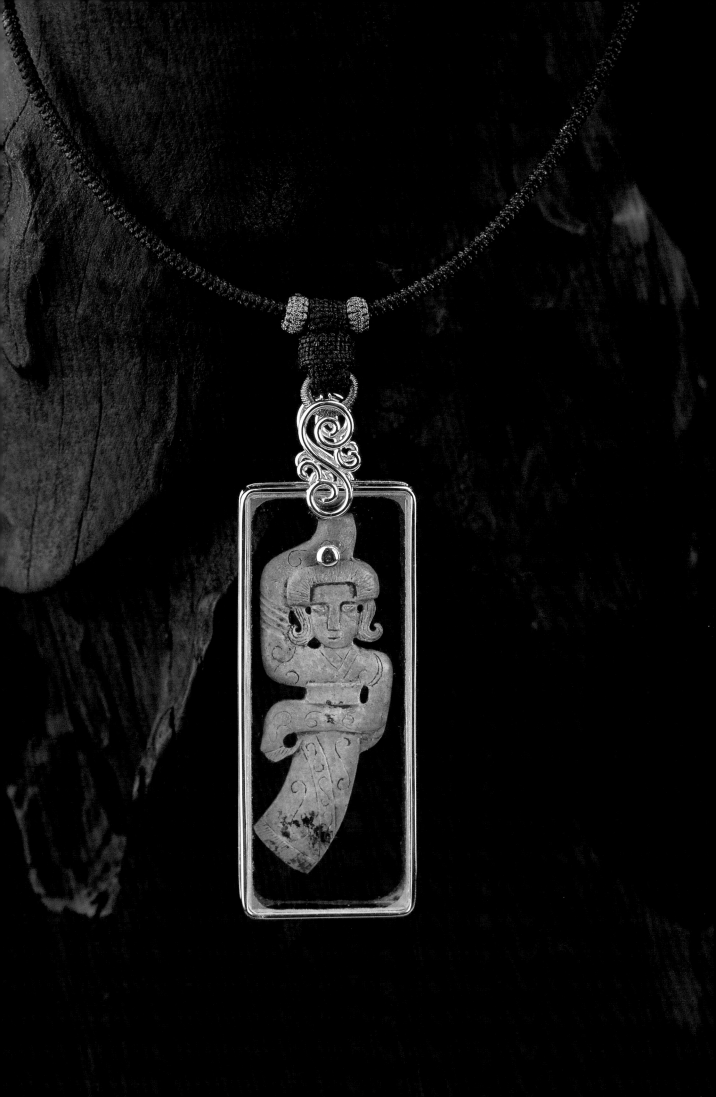

戰國粉黛
ladies in the warring states period

戰國 Warring States Period (476 - 221 B.C.)

綠松石舞人珮 turquoise dancer pendants × 2
Length: 62mm Width: 35mm Height: 5mm

綠松石算盤珠 turquoise abacus beads × 2
Length: 10mm Width: 10mm Height: 3mm

黃金管珠 golden coil & dots tube beads × 12
Length: 2mm Width: 2mm Height: 3mm

黃金圓片珠 golden disc spacer beads × 8
Length: 3mm Width: 3mm Height: 2mm

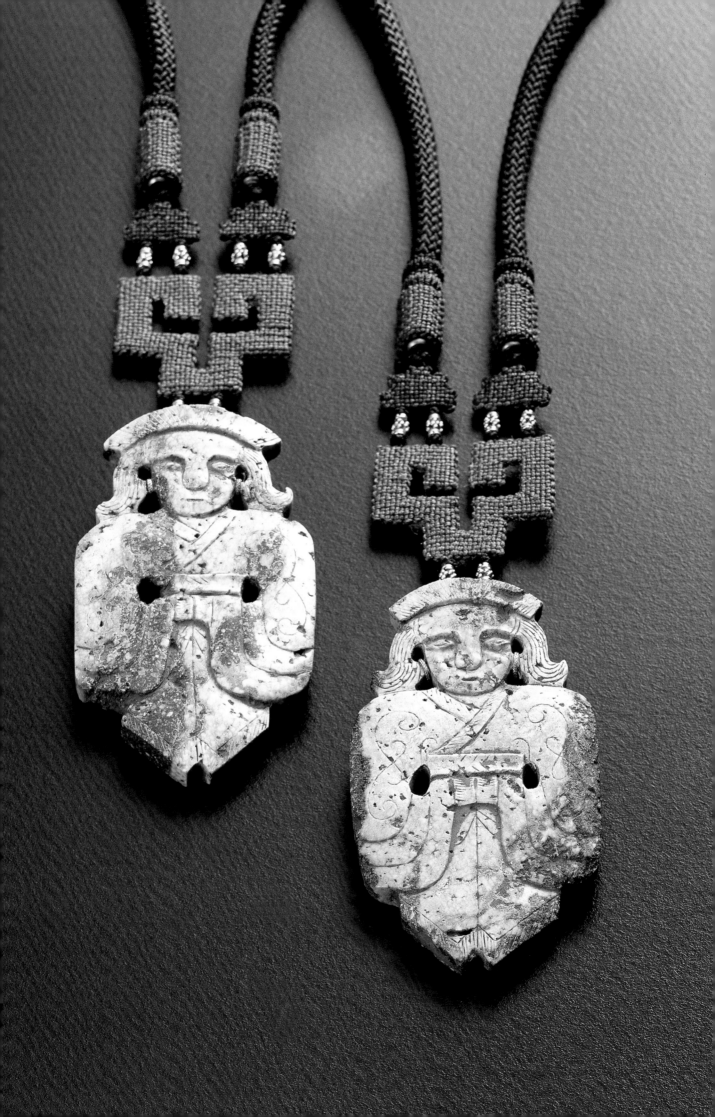

鳳凰于飛
a pair of flying phoenixes
西漢 Western Han Dynasty (202 B.C. - 9 A.D.)

綠松石鳳形珮 turquoise phoenix-shaped pendants × 2
Length: 30mm Width: 27mm Height: 5mm

綠松石算盤珠 turquoise abacus beads × 2
Length: 10mm Width: 10mm Height: 3mm

黃金點圈隔珠 golden coil & dots spacer beads × 16
Length: 3mm Width: 3mm Height: 2mm

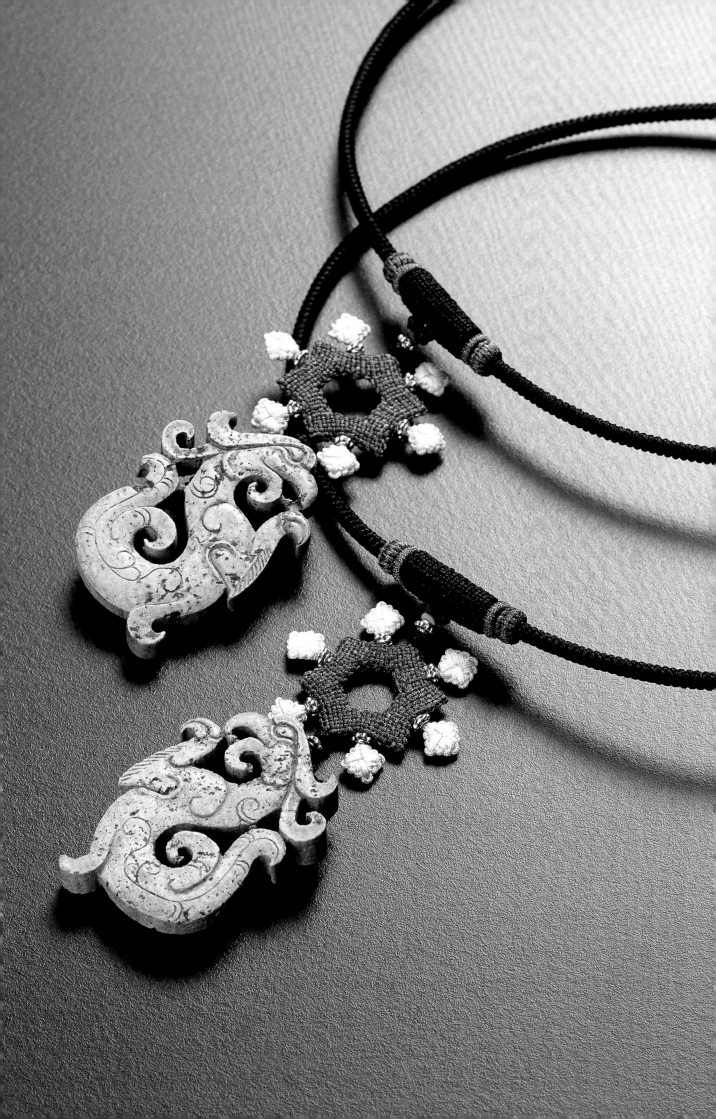

雙龍出海
a pair of dragons

西漢 Western Han Dynasty (202 B.C. - 9 A.D.)

綠松石龍形珮 turquoise dragon-shaped pendants × 2
Length: 55mm Width: 40mm Height: 5mm

綠松石算盤珠 turquoise abacus beads × 2
Length: 10mm Width: 10mm Height: 3mm

黃金點圈隔珠 golden coil & dots spacer beads × 40
Length: 3mm Width: 3mm Height: 2mm

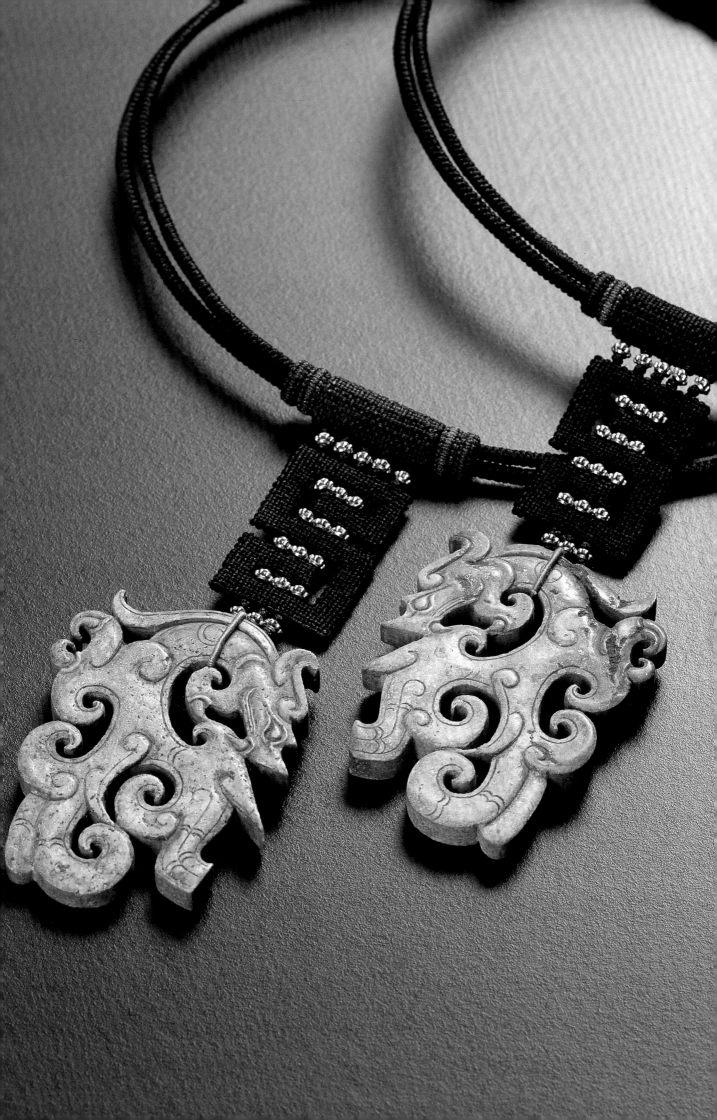

王者氣概
king of dragon

西漢 Western Han Dynasty (202 B.C. - 9 A.D.)

綠松石應龍珮 turquoise winged dragon pendant
Length: 62mm Width: 36mm Height: 5mm

綠松石橢圓珠 turquoise oval beads × 4
Length: 5mm Width: 5mm Height: 7mm

綠松石算盤珠 turquoise abacus bead
Length: 10mm Width: 10mm Height: 3mm

黃金點圈隔珠 golden coil & dots spacer beads × 10
Length: 3mm Width: 3mm Height: 2mm

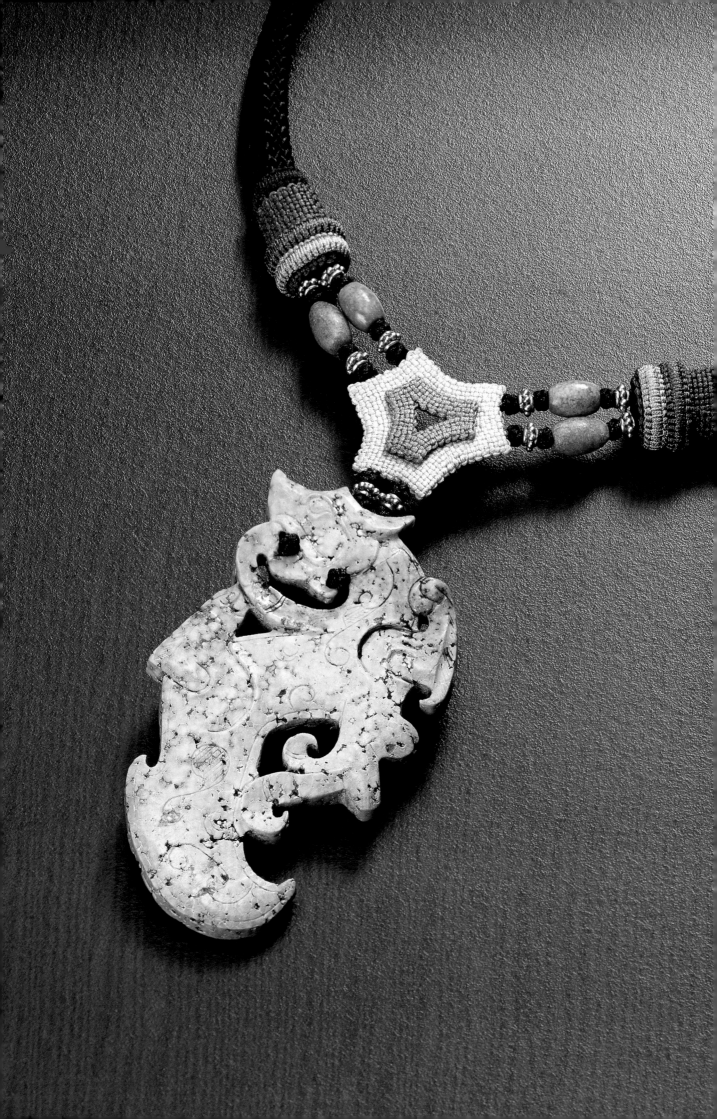

衣錦榮歸
turtle; metaphor for honor retirement

商 Shang Dynasty (c. 1700 - 1046 B.C.)

綠松石龜形墜 turquoise turtle-shaped pendant
Length: 40mm Width: 27mm Height: 6mm

綠松石牛形墜 turquoise buffalo-shaped pendant
Length: 40mm Width: 23mm Height: 18mm

黃金圈緣隔珠 golden coil edge spacer beads × 3
Length: 3mm Width: 3mm Height: 4mm

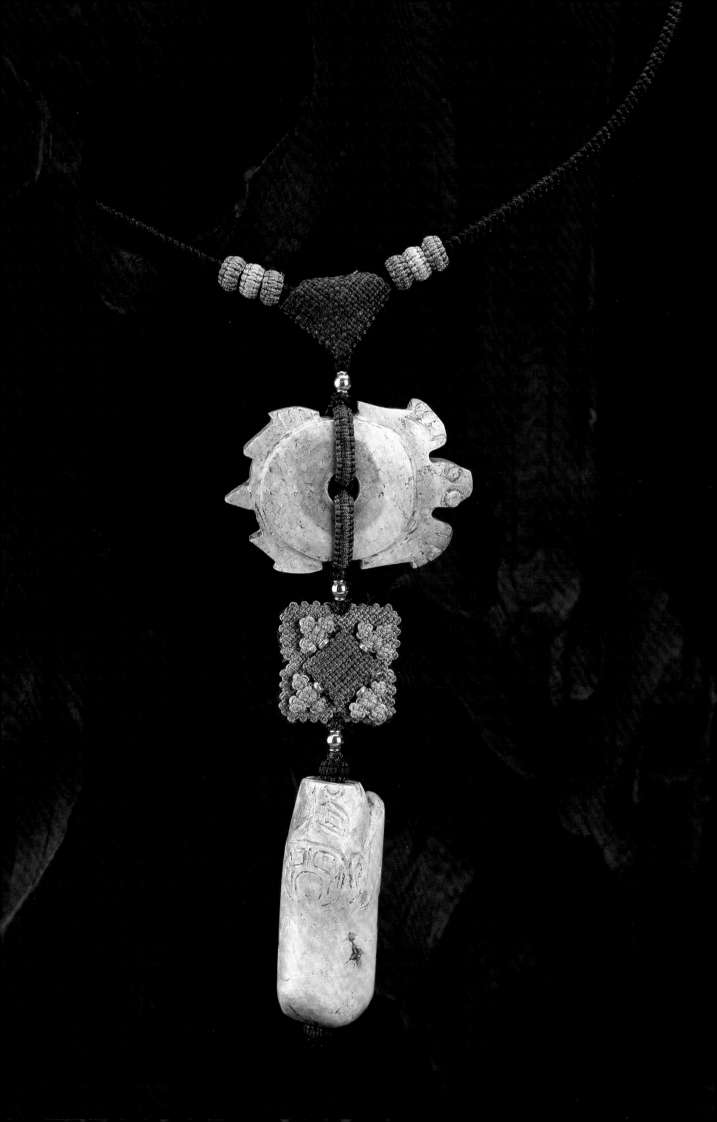

金璧交輝
the magnificent jade treasure

西周 Western Zhou Dynasty (1046 - 771 B.C.)

綠松石璧 a piece of flat turquoise with hole in center × 12
Length: 19mm Width: 19mm Height: 3mm

黃金花式組件 golden fancy connectors × 15
Length: 16mm Width: 10mm Height: 1mm

黃金點圈隔珠 golden coil & dots spacer beads × 25
Length: 3mm Width: 3mm Height: 2mm

瑪瑙珠 agate beads × 13
Length: 8mm Width: 8mm Height: 6mm

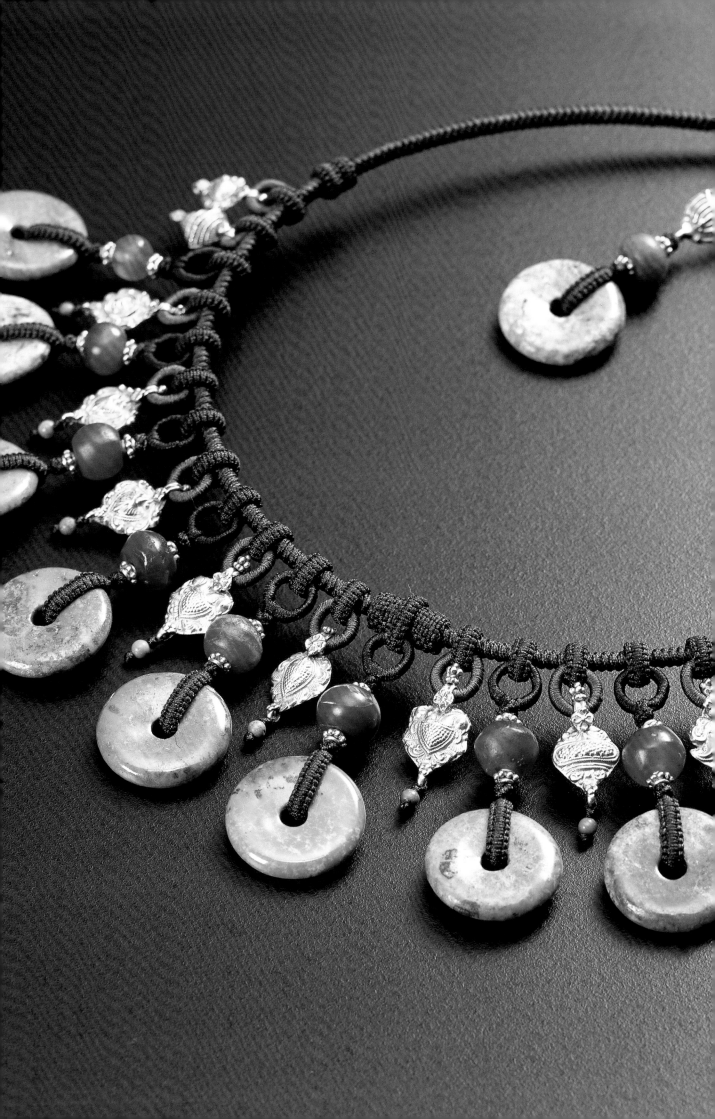

關關雎鳩
choiring pigeon

西周 Western Zhou Dynasty (1046 - 771 B.C.)

綠松石鳩形墜 turquoise pigeon-shaped pendants × 4
Length: 18mm Width: 15mm Height: 5mm
Length: 22mm Width: 15mm Height: 6mm
Length: 22mm Width: 15mm Height: 6mm
Length: 26mm Width: 16mm Height: 7mm

綠松石橢圓珠 turquoise oval beads × 5
Length: 5mm Width: 5mm Height: 7mm

黃金三葉草形珠 golden clover beads × 4
Length: 5mm Width: 4mm Height: 2mm

黃金圈緣隔珠 golden coil edge spacer beads × 5
Length: 3mm Width: 3mm Height: 4mm

黃金圓片珠 golden disc spacer beads × 5
Length: 3mm Width: 3mm Height: 2mm

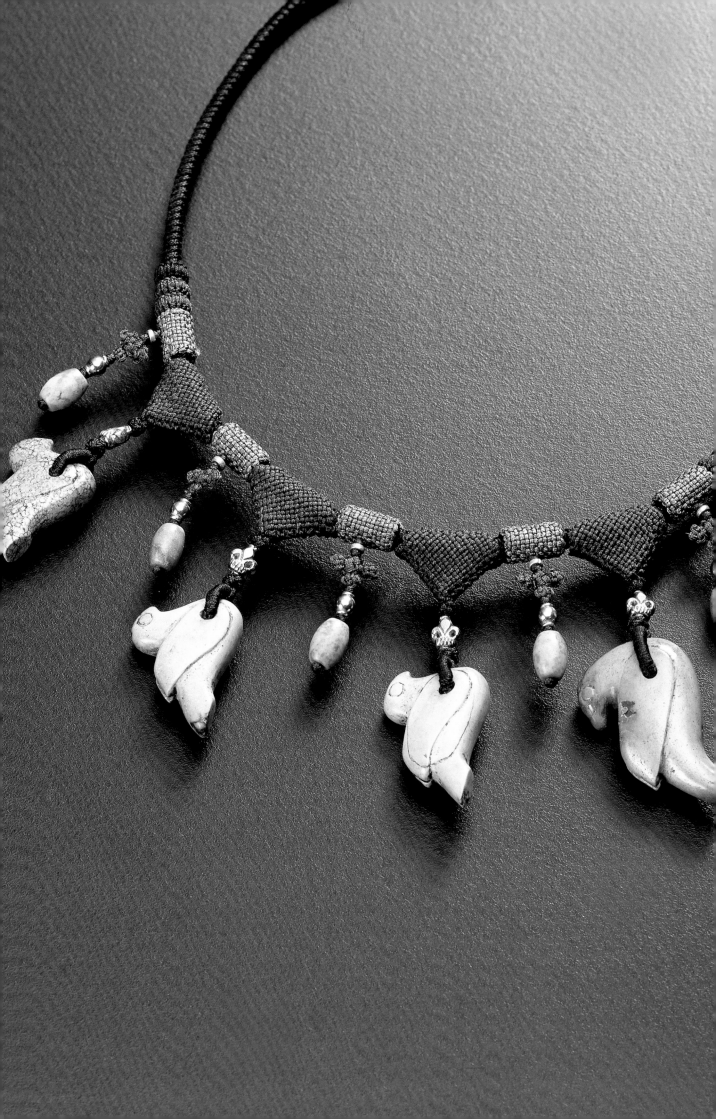

仲夏鳴蟬
tweeting cicadas

商 Shang Dynasty (c. 1700 - 1046 B.C.)

綠松石蟬形墜 turquoise cicada-shaped pendants × 5
Length: 32mm Width: 12mm Height: 6mm
Length: 33mm Width: 13mm Height: 6mm
Length: 43mm Width: 15mm Height: 8mm
Length: 38mm Width: 14mm Height: 8mm
Length: 30mm Width: 12mm Height: 6mm

黃金圈形珠 golden donut spacer beads × 5
Length: 5mm Width: 5mm Height: 4mm

黃金雙尖珠 golden bicone beads × 4
Length: 3mm Width: 3mm Height: 8mm

黃金珠帽 golden bead caps × 10
Length: 4mm Width: 4mm Height: 2mm

黃金點圈隔珠 golden coil & dots spacer beads × 2
Length: 3mm Width: 3mm Height: 2mm

琥珀桶形珠 amber barrel beads × 6
Length: 9mm Width: 9mm Height: 10mm

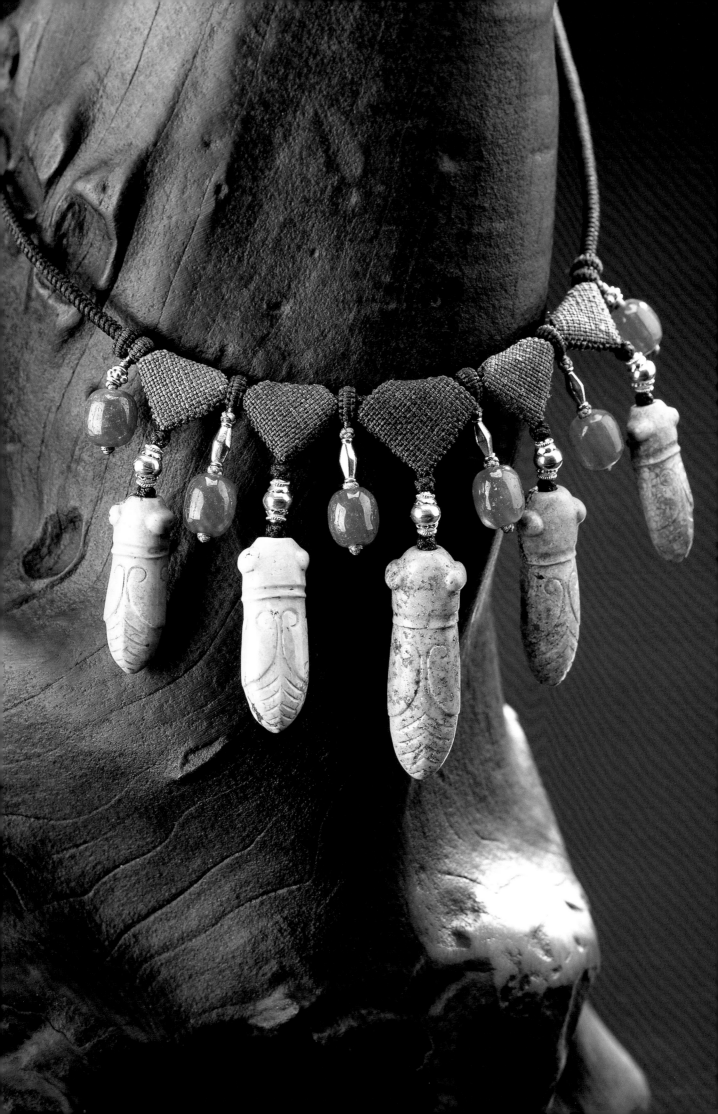

力作勤耕
plowing buffalo

西周 Western Zhou Dynasty (1046 - 771 B.C.)

綠松石牛形墜 turquoise buffalo-shaped pendant
Length: 42mm Width: 25mm Height: 20mm

綠松石牛首墜 turquoise buffalo head pendant
Length: 28mm Width: 22mm Height: 16mm

綠松石算盤珠 turquoise abacus bead
Length: 10mm Width: 10mm Height: 3mm

黃金珠帽 golden bead caps × 8
Length: 8mm Width: 8mm Height: 5mm

珊瑚珠 coral beads × 4
Length: 8mm Width: 8mm Height: 10mm

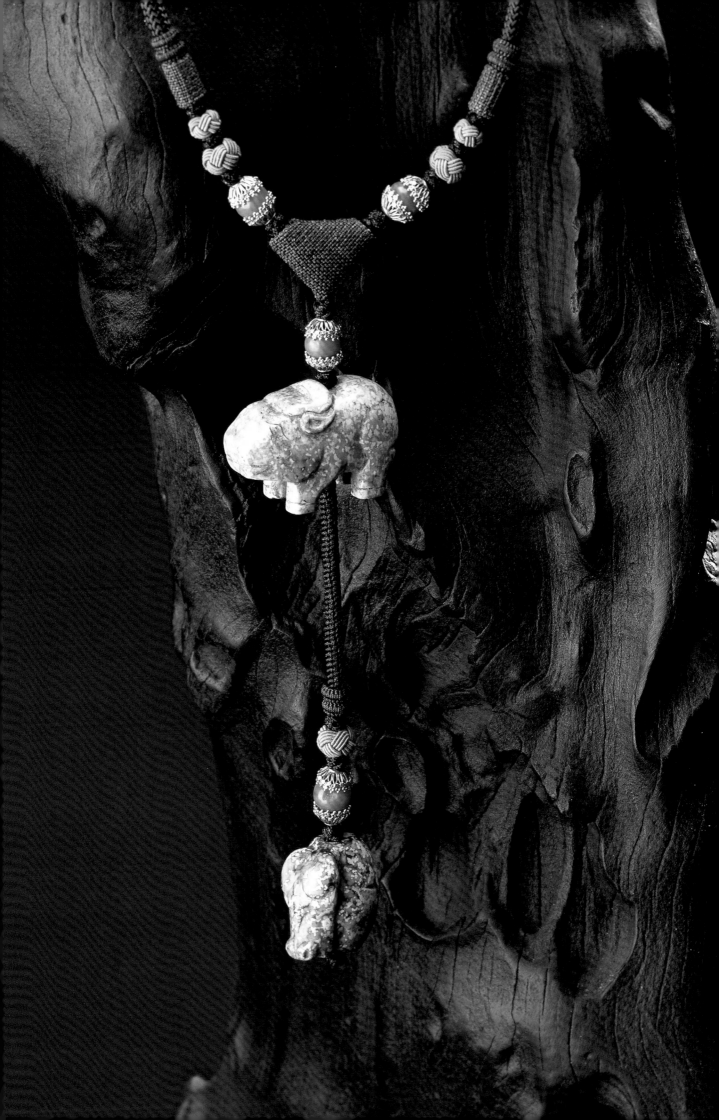

飛龍在天
dragon ascending towards the sky

西漢 Western Han Dynasty (202 B.C. - 9 A.D.)

綠松石龍形珮 turquoise dragon-shaped pendant
Length: 52mm Width: 33mm Height: 6mm

綠松石算盤珠 turquoise abacus bead
Length: 10mm Width: 10mm Height: 3mm

黃金點圈隔珠 golden coil & dots spacer beads × 10
Length: 3mm Width: 3mm Height: 2mm

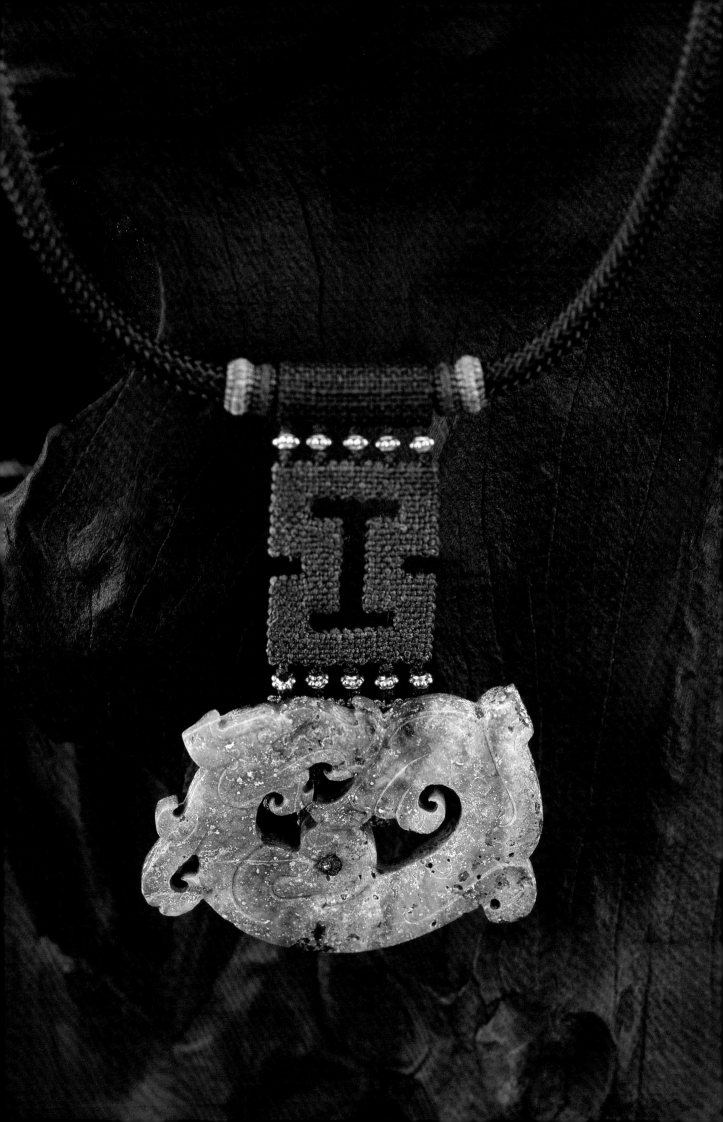

山獸之君
king of beasts

戰國 Warring States Period (476 - 221 B.C.)

綠松石虎形珮 turquoise tiger-shaped pendant
Length: 53mm Width: 30mm Height: 5mm

黃金點圈隔珠 golden coil & dots spacer bead
Length: 3mm Width: 3mm Height: 2mm

黃金擋珠 golden crimp beads × 8
Length: 2mm Width: 2mm Height: 1mm

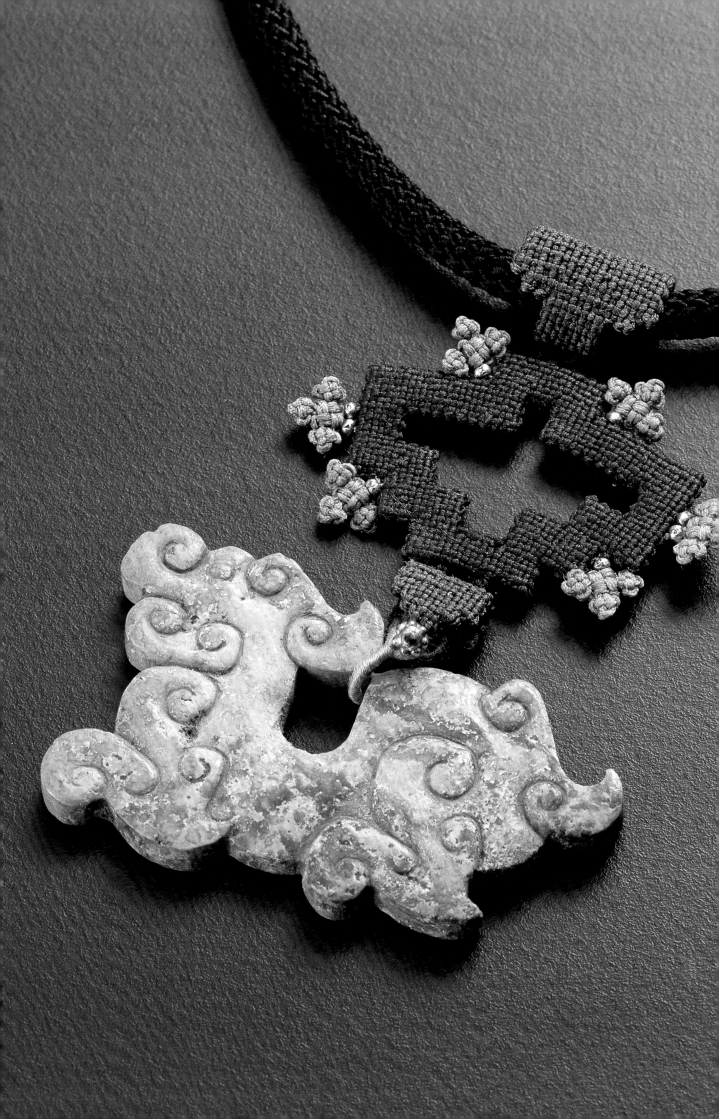

此情不渝
cicada; endless love

商 Shang Dynasty (c. 1700 - 1046 B.C.)

綠松石蟬形墜 turquoise cicada-shaped pendants × 2
Length: 42mm Width: 13mm Height: 9mm
Length: 48mm Width: 14mm Height: 7mm

黃金魚形招絲組件 golden fish filigree connectors × 2
Length: 32mm Width: 32mm Height: 4mm
Length: 32mm Width: 32mm Height: 4mm

黃金華飾隔珠 golden ornate spacer beads × 2
Length: 4mm Width: 4mm Height: 5mm

瑪瑙珠 agate bead
Length: 10mm Width: 10mm Height: 6mm

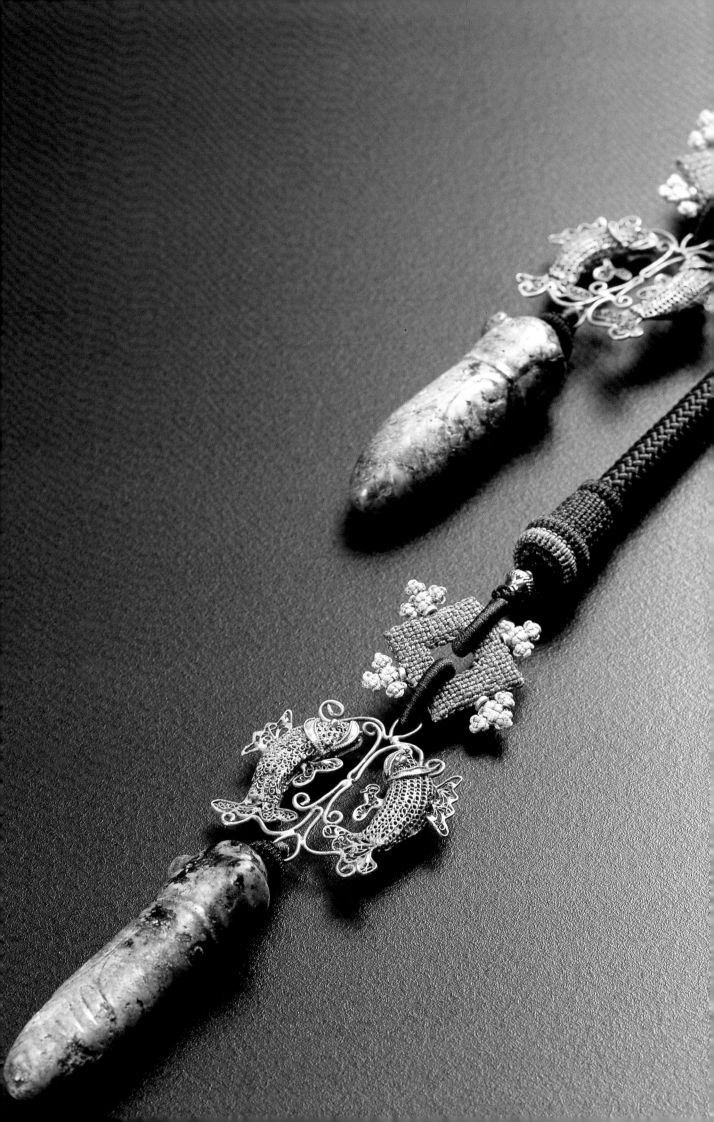

蛟龍得水
serpent into the water

商 Shang Dynasty (c. 1700 - 1046 B.C.)

綠松石蛟形墜 turquoise serpent-shaped pendant
Length: 35mm Width: 12mm Height: 8mm

綠松石橢圓珠 turquoise oval beads × 29
Length: 5mm Width: 5mm Height: 7mm

黃金管珠 golden coil & dots tube beads × 29
Length: 2mm Width: 2mm Height: 3mm

黃金點圈隔珠 golden coil & dots spacer bead × 29
Length: 3mm Width: 3mm Height: 2mm

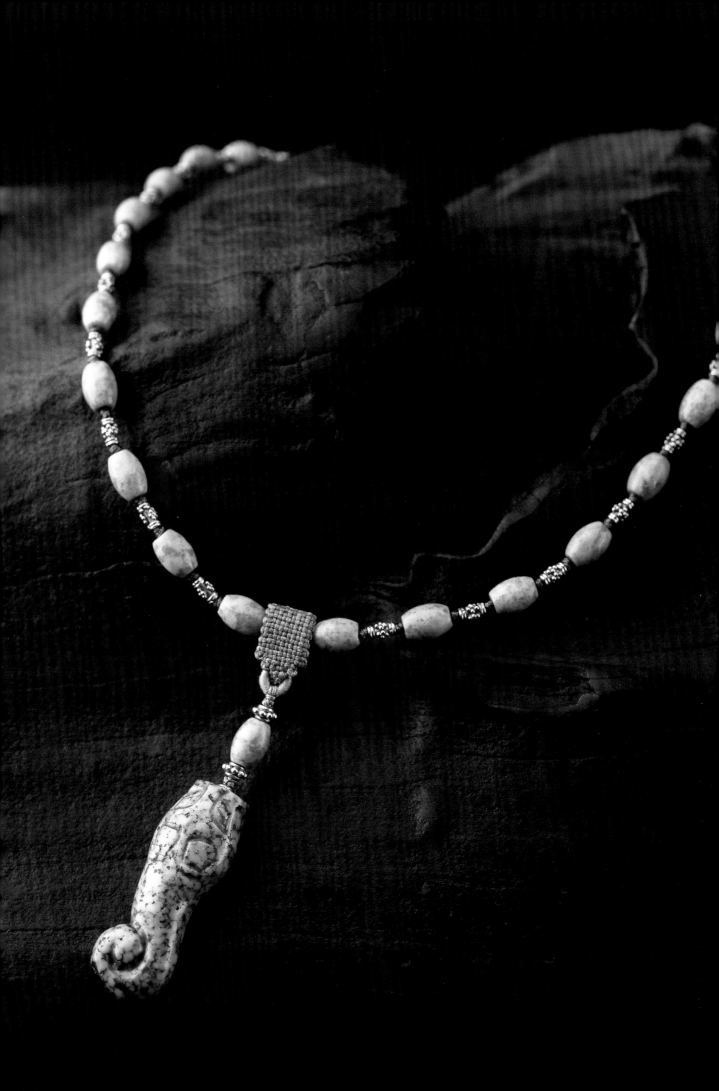

扭轉乾坤
buffalo; turn things around

商 Shang Dynasty (c. 1700 - 1046 B.C.)

綠松石牛首墜 turquoise buffalo head pendant
Length: 20mm Width: 20mm Height: 15mm

黃金珠帽 golden bead caps × 2
Length: 6mm Width: 6mm Height: 2mm

黃金繩紋珠 golden rope beads × 6
Length: 4mm Width: 4mm Height: 2mm

閃玉圓珠 nephrite round bead
Length: 10mm Width: 10mm Height: 10mm

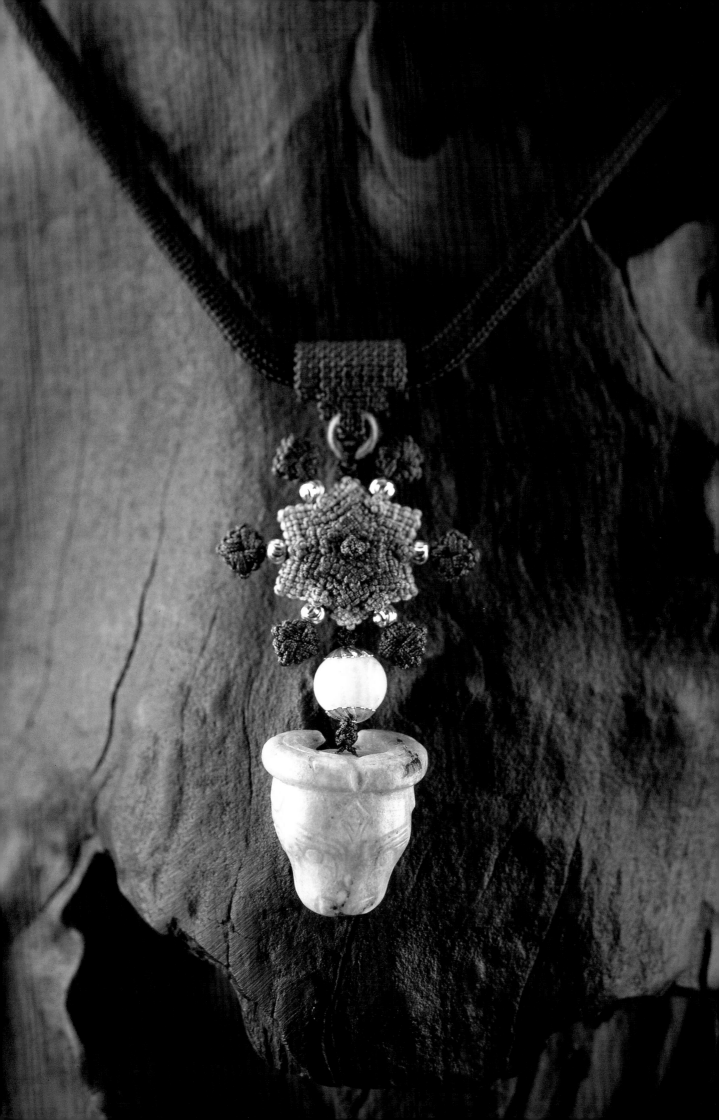

嫦娥仙侶
Chang-O's bunny friend

商 Shang Dynasty (c. 1700 - 1046 B.C.)

綠松石兔形墜 turquoise hare-shaped pendant
Length: 35mm Width: 17mm Height: 7mm

黃金珠帽 golden bead caps × 8
Length: 6mm Width: 6mm Height: 2mm

瑪瑙圓珠 agate round beads × 4
Length: 5mm Width: 5mm Height: 5mm

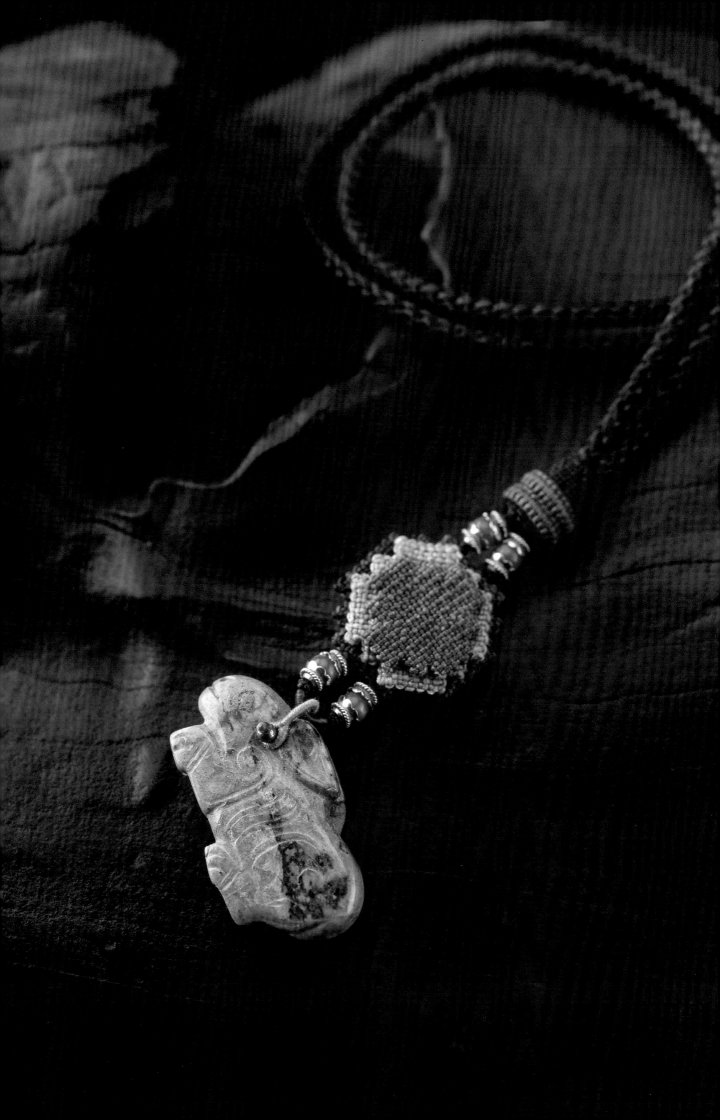

虎兕出柙
tiger out of its cage

商 Shang Dynasty (c. 1700 - 1046 B.C.)

綠松石虎形墜 turquoise tiger-shaped pendant
Length: 38mm Width: 12mm Height: 10mm

黃金冠形珠 golden crown bead
Length: 10mm Width: 10mm Height: 20mm

黃金擋珠 golden crimp beads × 8
Length: 2mm Width: 2mm Height: 1mm

黃金繩紋珠 golden rope beads × 2
Length: 4mm Width: 4mm Height: 2mm

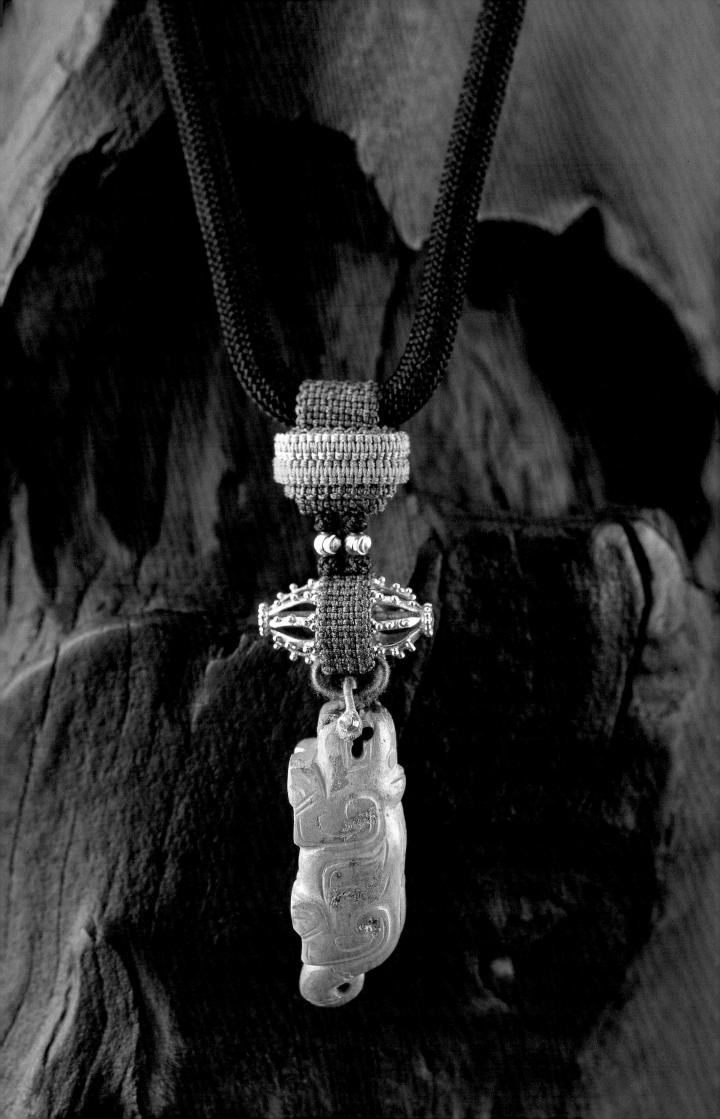

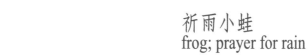

祈雨小蛙
frog; prayer for rain

商 Shang Dynasty (c. 1700 - 1046 B.C.)

綠松石蛙形墜 turquoise frog-shaped pendant
Length: 24mm Width: 20mm Height: 8mm

黃金冠形珠 golden crown bead
Length: 10mm Width: 10mm Height: 20mm

黃金繩紋珠 golden rope bead
Length: 4mm Width: 4mm Height: 2mm

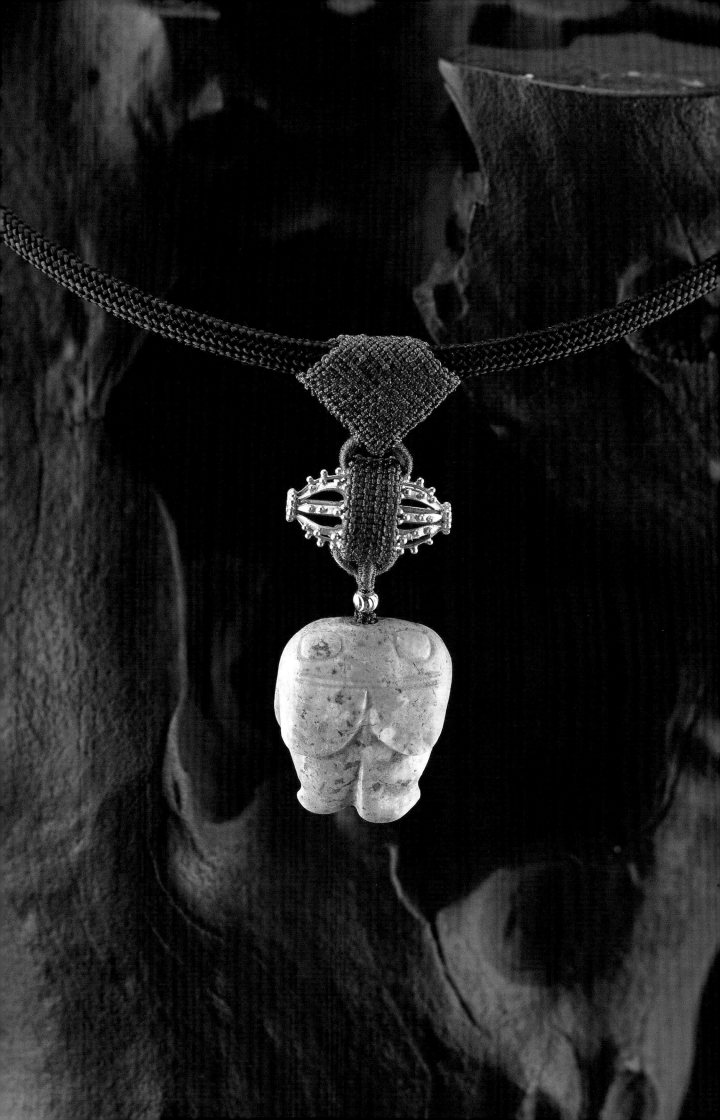

耕罷稍歇
resting buffalo

商 Shang Dynasty (c. 1700 - 1046 B.C.)

綠松石牛形墜 turquoise buffalo-shaped pendant
Length: 60mm Width: 48mm Height: 30mm

黃金雙尖凹槽珠 golden fluted bicone Bead
Length: 12mm Width: 12mm Height: 10mm

黃金擋珠 golden crimp bead
Length: 2mm Width: 2mm Height: 1mm

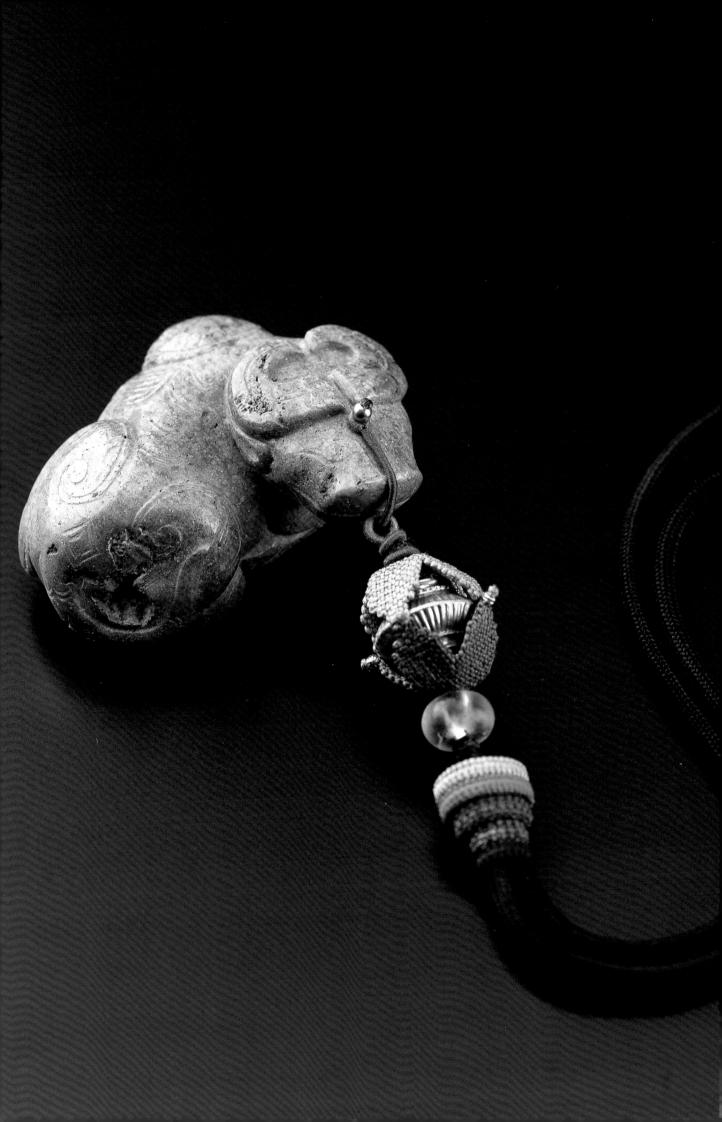

如意狻猊
ancient lions
明 Ming Dynasty (1368 - 1644 A.D.)

綠松石獅形把件 turquoise lion-shaped ornament
Length: 55mm Width: 35mm Height: 30mm

黃金珠帽 golden bead caps ×2
Length: 6mm Width: 6mm Height: 2mm

黃金繩紋珠 golden rope beads × 3
Length: 4mm Width: 4mm Height: 2mm

瑪瑙環 agate loop
Length: 30mm Width: 30mm Height: 3mm

閃玉圓珠 nephrite round bead
Length: 10mm Width: 10mm Height: 10mm

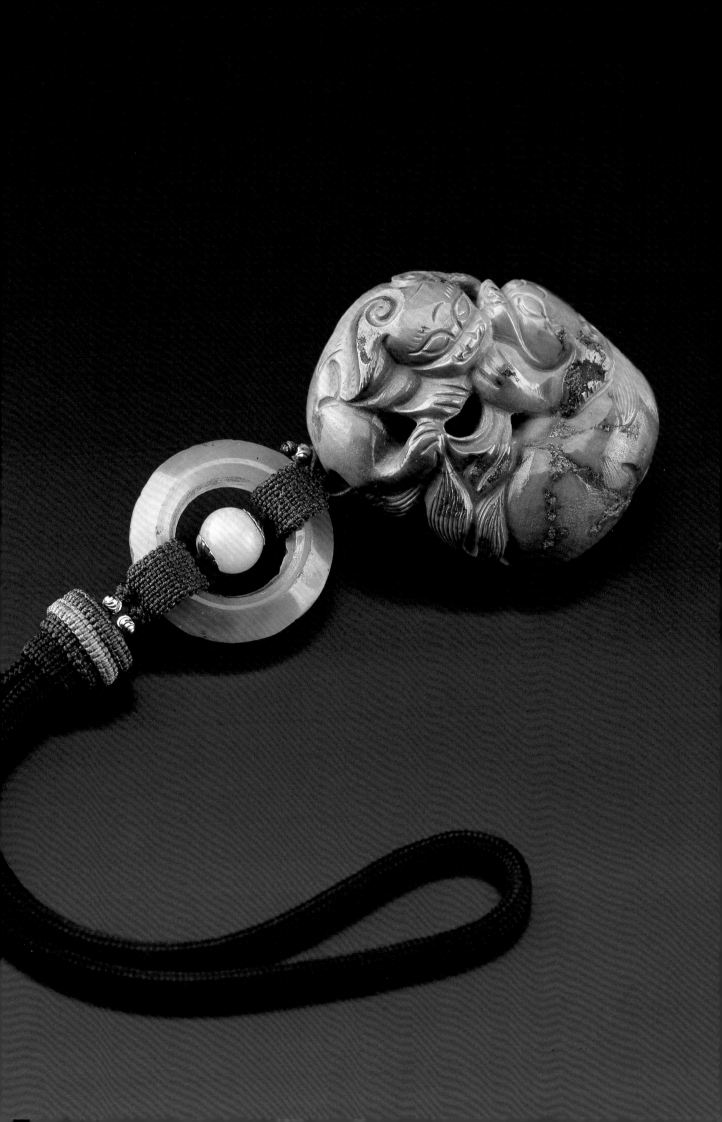

虎體元斑
tigers; like father, like son

商 Shang Dynasty (c. 1700 - 1046 B.C.)

綠松石虎形墬 turquoise tiger-shaped pendant
Length: 48mm Width: 32mm Height: 13mm

黃金繩紋珠 golden rope beads × 3
Length: 4mm Width: 4mm Height: 2mm

鐵質工字型扣 ironware H-shaped ouch; connector
Length: 33mm Width: 33mm Height: 5mm

閃玉珠 nephrite bead
Length: 12mm Width: 12mm Height: 6mm

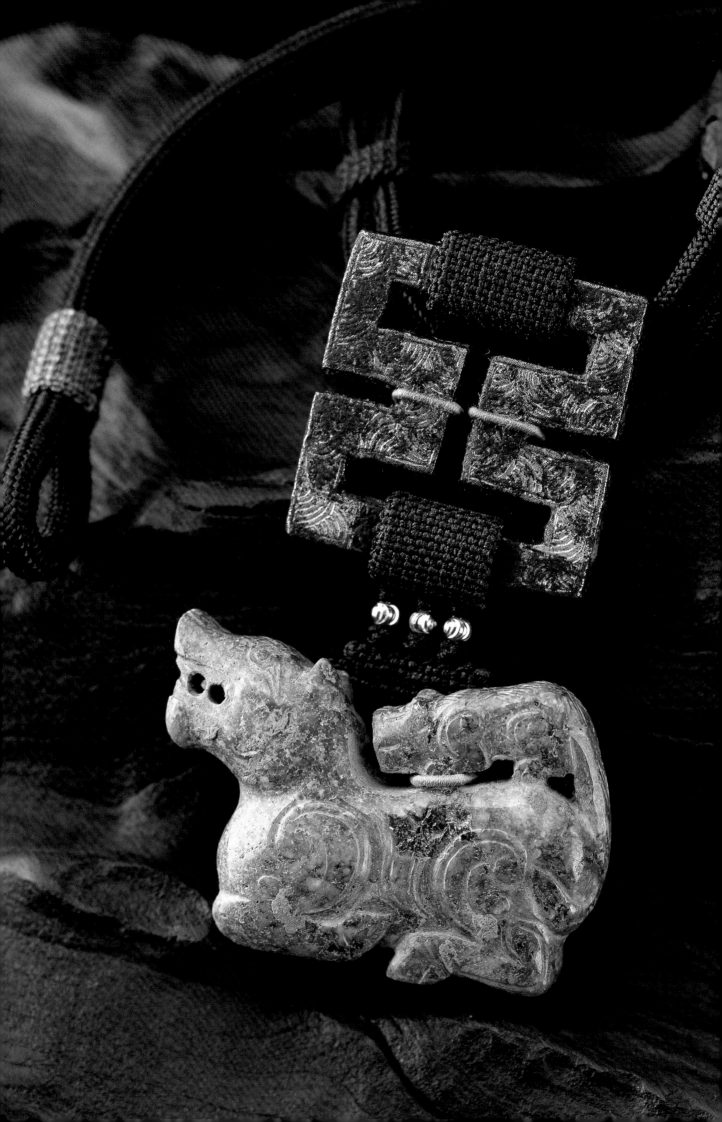

耄耋龜年
turtle; metaphor for longevity
西周 Western Zhou Dynasty (1046 - 771 B.C.)

綠松石龜形墜 turquoise turtle-shaped pendant
Length: 60mm Width: 32mm Height: 10mm

黃金繩紋珠 golden rope beads × 4
Length: 4mm Width: 4mm Height: 2mm

黃金擋珠 golden crimp beads × 2
Length: 2mm Width: 2mm Height: 1mm

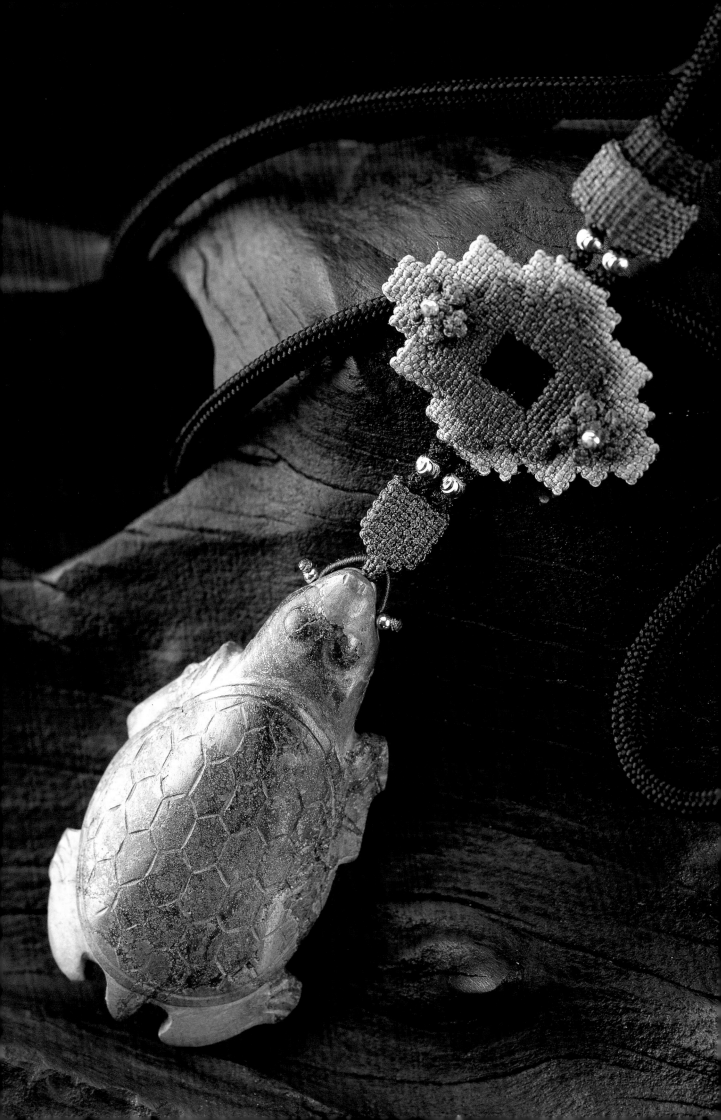

饕餮奇獸
a mythical ferocious animal

商 Shang Dynasty (c. 1700 - 1046 B.C.)

綠松石獸面墜 turquoise animal totem pendants × 3
Length: 24mm Width: 14mm Height: 4mm
Length: 25mm Width: 13mm Height: 4mm
Length: 23mm Width: 14mm Height: 5mm

綠松石算盤珠 turquoise abacus bead
Length: 10mm Width: 10mm Height: 3mm

綠松石圓珠 turquoise round beads × 74
Length: 5mm Width: 5mm Height: 5mm

黃金花式組件 golden fancy connectors × 3
Length: 16mm Width: 10mm Height: 1mm

黃金圈緣隔珠 golden coil edge spacer beads × 14
Length: 3mm Width: 3mm Height: 4mm

黃金點圈隔珠 golden coil & dots spacer bead × 5
Length: 3mm Width: 3mm Height: 2mm

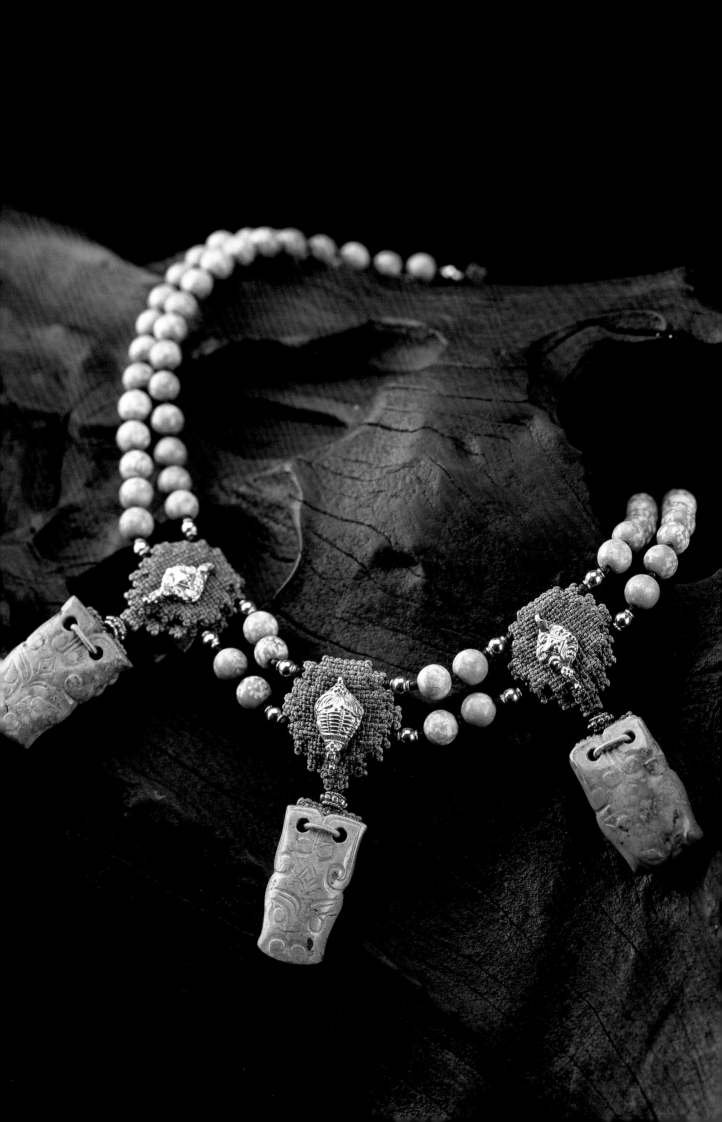

器型舉隅

Glossary on Chinese Ancient Utensils

I.蟬形器

先民將蟬視為「復活和永生」的象徵，源自於它的生命週期：幼蟲孵出後，隨即鑽入地下吸食植物根部的汁液維生，經歷四次化蛹蛻皮後，在傍晚時分破土而出，憑藉本能攀爬至可附著之處，抓牢後，開始最終的成蟲羽化。

蟬形器的選用可追溯至新石器時代，商代至戰國墓葬中常有出土，大多是懸掛佩帶用的裝飾。蟬體扁平，中厚邊薄，眼目突出兩側，口器分明，陰線刻劃兩翅，腹部有弧形內凹的橫紋，頭部有一繫孔。作為隨葬的主要器物的口含（無穿繩之孔），最早見於河南洛陽中州路816號西周早期墓，其後未見流行，直至漢代才發展成為普遍的風俗並持續到魏晉南北朝。

東晉·葛洪於《抱朴子·對俗》謂之：「金石在九竅，則死人為之不朽。」這種思想實際上是時人「超脫昇華」的心理過程（生者辟邪、死者護屍，甚至食之可以成仙得道），不可避免地摻入了難以言喻的玄奧內容。是故，盛行用玉石雕琢具有護符意義的琀蟬，冀望死者魂魄脫離軀殼後，來日靈神蛻變重生。

II.蠶形器

蠶，原產中國北部，以桑葉作為主食，是絲綢原料的主要來源。中國人工養蠶的歷史已可遠溯三千年前，在人類經濟生活和文化進向上有著舉足輕重的地位。幼蟲的食欲十分旺盛，晝夜不停地嚼吃桑葉，故生長速度驚人。當進入下個齡期，約有一整天的時間，會如睡眠般的不吃也不動，稱作「休眠」。體內進行準備後始有蛻皮動作，從蟻蠶到五齡熟蠶吐絲結繭，共需歷經四次。約等待十天，羽化成為蠶蛾。

由產卵到孵化，至結繭再化蛾，幼蟲與成蟲在形態結構及生長習性上迥然異趣，此一迴圈過程，即為昆蟲的「完全變態發育」。先秦時期，戰事頻仍且醫藥未濟，華夏先民的平均壽命略低於二十五歲，自然對展延壽元抱持莫大的渴望。藉由觀察周遭微小昆蟲的盛衰歷程中，衍生出不可名狀的企盼，雖無法逃避死亡，但仍存有一絲遐想，得到某種神秘的力量來轉化生命模式。

III.螽斯形器

昆蟲，別名「蟈蟈」，扁圓柱狀，體長逾寸，綠褐色，翅短厚，絲狀觸角，後肢節足十分發達。雄蟲前翅具發音器，能顫翅銼鳴，響聲類金屬感，較蟋蟀更為尖銳、刺耳，鴻音或可遠傳一、兩百公尺。成蟲屬雜食性，肉食性強於植食性，對農作物造成程度不一的危害。夏季常見

於草叢、矮樹、灌木叢中，善於跳躍不易捕捉。

原始社會末期開啓了蟲斯崇拜的先河，《說文解字》纂輯：「禹，蟲也。」《爾雅·釋蟲》又載明：「國貉，蟲蟄。」清·郝懿行義疏：「螽蟲即蟲螽，螽猶蟄也，言之聲響也。」夏禹是藉以禹蟲—蟋蟀來命名的，氏族之圖騰亦源自於此。西漢·揚雄《法言·重黎》敘致：「昔者姒氏治水土，而巫步多禹」，即是釋述進行禱祭時之舞蹈近似蟲斯那樣的跳步。

每頭雌蟲一生產卵約兩百至四百枚，故《毛詩·周南·螽斯序》贊曰：「后妃子孫衆多也，言若螽斯不妒忌，則子孫衆多也。」通篇文字都在歌頌螽斯的族類興旺，是生產力低下時對血脈繁育的殷求。

IV.魚形器

魚類是原始社會重要的蛋白質來源之一，同時具有出游從容與繁衍多產的美意象徵。佩魚之風始見於商代，墓葬遺址出土諸多小型片狀魚形雕件，嘴部帶孔，尾端有長樺，似刻刀，推估是隨身攜帶的工具。

東漢·辛氏《三秦記》曰：「河津，一名龍門，水險不通，魚鱉之屬莫能上，江海大魚薄集龍門下數千，不得上，上則為龍也。」為最早「魚化成龍」的文字記載，據此或可推論「魚躍龍門」的民間傳說約莫在西漢初期才逐步形成。鱘魚為繁衍後代會逆水上朔形成跳躍的群體，借以喻人舉業成功或地位高升。

V.蛙形器

蛙，無尾的兩棲動物，前肢短，後足長，趾間有蹼，擅於跳躍和泅水。具冬眠行為，卵生，繁殖時間約在每年四月中下旬，依種類不同，所產卵數由幾百至數千枚。由於皮膚裸露，難以有效地防止體內水分的散發，大部分生活在熱帶和溫帶多雨的陰濕地區，以昆蟲、小型節肢動物或蠕蟲為主食，益於農事。

原始先民將蛙類多產與人類的繁育聯繫起來，作為一種生殖崇拜的原始信仰。又關注到蛙鳴和節氣有著莫名的契合，透過「青蛙叫，暴雨到」的自然現象，視蛙類為司水喚雨的神靈。新石器時期，黃土高原上古羌人的蛙形圖騰，業已見於的彩繪陶器及雕塑中。「蛙」與「媧」兩字諧音，無論是母系氏族的首領表記，或是部落始祖的集合概念，皆是華夏文化的源頭之一。

VI. 龜形器

龜，屬半水棲、半陸棲性爬行動物。尖首探伸，圓目鼓起；腹背硬殼，背甲呈橢圓形，中線突起脊棱，紋理緻奧；屈足短尾。主要棲息於江河、湖泊、池塘及其它水域。性情溫和，遇到敵害或受驚嚇時，便將頭、四肢和尾縮入。耐饑渴，數月不食也不虞餓亡，部分品種的龜類壽命甚至可長達三百多年。龜肉富含脂肪，可製油，卵能食用，甲又入藥，具有頗高的營養與藥用價值。

新石器時期安徽含山縣凌家灘遺址早見龜甲造型占卜器，藉手玄龜至冥間去詣問祖考，經卜兆示誨後世。假黑色為徵，龜類作為北方幽晦不明（永晝現象）地域的水介代稱也就不難理解。東晉・葛洪於《抱朴子・論仙》載云：「謂生必死，而龜鶴長壽焉。知龜鶴之遐壽，故效其道引以增年。」南梁・任昉《述異記》亦述及：「龜一千年生毛，壽五千歲謂之神龜，壽一萬年曰靈龜。」綜上所陳，在在體現前人對龜類「壽而有靈」的概觀認知。

VII. 燕形器

燕，雀形目燕科小型候鳥，翅尖而長，尾叉似剪，背羽多呈輝藍黑色，故又名「玄鳥」。常在居處內或屋簷下營巢棲住，捕食昆蟲，對農作物有益。
殷商的肇始源自《詩經・商頌》：「天命玄鳥，降而生商」的傳說。仲春三月，燕子築巢產卵，先民臆想，燕子飛臨便是繁衍的佳期，於是夫妻雙雙同赴郊野曠闊之地，舉行求子祭祀活動，此一時期所孕之子，稱作「玄鳥所生」。商人的先祖─契，由母簡狄於途中吞食燕卵後而懷孕誕下，世人直觀地認定，一切皆屬天意。

圖騰崇拜及萬物有靈是原始社會共同的信仰形式，隨著企羨羽鳥翔然天際超乎人類的能力而潛移默化，屢屢見於中國東半部飛禽聚集地和玉器文化分布範圍。

VIII. 鷹形器

鷹，泛指小型至中型白晝活動的隼形目肉食性動物，包含鷹科與隼科，即是漢語中指稱的鷹、隼、鵟、鵰、鷲、鳶等。鷹科翅寬圓而鈍，擅於高空持久盤旋翱翔；隼科翅稍長而狹尖，擅於疾飛俯掠追捕獵物。隼形目弧喙鉤爪強大，體形矯健，兩眼側置，視力敏銳，以嚙齒類、爬蟲類、小型至中型哺乳類或禽類，甚至昆蟲為食，多數對農業有益。

隼形目多為候鳥，春末夏初到臨東北、華北地區繁殖；秋初結群南遷越冬。棲息環境多樣，開闊的山麓、丘陵；臨海的河谷、崖岸；濱水的沼澤、湖泊；荒漠的草地、苔原等處均可迭見。猛禽因具備覓食的優勢，幼鳥常被狩牧民族馴養，用以捉取獵物。滿族先祖自肅慎地起，早以

「放鷹」名世，諸朝歷代更是均設專司抓攫和飼養的機構，「海東青」（白隼）的俗稱直至今日仍為人傳詠不已。

位於中國東北部遼河流域的紅山文化，出土諸多鷹形佩飾及各類鳥形玉件，據此或能推索原始先民對不可見的自然力量莫名渴切，甚而遙想薩滿信仰代神立言之玄秘象徵儀式，且可略窺北方匈奴部族特有動物風格金屬器什之濡漸，呈露遊牧民族粗獷驃悍的文化間或向中原地方滲和的跡狀。

IX.虎形器

虎，亞洲陸地上最強大的食肉動物之一，據迄今出土化石分析，約兩百萬年前起源於東亞（即長江下游地區），然後沿著兩個主要方向擴散—沿西北方向的森林和河流系統進入亞洲西北部：沿南和西南方向進入東南亞及印度次大陸。

《說文解字》輯錄：「虎，山獸之君。」其性兇猛，行動迅捷，處於所屬食物鏈中的最頂端，在自然界中鮮有天敵。具領域行為，棲居於森林、灌木和野草叢生的地帶，以大中型食草動物為食，亦會捕食其他的食肉動物。毛色黃棕，背部和體側橫列黑色狀斑紋，斑紋延伸至前額，中間常見串接，極似「王」字，故有「叢林之王」之美稱。

鋒利如刀的虎爪和犬齒，還有條鋼管般的尾巴，勇猛、威嚴的形象於歷紀餘跡中打下凜畏的烙印。虎的圖騰崇拜早見於新石器時期黃河流域中游的仰韶文化、石家河文化，春秋、戰國時期更遞嬗為武力之代稱，採銅制的「虎符」作為中央發給地方官員或駐軍將領的調兵憑證。

IX.兔形器

哺乳動物，長耳，上唇縱分，簇狀短尾，後腿較前肢強健，擅於跳躍、奔跑。雌兔成長到八個月大時即具生產能力，懷孕三十天後，每胎可產小兔三至十隻，一年可產數次。其豐腴的軀幹與絕佳的繁殖能力，成為原始先民嚮往生命衍續的母性代身之一。兔的經濟價值頗甚，毛供紡織，皮可製衣，亦是美味的肉食來源。

月中有兔的傳說，始於春秋時期。戰國·屈原《楚辭·天問》有云：「夜光何德，死則又育？厥利維何，而顧菟在腹。」兔性溫馴，屬夜行動物：通體圓絨，毛色皎潔，恰似月華：兔口有缺，正似月虧，成為月神崇拜的象徵。河南鄭州出土的西漢晚期畫像磚《東王公乘龍》出現了玉兔搗藥的形象，如實反映了神話流傳的概況。

XI. 牛形器

哺乳動物，草食反芻家畜，眼稍突，口方大，鼻鏡圓張，角向後彎曲成半月狀，外軀粗壯。汗腺不甚發達，體溫調節能力差，喜浸浴水中，藉以散熱；或泥潭打滾，以避免蚊虻的叮咬。主供役用，挽重力強，可達體重的兩倍以上，頗適耕作、曳車。趾端有蹄，耐浸泡，步踏穩重，能在泥漿中緩走自若。乳供飲，肉能食，角可工飾。

《山海經‧海內經》：「稷之孫曰叔均，是始作牛耕。」亞洲水牛約於西元前四千年被馴化，性溫順，易調教，以耐勞著稱。作為耕稼文化中最典型的勞力動物，屢屢成為農人感懷的對象。春秋時期，中國邁入鐵器時代，鐵器農具的出現令牛耕技術取得重大的革易。西漢‧司馬遷《史記‧仲尼弟子列傳》：「冉耕，字伯牛。」「司馬耕，字子牛。」牛與耕相比，用作人名，證說使牛耕田已經是時人所習常見慣的事狀。

XII. 鹿形器

呈溫馴跪臥狀或靈動奔跑狀，雙面均以陰線淺雕出鹿之臣字目和鼻、口。長角分枝，伸頸前望，圓目張耳，短尾蹄足，通體圓碩。為北方草原圖騰崇拜或泛靈信仰之體現。早在三千年前的西周，皇家獵苑業已半人工馴養麋鹿，但肇因於自然氣候變化及人類過度獵殺，時至東漢末年就近乎絕種，鹿形器亦日漸式微。

鹿科動物是哺乳類中最富經濟價值的種類，有著極高的藥用價值。中國歷代醫家甚至認為：鹿為仙獸純陽多壽之物，全身皆益於人。又肉可食用，皮可製革，角可供作裝飾，其充滿活力的形象深植於遊牧民族的記憶，衍變成雄健祥瑞、驅除邪祟的表徵。

I.Cicada-shaped Utensil

The fact that early people took cicadas as a symbol of resurrection and eternity originates from the special life cycle of a cicadas. When the eggs hatch, the newly hatched nymphs drop to the ground, where they burrow. The nymphs feed on root juice and have strong front legs for digging. In the final nymphal instar, they construct an exit tunnel to the surface and emerge. They then molt on a nearby plant for the last time and emerge as adults.

The record of usage of cicada-shaped utensil could be dated back to Neolithic and most pieces came out of excavation between Shang Dynasty and Warring states period are decorative pendants. The body of cicadas is flat in general, bulging outward from the center. Its eyes set wide apart on the sides of the head and prominent mouth. The pair of wings is engraved with fine lines. There are horizontal curves inward on the belly and a string hole on the head. People at that time put cicada-shaped utensil (those without a hole on the head) to the deceased's mouth as funerary objects. The earliest discovery is at the tomb of Western Zhou in Luoyang, Henan Province. Not until Han Dynasty did it develop to pervasive folklore and continued to exist in both Jin Dynasty and Southern and Northern Dynasty.

Ge Hong (a scholar in Eastern Jin Dynasty) disclosed a concept of pursuing eternity by way of holding gold and precious metal in the mouth of the dead in his book entitled "Baopuzi." The notion indeed is similar to psychological process of nowadays of putting grasping behind and moving forward to the next level. (Functions of gold and precious metal include warding off the evils from possessing the living and the dead. It is even believed that humanity may achieve immortality with the help of swallowing gold and precious metal.) Therefore, cicada-shaped jade and stone engravings enjoyed wide popularity. People took cicadas' life cycle as well as the molt process as a symbol of rebirth, hoping the spirit would be able to revive after the death some day in the future.

II.Silkworm-shaped utensil

The domesticated silkworm derives from northern China, feeds on mulberry leaves and is main source material provider of silk fabric. The practice of breeding

silkworms for the production of raw silk, has been underway for at least 3,000 years in China. It has played an important role in human's economic activity and cultural progress. Baby silkworms grow very fast due to great appetite and continuous feeding. When entering to next instar phase, they stay in a quasi-sleep mode without eating or moving for approximately a full day, called dormancy. After they have molted four times, their bodies become slightly yellow and the skin becomes tighter. The larvae will then enter the pupa phase of their life cycle and enclose themselves in a cocoon made up of raw silk produced by the salivary glands.

The process of breeding, hatching, cocoon and molting is called complete metamorphosis, which implies great difference between baby insects and adult insects on their external shapes and internal natures. The life expectancy of people before Qin Dynasty was slightly lower than 25 years because of ruthless wars and medical shortage; people rightly craved prolonged life and achieving longevity. Ancient people developed expectations by means of observing life cycle of small insects in the ambient surroundings. Notwithstanding the goal of escaping death had never been achieved in the end, they still had hope to gain certain oracular powers to transform their life courses.

III.Longhorned grasshopper-shaped Utensil

Long-horned grasshopper, also called katydid, is an insect. The body is flat in cylinder shape and about an inch long in lenth. They are yellow green in colour, have thick short wings, hairlike antennae and well-developed hind femurs. Male long-horned grasshoppers make easily heard noises usually do so by rubbing the hind femurs against the forewings or abdomen. The noise is like metal sound that could travel up to 1-2 meters, which is the way more grating and sharper than crickets'. Adult long-horned grasshoppers are omnivorous, more inclined to carnivorous than herbivorous and considered harmful insects to crops. They are often seen in trees, bushes, or shrubs in summer. It is hard to capture due to their exceptional leaping ability.

The worship of long-horned grasshopper had started from the end of primitive society. Ancient dictionaries including Shuowen Jiezi and Erya recorded the relation

between the insect and Yu the Great. Hao Yi-Hsing's exegesis in Qing Dynasty also had the same statement that the name of Yu the Great is derived from a katydid and so is the clan totems. Yang Xiong in Western Han Dynasty described, "Yu the great used to control the waters and witch-steps are mostly performed in Yu style." which demonstrated the dance of Yu is close to long-horned grasshoppers' leaping poses.

The egg amount laid by a single female long-horned grasshopper in the lifetime reaches approximate 200 to 400. Therefore, Zhou Nan spent a whole paragraph in Songs; Mao's preface extolling long-horned grasshopper's huge family and good reproductivity. It reflected the expectation towards producing more offspring when the fertility was very low.

IV.Fish-shaped Utensil

Fish plays an important role as a main nutrition source of protein in primitive society and is also a symbol of serenity and fertility for its elegant swimming gesture and biological features. Anthropological studies indicate that people started to wear nephrite fish-shaped ornaments from Shang Dynasty. Many small flat pieces of fish-shaped engravings were found at excavation relics, which have holes on the mouth and long holder in the end as gravers assumed to be carry-on tools.

An early depiction of transformation from fish to dragon was in a book entitled "Note of three Qins" in Eastern Han Dynasty. The story says thousands of fish crowded in a rapid river mouth called Dragon Gate to get through and only capable fishes can make it to transform into dragon. It is also the earliest record of written language that dragon originates from fish. According to the depiction, we could probably assume the folklore of "fish leaping over dragon gate" formed in late Western Han Dynasty. Sturgeon will gather to a group swimming and leaping upstream against the river's strong current. Chinese usually use the image referring to success in business or promotion in a hierarchy.

V.Frog-shaped Utensil

Frogs are amphibians, with short front legs, long back legs, webbed digits (fingers

or toes) and the absence of a tail. They are widely known as exceptional jumpers as well as swimmers. They are belonging to oviparous and hibernating animals. The breeding season starts at late April every year. The number of eggs varies upon species, ranging from hundreds to thousands. Due to their permeable skin, frogs are often semi-aquatic or inhabit humid areas in Torrid and Temperate Zones. Adult frogs follow a carnivorous diet, mostly of arthropods, annelids and gastropods. They are beneficial animals to crops.

The ancients connected frog's productive feature with humanity's fertility as the primitive religion of reproductive worship. Additionally, they also discovered a mystical match between frogs' call and the solar term through the natural phenomenon, "When frogs sing, it pours." Thus, frogs are regarded as deities in charge of water and rain. The ancient Qiang people's frog totem in Loess Plateau has been revealed on the Neolithic excavated painted potteries and sculptures. Pronunciation of frog in Chinese and 媧(女媧; Nu Wa: a goddess in ancient Chinese mythology best known for creating mankind and repairing the wall of heaven.) is homonymic. Either the matriarchal chieftain logo or the set concept of the first ancestor of all tribes is the origins of Chinese culture.

VI.Turtle-shaped utensil

Turtles are reptiles of the order Testudines, characterised by a special bony orcartilaginous shell developed from their ribs that acts as a shield. The carapace and plastron are joined together on the turtle's sides by bony structures called bridges. The inner layer of a turtle's shell is made up of about 60 bones that include portions of the backbone and the ribs, meaning the turtle cannot crawl out of its shell. Turtle habits mainly in the rivers, lakes, ponds, and other areas of water. The nature is mild and they withdraw their necks into their shells while facing threats or getting frightened. They have evolved ability of resisting dehydration and starvation over months. Some species can even live more than 300 years. The meat contains abundant fat, which could be used for the production of oil, turtle eggs are edible and shells are widely used for medical purposes. In general, turtle is highly nutritious food as well as valuable medicinal properties.

The earliest turtle shell as divinatory tools was unearthed in the Neolithic excavation site, Lingjiatan, located in Hanshan in Anhui. Diviners entered the underworld by holding the mystical turtle to ask ancestors for things they want to know and offered a prediction or forecast the present people by studying the cracks on the shells. Because the color black signifies water in Wu Xing theory, it is understandable why turtle is regarded as the leader of aquatic animals in north regions of chaos (the polar days phenomenon). Ge Hong (a scholar in Eastern Jin Dynasty) described in his book Baopuzi, "As a man lives, so shall he die. Hence, turtles and cranes have long lives. People therefore, like to follow their way to live longer and healthier." "Shu Yi Ji" by Ren Fang of Southern Liang also noted: "Turtles start to grow hairs after living for a thousand years. The name of divine tortoise is given to which lives for five thousand years. For those living for 10 thousand years are called god tortoise." In conclusion, the ancients mystified turtle's character of divinity and made it a symbol of longevity.

VII.Swallow-shaped utensil

The swallows are a group of passerine birds in the family Hirundinidae which are characterised by their adaptation to aerial feeding. They have longpointed wings and scissor-like tails. Some people call them "black birds" for the glorying dark blue feathers on the backs. Swallows have often nested and habited inside or under the eaves, hunting insects of gliding. They are beneficial animals to crops.

The origin of Shang Dynasty is derived from a mythology mentioned in The Book of Songs: Shang Paean: "Heaven bade the dark bird to come down and bear Shang." March of spring is the season of swallows of nesting and breeding; therefore, ancient people conjectured that arrival of swallows signified a good time to produce offsprings. Couples went to wilderness area to hold a ritual of praying for children. Baby conceived during that period is called son of black bird. The ancestor of Shang Dynasty, Xie is believed to be the son of black bird as his mother was conceived after swallowing a swallow egg in the middle of the road. People have directly presumed it is the will of Heaven.

Totemism and animism are common forms of religion in primitive society. With people's admiration of bird's supernatural power of soaring in the sky, the altered

religious forms have been widely seen at many birds' habitats in east China and sites of jade-using cultures.

VIII.Hawk-shaped Utensil

Hawk refers to generally any of the group of carnivorous Falconiformes, including Accipitridae and Falconidae which are referring to accipiter, falcon, buzzard, eagle, vulture, and kite in Chinese-speaking areas. Falconiformes have broad rounded wings and are capable of flying at great altitude. The wings of accipitridae are longer and pointed which make them exceptional raptors to hunt by dashing down to the ground. Falconiformes have round eyes with extremely keen eyesight which enables them to spot potential prey from a very long distance. They prey on small animals, including rodents, reptiles, small to medium-sized mammals or birds, sometimes even feeding on insects. Most of them are beneficial animals to crops.

Great groups of falconiformes are migratory birds, breeding in eastern China in late spring and early summer and migrating in flocks southward through the winter. Their habitats are various, e.g. open mountain foot, hills, and valleys near the river, cliff ledges on the coast, ponds, lakes, tundra as well as desert grasslands. Because they are born with great preying ability, hunting nationality often tames baby falcons to hunt. Early ancestors of Manchu people have known of their falconry in Sushen, northeast of ancient Chinese people. Central government of all dynasties has set up organizations specializing in catching and breeding hawks and eagles. Hai Dong Qing was an important breed of hunting eagle for Jurchen tribes. Until today, people still use hai dong qing as gyrfalcon's nickname.

According to many falcon-shaped pendants and all kinds of bird-shaped jades unearthed at Hongshan culture sites in the reaches of Liao River in northeast China, we are able to assume that the ancients craved for invisible nature power so badly and even to imagine mystical rites of the god-possessed shaman in Shamanic beliefs. Meanwhile, with the discovery of characteristic animal style metal utensils of Huns tribes in central China, it indicates the nomadic culture had gradually integrated with cultures in Central Plain.

IX.Tiger-shaped Utensil

Tiger is one of the most powerful carnivores in mainland Asia. According to analysis of current excavated fossils, it originated from east Asia (lower Yangtze Valley), dispersing to major two directions–one is following the northwest direction via woods and rivers to enter northwest Asia, the other is along south and southwest direction to enter southeast Asia and Indian subcontinent.

"Tiger, king of mountains." (Shuowen Jiezi; Chinese character dictionary) Tiger is at the top of food chain and has rare natural enemies for its ferocious nature and rapid movement. They are territory predators, living in the forest, bushes, and wild grass and feeding on large and medium-sized herbivores as well as some carnivores. Their most recognizable feature is a pattern of dark vertical stripes on reddish-orange fur with lighter underparts. The extended vertical stripes to forehead often crossing with horizontal lines forms a 王 shape (wang; king). Thus, tigers win the good name of "King of forests."

Tigers have sharp-edged claws, large canines, and a steely tail. They have symbolized bravery and grandeur in many ancient mythology and folklore. The earliest record of worship of tiger totem has been found in Yangshao culture and Shijiahe culture located along middle reaches of Yellow River during Neolithic Period. By the time to Spring and Autumn Period and Warring States Period, the worship has further upgraded to become a code word of military strength. The central government distributed bronze tiger-shaped statues to local officials or military commanders as the token of military leadership.

X.Hare-shaped Utensil

Hares are belonging to mammals, with long ears, split upper lips and a short tufted tail. Their hind legs are larger and more powerful than two front paws, which make them good at leaping and running. A doe is able to produce children at the age of 8 months. Normal gestation is about 30 days and the average size is usually between 3 and 10 babies. A doe can give birth many times in a single year. The chubby body and the ability of rapid reproduction become one of maternal symbols of the ancients' yearning for continuity of life. Hares have high economic value as their pelts could

be used for clothing and weaves and they are also common source of meat.

The lore of moon rabbit begun in Spring and Autumn Period. The major poet of Warring States Period, Qu Yuan once described in Heavenly Questions of section of Chu Ci that "What capability does the moon own exactly to revolve from gloom to luminescence? What is it good about taking care of rabbits" ? Hares have become a symbol of lunar deity worship for certain characters they possess. For instance, they are nocturnal animals with tamed nature, their fur emerges illuminating color like moonlight, and clef lips just resemble the black part of moon. King Father of the East Riding a Dragon, the pictorial brick of late Western Han Dynasty excavated in Henan Zhengzhou showed the image of hares pounding herbs that honestly reflected the general situation of spreading mythologies.

XI.Buffalo-shaped Utensil

The water buffalo is a large bovine animal, belonging to mammals. They are herbivorous and ruminate, with intriguing eyes, a square mouth, round nostrils and horns curling backward like new moon. Because insufficient development of the sweat gland system and weak thermotaxis, they spend much of their time in the water or mud, which keeps them cool and protects them from biting insects. Water buffalos are mainly used for heavy works, such as pulling carts and carrying loads. The maximum loading weight could be more than twice of their weight. Their feet are large and the toes can spread apart to give them better footing in mud. They are major source of meat and milk providers. The horns are often made into ornaments.

According to the description from Classic of Regions Within the Seas, a section of "Classics of Mountains and Seas," water buffalo are domesticated around 4000 B.C. They are tame and featured for capability enduring for hard works. As the most typical animal labor in farming culture, water buffalo have been receiving appreciation from farmers. In Spring and Autumn Period, China entered Iron Age and the agricultural invention of iron-made implements enhanced revolution of plowing technology. Biographies of the disciples of Zhongni, a chapter of Shi Ji by Sima Qian in Western Han Dynasty, "Ran Geng is styled boniu. Sima Geng styled Ziniu." (Niu is pronunciation of buffalo in Chinese) The wider usage of Niu instead of Geng in

naming proved that buffalo had been commonly used for the plowing of the fields.

XII.Deer-shaped Utensil

The image on the surface depicts deer tamely lying prone or running vigorously. The eyes, noses, and mouths are finely engraved with light lines on both sides. The portrait of a deer is often seen in gesture of craning neck with branchy antlers, opened ears, round eyes and short tails. It is embodiment of totem worship of northern nomadic totemism or animism. Imperial park for Animal Husbandry had started breeding deer in Western Zhou Dynasty over 3,000 years ago but the breed had been already on the verge of extinction by late Eastern Han Dynasty due to climate change and overhunting. Deer-shaped utensil had been less seen thereby.

Deer is considered the most economic value added specie in mammals and highly therapeutic property. Chinese physicians of all generations even regard deer as a divine creature full of masculine and a symbol of long life. The whole body is serviceable in many different ways. Their meat could be served as food, skin may be used for leather production and antler is the best material of decorative ornaments. The energetic deer image ingrained in the memory of nomadic nationalities has gradually developed to a symbol of wellness, healthiness and talisman.

參考書目
BIBLIOGRAPHY

專書 Books

1. 于寶東。《遼金元玉器研究》。呼和浩特市：內蒙古大學出版社，2007年12月1日。

2. 尤仁德。《古代玉器通論》。北京市：紫禁城出版社，2002年2月。

3. 天津市藝術博物館 編。《天津市藝術博物館藏玉》。香港：文物出版社：兩木出版，1993年10月。

4. 中國美術全集編集委員會 編。《中國美術全集》（雕塑編）。北京市：人民美術出版社，1986-1989年。

5. 古方 主編。《中國出土玉器全集》。北京市：科學出版社，2005年10月。

6. 田自秉。《中國工藝美術史》。台北市：文津出版社，1993年07月15日。

7. 史樹青 主編。《中國文物精華大全》（金銀玉石卷）。香港：商務印書館（香港）有限公司，1994年10月15日。

8. 牟永抗、雲希正 主編。《中國玉器全集》（1 原始社會）。石家莊市：河北美術出版社出版，1993年3月一版二刷。

9. 李念祖。《昭華錫福》。台北市：漢藝色研文化事業有限公司，2004年8月。

10. 李念祖。《嘉瑞延喜》。台北市：漢藝色研文化事業有限公司，2002年11月。

11. 李學勤。《東周與秦代文明》。上海市：上海人民出版社，2007年11月。

12. 林巳奈夫。《中國古玉研究》。台北市：藝術圖書公司，1997年。

13. 周南泉。《中國古玉斷代與辨偽2 古玉動物與神異獸卷》。台南市：文沛美術圖書出版社，1994年1月。

14. 周南泉。《中國古玉斷代與辨偽3 古玉人神仙佛卷》。台南市：文沛美術圖書出版社，1995年1月。

15. 柳冬青。《紅山文化》。呼和浩特市：內蒙古大學出版社，2002年9月。

16. 香港藝術館 製作。《中國肖生玉雕》。香港：香港市政局，1996年1月。

17. 姜濤、王龍正、喬斌。《三門峽虢國女貴族墓出土玉器精粹》。台北市：眾志美術出版股份有限公司，2002年9月。

18. 殷志強。《古玉至美》。台北市：藝術圖書公司，1993年3月30日。

19. 國立故宮博物院編輯委員會 編。《國立故宮博物院藏新石器時代玉器圖錄》。台北市：國

立故宮博物院，1992年12月。

20. 那志良。《中國古玉圖釋》。台北市：南天書局有限公司，1995年8月三刷。

21. 那志良。《古玉論文集》。台北市：國立故宮博物院，1983年7月。

22. 那志良 編撰。《玉器辭典》。台北市：雯雯出版社，1982年。

23. 傅忠謨。《古玉精英》。香港：中華書局（香港）有限公司，1989年。

24. 傅熹年。《古玉掇英》。香港：中華書局（香港）有限公司，1995年。

25. 楊伯達。《古玉史論》。北京市：紫禁城出版社，1998年。

26. 楊美莉。《故宮環形玉器特展圖錄》。台北市：國立故宮博物院，1995年。

27. 劉如水。《中國古玉鑑別總論》。台北市：商周出版：城邦文化事業股份有限公司發行，2004年5月1日。

28. 劉如水。《中國古玉年代鑑別》。台北市：商周出版：城邦文化事業股份有限公司發行，2004年5月5日。

29. 劉良佑。《古玉新鑑》。台北市：尚亞美術出版社，1993年8月三版。

30. 郭繼生 主編。《美感與造型》。台北市：聯經出版事業公司，1997年8月初版十刷。

31. 賴素鈴。《民族交流與草原文化》。台北市：祥瀧股份有限公司，2000年9月。

32. 錢憲和、方建能 編著。《史前琢玉工藝技術》。台北市：國立臺灣博物館，2003年3月1日。

33. 錢憲和、譚立平 主編。《中國古玉鑑：製作方法及礦物鑑定》。台北市：地球出版社，1998年10月。

34. 陳曉啟 主編。《中國金銀琺瑯器收藏與鑑賞全書》。天津市：天津古籍出版社，2005年8月。

35. 陳德安、張光遠 撰文。《三星堆傳奇 華夏古文明的探索》。台北市：太平洋文化基金會，1999年3月。

36. 鄧淑蘋。《古玉圖考導讀》。台北市：藝術圖書公司，1992年9月30日。

37. 鄧淑蘋。《群玉別藏》。台北市：國立故宮博物院，1995年。

38. 鄧淑蘋。《群玉別藏續集》。台北市：國立故宮博物院 1999年。

39. 鄧聰 主編。《東亞玉器》（全三冊）。香港：香港中文大學中國考古藝術研究中心，1998年1月。

40. 欒秉璈。《怎樣鑑定古玉器》。北京市：文物出版社，1984年。

論文與期刊 Papers &Journals

1.方英明。〈綠松石的藝術價值及鑒賞〉。《收藏界》（總第84期）。西安市：寧夏雅觀收藏文化研究所編輯部，2008年12月1日。

2.方輝。〈東北地區出土綠松石器研究〉。《考古與文物》（總159期）。西安市：考古與文物編輯部，2007年1月30日。

3.中國社會科學研究所二里頭工作隊。〈河南偃師市二里頭遺址中心區的考古新發現〉。《考古》（總454期）。西安市：考古與文物編輯部，2005年7月25日。

4.王海文。〈春秋、戰國時期的青銅工藝（續）〉。《故宮博物院院刊》（總第34期）。北京市：紫禁城出版社，1986年11月。

5.孔德安。〈淺談我國新石器時代綠松石器及製作工藝〉。《考古》（總416期）。北京市：考古雜誌社，2002年5月25日。

6.李存信。〈二里頭遺址綠松石龍形器的清理與仿製復原〉。《中原文物》。鄭州市：中原文物編輯部，2006年8月20日。

7.胡鳳英。〈綠松石飾件賞析〉。《收藏界》（總第105期）。西安市：寧夏雅觀收藏文化研究所編輯部，2010年9月1日。

8.浙江省文物考古研究所、東陽市博物館。〈浙江東陽前山越國貴族墓〉。《文物》（總六二六期）。北京市：文物出版社，2008年7月15日。

9.馬道闊。〈安徽廬江發現吳王光劍〉。《文物》（總三五七期）。北京市：文物出版社，1986年2月。

10.楊美莉。〈就購藏的綠松石首玉虎談中國古代的綠松石雕作〉。《故宮近年購藏玉器賞析與研究學術研討會》。台北市：國立故宮博物院，2000年12月14日。

11.楊益民、郭怡、謝堯亭、夏季、王昌燧。〈西周倗國墓地綠松石珠微痕的數位顯微鏡分析〉。《文物保護與考古科學》（第20卷第01期）。上海市：文物保護與考古科學編輯委員會，2008年2月15日。

12. 郝用威、郝飛舟。〈中國新石器時代綠松石文化〉。《岩石礦物學雜誌》（第二十一卷增刊）。北京市：岩石礦物學雜誌編輯部，2002年9月。

13. 錢憲和、劉聰桂 主編。《海峽兩岸古玉學會議論文專輯》。台北市：國立臺灣大學出版委

員會，2001年。

14. 劉萬航。〈綠松石－最早用於裝飾的寶石〉。《故宮文物月刊》（1卷9期），台北市：國立故宮博物院，1983年12月。

15. Mark P. Block. *TURQUISE: Mines, Mineral, & Wearable Art*. Atglen Pennsylvania: Schiffer Publishing Ltd. Company, 2007.

辭典、工具書 Thesaurus

1. 吳山 主編。《中國工藝美術辭典》。台北市：雄獅圖書股份有限公司，1995年10月二版。

2. 李松。〈春秋戰國工藝美術〉。《中國大百科全書》（美術 I）。北京市：中國大百科全書出版社，1999年12月。

3. 沈柔堅 主編。《中國美術辭典》。台北市：雄獅圖書股份有限公司，1997年10月三版。

4. 洪文慶 主編。《中國美術備忘錄》（增訂版）。台北市：石頭出版股份有限公司，2007年1月增訂一版。

5. 詹姆斯‧霍爾(James Hall)。《東西方圖形藝術象徵辭典》。*(Illustrated Dictionary of Symbols in Eastern and Western Art)*。韓巍 等譯。北京市：中國青年出版社，2000年5月1日第一版。

淳雅齋藏綠松石飾
翁啓榮結藝
Treasured Turquoise from
Wang Hsien-Chao's Collection

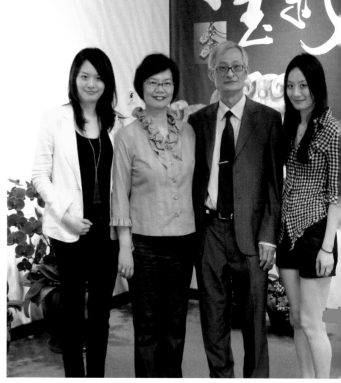

松玉新賦：淳雅齋藏綠松石飾暨翁啓榮結藝／黃
俊菘撰文；王顯昭，張海燕主編.—初版.—
臺北市：王顯昭，2012.08
226面；21x29.7公分
ISBN 978-957-41-9447-6(精裝)

1.蒐藏品 2.奇石 3.編織工藝
999.21 101016970

主　　編：王顯昭、張海燕
結　　藝：翁啓榮
撰　　文：黃俊菘
翻　　譯：朱桂榕
攝　　影：君子堂
美術編輯：覺色廣告設計有限公司
承　　印：美育彩色印刷股份有限公司
版　　次：初版
發行日期：2012年8月
發行數量：1000本(軟精裝)
定　　價：新台幣 2000 元
發行單位：王顯昭
　　　　　台北市北投區明德路337巷17號3樓
　　　　　電話：02-28219801　傳真：02-28219801
版權所有　翻製必究

Director Wang Hsien-Chao & Chang Hai-Yen
Chinese Knots Artist Wong Qi-Rong
Writer Huang Chun-Sung
Translator Chu Kuei-jung
Photography Photonews Co., Ltd.
Graphic Design Feeling Good Advertised Co., Ltd.
Printer Merity Color Printing Co., Ltd
Edition First edition
Publication Date Aug 2012
Copies Printed 1000 copies
Publisher Wang Hsien-Chao
 11280, 3F., No.17, Lane 337, Ming Rd., Taipei, Taiwan(R.O.C)
 Tel: 886-2-28219801 Fax: 886-2-28219801
 E-mail: hc_wang112@yahoo.com.tw
 Blog: http://blog.xuite.net/chun_ya.studio/twblog

代理經銷／白象文化事業有限公司
402 台中市南區美村路二段 392 號
電話:(04)2265-2939 傳真:(04)2265-1171